TEXT BY
Olivia Snaije

PARISIAN CATS

PHOTOGRAPHY BY
Nadia Benchallal

Flammarion

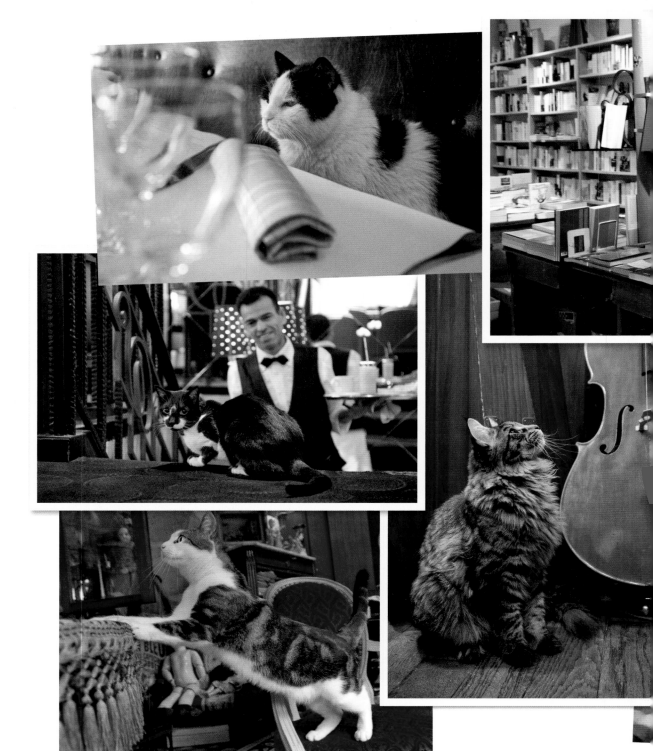

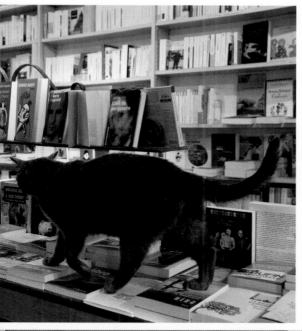

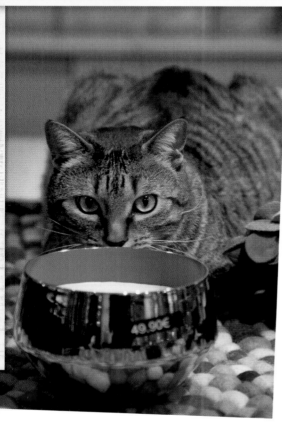

CONTENTS

INTRODUCTION

Paris, unlike Rome or Cairo, is not a city immediately associated with cats. And yet, once you begin to look around, cats are everywhere. Not in gangs eating pasta, or dotted around a marketplace, but cozily ensconced in a basket in the corner of a restaurant, lazing in the sun in a gallery window, or fast asleep atop a bistro dessert case.

The inspiration for this book came about after seeing these alluring creatures in shops and cafés that are central to Parisian daily life. These cats have not only become the mascots of their establishments, they live in the city's loveliest or most historical and culturally rich neighborhoods, spending their days roaming seventeenth-century gardens or cavorting in the nineteenth-century Grand Palais. By observing and photographing the cats in their everyday lives and speaking to the people who care for them, we embarked on a feline odyssey throughout the city, rediscovering and re-imagining it from a cat's point of view.

Cat lovers will notice these animals in various shapes or forms all around Paris. In the Montparnasse cemetery, for example, Niki de Saint Phalle's giant, colorful, mosaic tombstone of a cat is impossible to miss. Also omnipresent are cats in Paris cafés, bistros, and restaurants. Unlike most Anglo-Saxon countries where health codes prohibit animals in eating establishments, in France pets are forbidden only in the kitchen itself.

Like all urban areas, Paris has a mouse problem, and many café cats were initially acquired to control the rodent population. Very soon, however, the cats became the pride and joy of their establishments, charming customers and attracting newcomers. But some cats—like

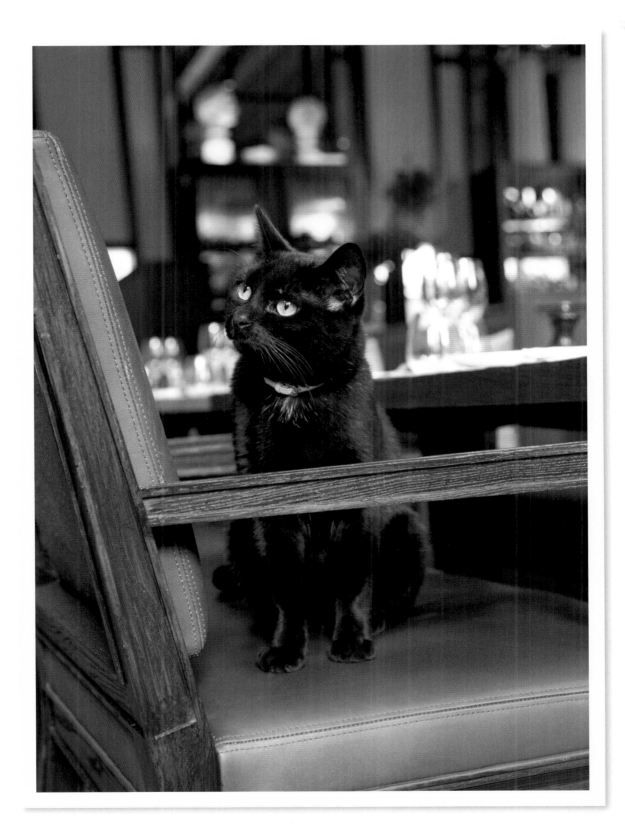

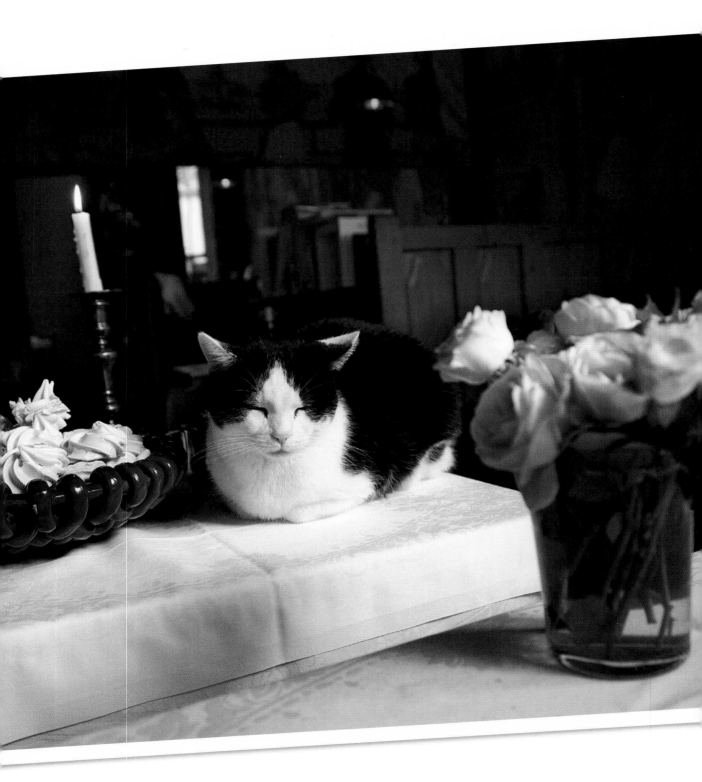

Mickey, who was Le Select café's cat for over two decades—arrived of their own accord and simply decided to stay, confirming the adage that you don't choose a cat, a cat chooses you.

In selecting which cats to include in this book, one often led to another, and after a while there was no telling where it would end. On the Left Bank, we were told about Swiffer, the cat in Le Café Zéphyr on the Right Bank. We learned about Zwicky, a cat living at Fleux—a chic design store in the Marais—from a nearby bookshop. An employee at a Parisian stained-glass studio called frequently to alert us to new cat sightings. And soon we found cats everywhere.

Being cats, of course, they have all carved out a very pleasant existence for themselves and have adapted in the best possible way to their Parisian environment—whether at a busy crossroads such as the Café RUC near the Palais Royal and the Louvre, or across the street from the lovely Luxembourg Gardens at the café Le Rostand. Some cats have the neighborhood attuned to their needs: if Arthur from the bookshop Page 189 wants to get into the building next door, he heads to the adjacent Italian specialty shop, and meows until the owner comes out from behind the counter and punches in the door code to let him in. While preparing the book, we had to adapt to the cats' schedules, waiting for certain felines to return to Paris after their summer vacations in the country.

Parisian cats are also ubiquitous in art and literature. French novelist Colette immediately comes to mind: the original cat woman, she wrote about her beloved pets in her novels, letters, and memoirs, and lived her last years in an apartment overlooking the Palais Royal Gardens, surrounded by felines. Her friend, the writer, artist, and filmmaker Jean Cocteau lived around the corner and loved cats too; they provided inspiration for several of his paintings, sculptures, and poems. Photographer Robert Doisneau's black-and-white images of Paris in the 1950s included many cats, pictured with concierges, sitting next to vagabonds, or slinking along the city's rooftops at night.

The most iconic Parisian cat appears on Steinlen's oft-reproduced nineteenth-century poster for Rodolphe Salis's famous Cabaret du Chat Noir. Imagine our delight when we discovered by chance that a black cat named Salis lives in the Montmartre museum, which has a collection dedicated to memorabilia from Le Chat Noir cabaret.

The irresistible cats in this book lead the reader on a singular tour of the French capital, uncovering its rich history and beguiling locations along the way. Cats, those featured here and their successors, form an integral part of the Parisian landscape and add undeniable character—dignified and zany, independent and affectionate—to the City of Light.

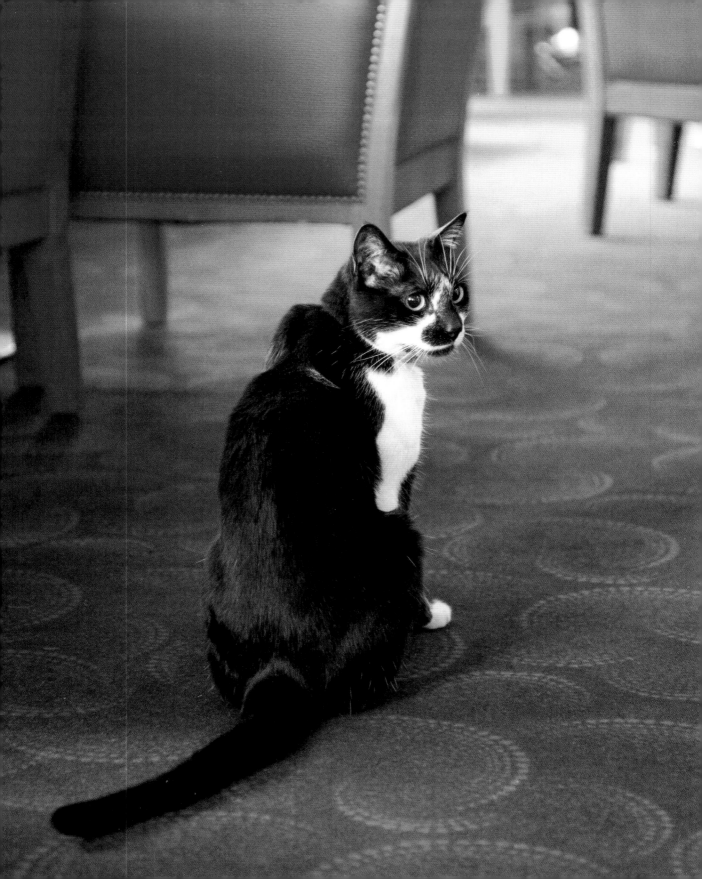

With a slight stretch of the imagination, one can conjure up what the Roaring Twenties might have been like in this nineteenth-century café-brasserie. Au Père Tranquille is a former cabaret located next to the once-great marketplace Les Halles. An advertisement flyer from the 1920s, which the current owners found in the cellar and reprinted, shows an elegant couple, the man in a top hat, getting out of an expensive car and being shown into the supper club. Besides dancing, singing, wining, and dining, Au Père Tranquille promised entertainment from midnight until morning.

Today's schedule is more sensible—the brasserie opens early and closes at midnight. Vanille, the resourceful black-and-white cat who has belonged to the establishment since 2005, is strategically fed at closing time, ensuring that she will return from her wanderings and be safely inside before the staff leaves.

Au Père Tranquille is located on a street named for a sixteenth-century Renaissance architect, Pierre Lescot, who worked for a succession of kings for thirty-three years, adding on to the Louvre palace, as well as designing the nearby Fountain of the Innocents (Fontaine des Innocents). Today, the street, while pedestrian, is always bustling, so the café is rarely empty.

Damien Revel, who began working at Au Père Tranquille in 2002, is one of three managers who alternate at the brasserie. Taking care of Vanille "is part of the job," says Revel, adding that he is the one who takes her to the vet. Vanille, with a white chest and black nose, roams the vast and busy territory of Les Halles, the celebrated twelfth-century marketplace, which inspired the title of Émile Zola's third novel, *Le Ventre*

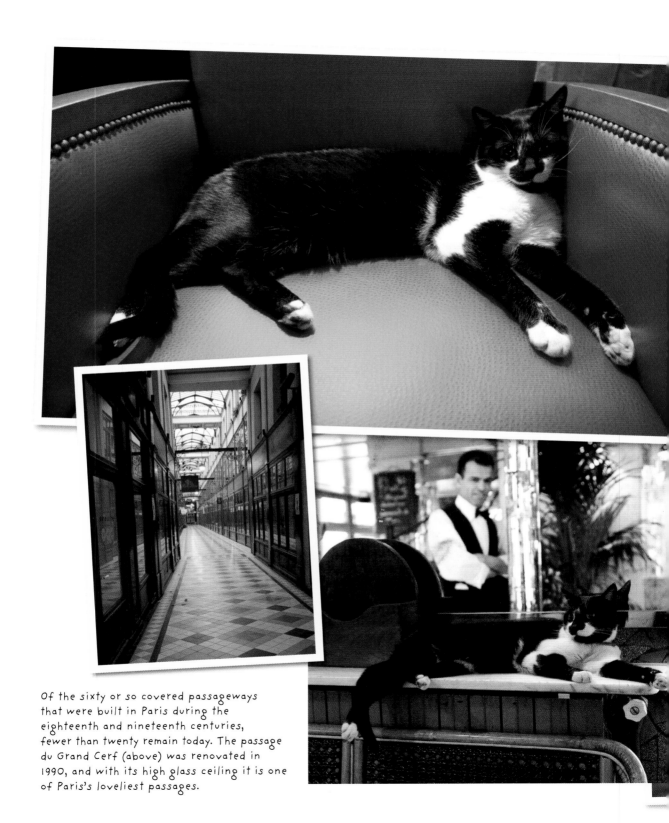

Of the sixty or so covered passageways that were built in Paris during the eighteenth and nineteenth centuries, fewer than twenty remain today. The passage du Grand Cerf (above) was renovated in 1990, and with its high glass ceiling it is one of Paris's loveliest passages.

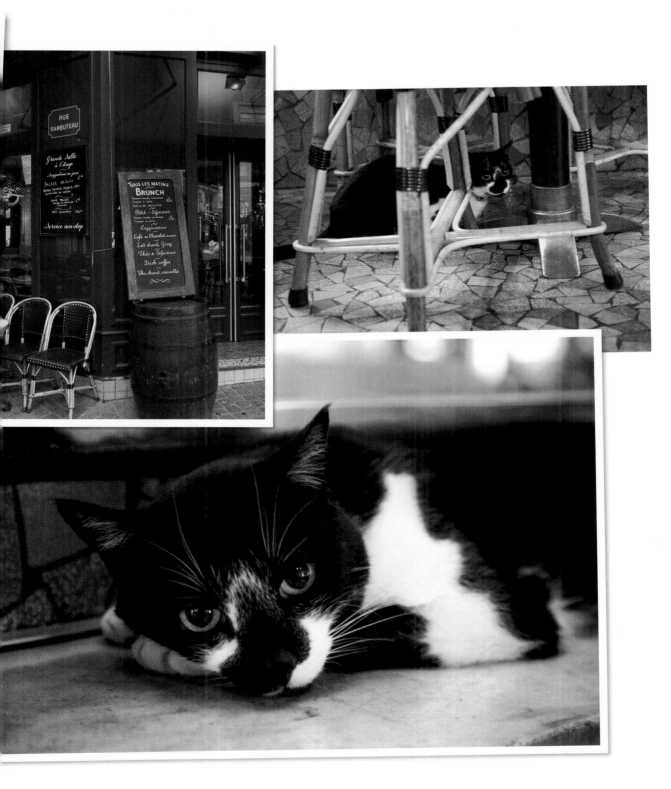

de Paris (*The Belly of Paris*). Les Halles was the bosom of a far-reaching network of food markets that date back to the fifteenth century and remain part of the fabric of Parisian life. Les Halles was also captured by photographer Robert Doisneau, who had been using the market as a source of inspiration since 1933. Doisneau's black-and-white and later color portraits of butchers, fishmongers, and vegetable and flower stalls, as well as the Victor Baltard–designed structure of Les Halles itself, committed the great market to photographic memory.

Perhaps in an atavistic attempt to once again find the atmosphere of Les Halles, which was relocated in the 1970s to Rungis in the southern outskirts of Paris, Vanille once climbed into a delivery truck that was going there. "Someone found her in the market and called us after checking her tattoo," recounts Damien. "We had to go pick her up."

One of Au Père Tranquille's waiters, Sami Ben Hag Sassi, has worked at the brasserie for over thirty years. Slight and nimble-footed, he knows all the regular patrons and points out a musician who sketches Vanille and then makes postcards from his drawings. Another customer regularly brings in nail clippers to deal with Vanille's claws, he adds.

With a shade of annoyance and a tinge of pride, Sami discloses that Vanille sometimes hunts birds and brings them upstairs to the first floor, where there are bookshelves laden with novels, comfortable sofas, and armchairs placed cozily around tables. "Then there are feathers everywhere. Have you ever tried vacuuming feathers from a wall-to-wall carpet?" Most of the waiters have known Vanille since she was a kitten and are used to her wanderings, although she is never far from her home base, where she often settles on the radiators as soon as the weather gets chilly or "on our laps in the office when we're doing the accounts," says Damien.

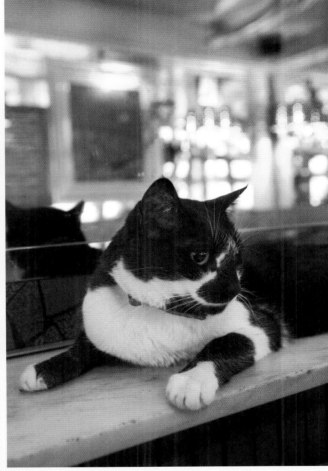

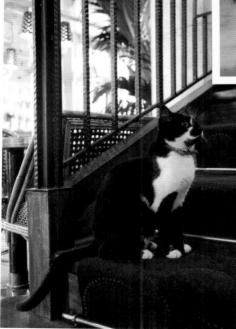

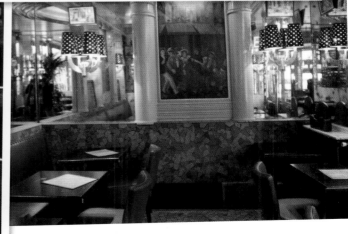

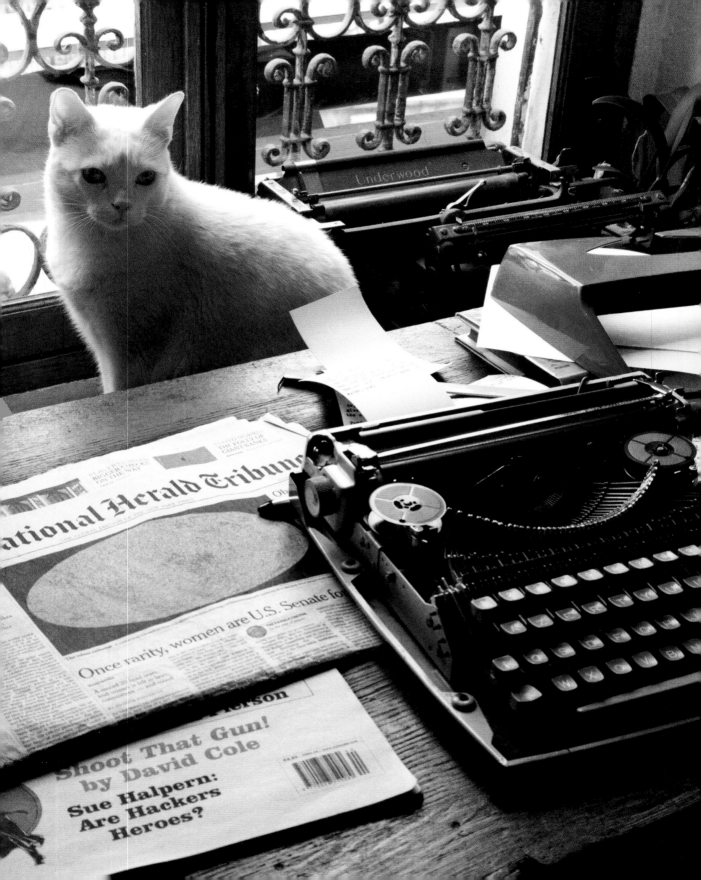

Shakespeare and Company
37, rue de la Bûcherie
75005 Paris
+33 1 43 25 40 93

Kitty

I f one were to choose the best-loved Anglo-Saxon institution in Paris, it would probably be the bookstore Shakespeare and Company. Founded in 1951 by the late George Whitman, a transplanted American, the Latin Quarter bookshop overlooks the Seine and Notre Dame Cathedral at Paris's kilometer zero. Whitman adopted the name Shakespeare and Company with the blessing of the legendary Sylvia Beach who had established her eponymous bookshop in 1919 and ran it until the German occupation of Paris during World War II. George's daughter Sylvia (named after Beach) now runs the bookshop with David Delannet, her partner in life and in business. Poets and writers such as Allen Ginsberg, Lawrence Durrell, Henry Miller, Jack Kerouac, and Anaïs Nin, among many others, graced his shop—as did at least seven felines-in-residence over the years, a number of them called Kitty.

"There have always been cats at Shakespeare," says David. The bookshop's current Kitty, a snow-white, blue-eyed male with a bemused expression, was also George's last cat and stayed by his side until his death in 2011 at the age of ninety-eight. Perhaps because the current Kitty was raised by the Whitmans' dog, Colette, he is incredibly gregarious and obedient for a cat and seems at ease among the throngs of customers flowing through the entrance of the shop.

The entry wall is covered with photographs and paintings of famous patrons; among these is a photo of Ernest Hemingway with a cat in his arms. Customers wind their way through the nooks and crannies of the ground and upper floors, some settling with a book on the velvet-covered armchairs, others on a wooden banquette. Kitty likes

Paris's antique booksellers, or *bouquinistes* (below), have been around since the seventeenth century. Today there are 216 *bouquinistes* installed along the banks of the Seine who sell antique editions of books, secondhand contemporary novels, engravings, prints, and magazines, among other items.

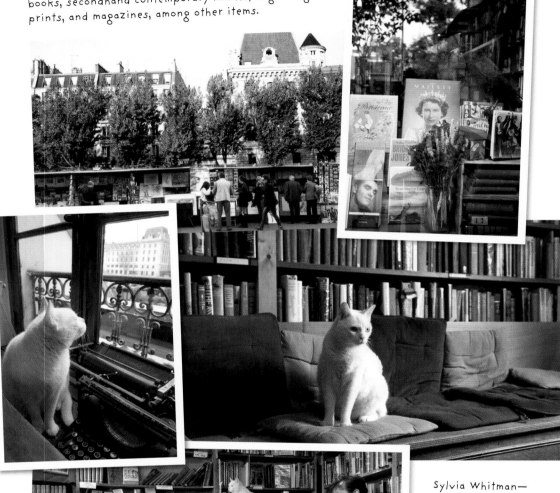

Sylvia Whitman—the daughter of Shakespeare and Company's founder—and her partner David Delannet, with their dog Colette and the late George Whitman's cat Kitty (left).

sitting in places where he has a vantage point: on top of the piano, wedged between the window and an Underwood typewriter behind a desk, or on the highest surface of a bookcase where he often knocks books down. The typewriter has been used by a long list of Shakespeare and Company resident writers known as tumbleweeds, who, in exchange for temporary lodging above the bookshop, must write a one-page autobiography, read a book a day, and help out in the shop.

"Kitty really is very cool," notes David. "He's intrigued by the street but never actually goes outside. He just hangs out. Once, he was on the sofa in the bookshop, and five people were gathered about with someone playing the piano very softly so that it wouldn't disturb him. When you have an animal in a business, it imposes a certain rhythm and silence."

If Kitty were to venture past the welcoming metal green tables, chairs, and wooden benches set up in front of the bookshop and the cast iron Wallace drinking fountain— designed by sculptor Charles-Auguste Lebourg and financed by philanthropist and Parisian-by-adoption Richard Wallace in the nineteenth century—he would find extraordinary monuments on both sides of the shop as well as a small park. This public park, which contains a locust tree that is over four hundred years old, used to be part of the adjoining twelfth-century church Saint-Julien-Le-Pauvre, which replaced an older church from the sixth century. On the other side of the bookshop, just across the rue Saint-Jacques, which leads uphill toward the Sorbonne University, is the gothic Saint-Severin church, named after a hermit from the sixth century. In addition to a lovely fifteenth-century cloister with two immense trees that Kitty would undoubtedly enjoy, the interior of the church features impressive twisted stone pillars that resemble a forest of palm trees. Just beyond the church is the narrowest street in Paris, the rue du Chat qui pêche (the cat that fishes), named, purportedly, after a black cat that belonged to a church canon and would fish in the Seine with its paw.

Kitty may not fish, but it is clear that he is more than just another Shakespeare cat. Many see him as a representation of George's spirit, welcoming book lovers to his shop.

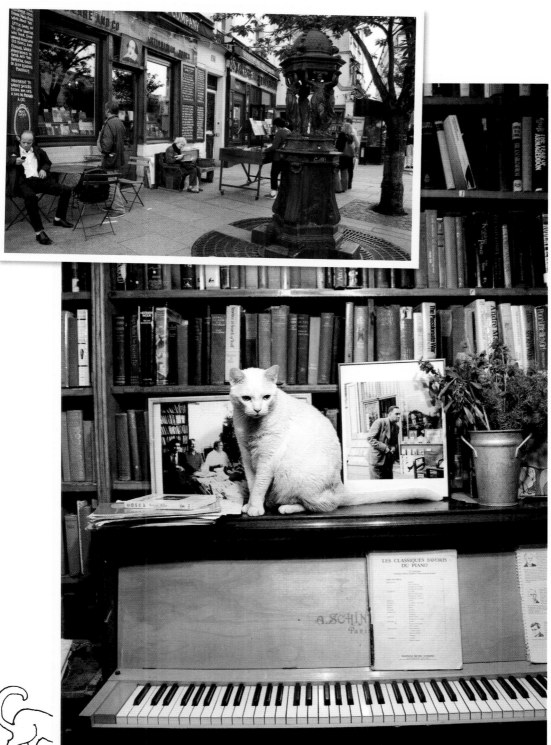

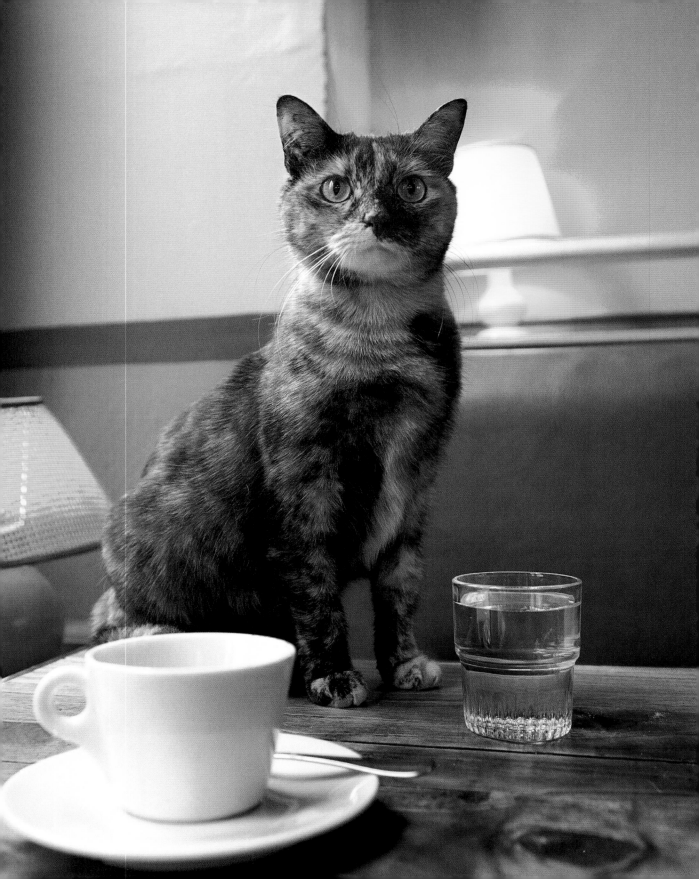

The Café de l'Industrie, a neighborhood institution on the rue Saint-Sabin, is just behind the imposing place de la Bastille, symbol of the French Revolution, where the former medieval fortress and prison, symbols of the monarchy, were stormed by the populace in 1789. The late Gérard Le Flem, an inveterate globe-trotter and painter, opened the café in 1990, maintaining an authentic 1920s feel with an eclectic, haphazard mix of his own paintings and objects he picked up during his travels. A glamorous black-and-white portrait of a youthful Jean-Paul Belmondo by Studio Harcourt, the celebrated Parisian photography studio, hangs next to Gauguin-style paintings by Gérard and an African mask; a Botero-type oil painting complements a bust of an African woman in a turban. Burgundy-colored carpets are thrown over the dark parquet floor, and small lamps give off soft lighting. Gérard's son Benoît, who has worked here since he was a teenager, now manages the café, which has two annexes on the same street. Mimine, a green-eyed calico, has been the house cat since 2002, following the disappearance of a series of stolen or runaway kittens. "She's a little wild," says Benoît, "which is what has saved her. We have one thousand clients coming in each evening, and we've already caught people trying to stick her under their coat."

Cherished by customers, both old and new, the delicate Mimine is self-contained and discreet—she decides which patrons to adopt and when. She alternates between

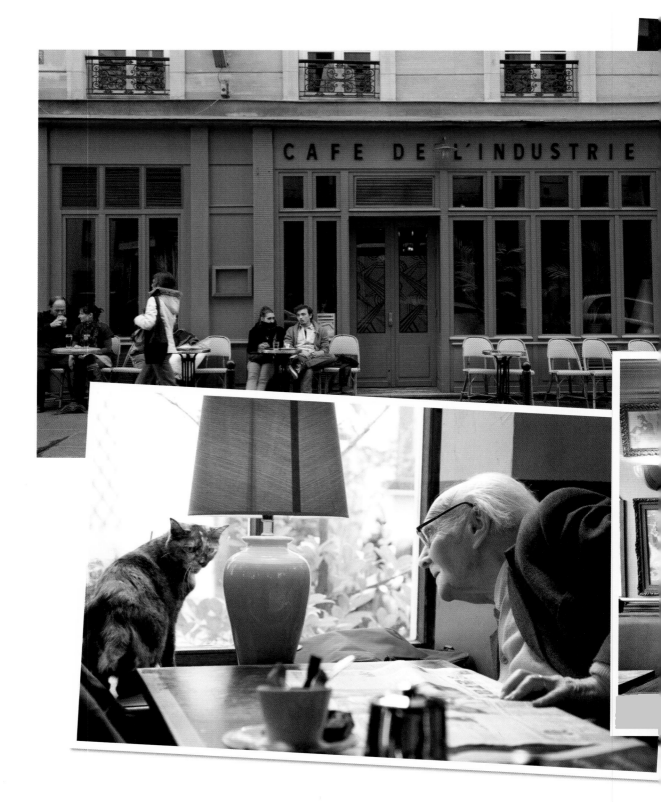

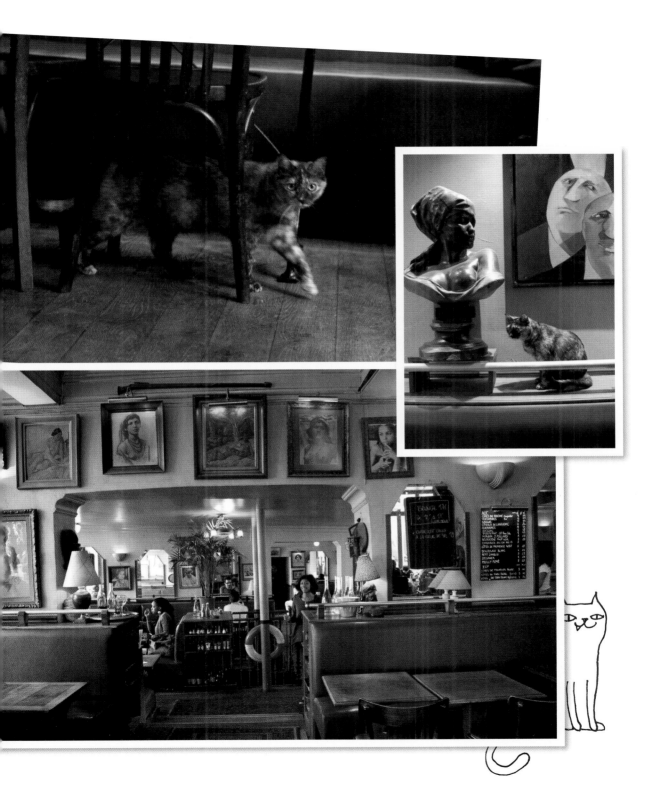

the three locations but mainly stays at the original café, where "she curls up somewhere and pretends she's a statue, then at 11 p.m. she makes an appearance and demands to be petted," says Benoît.

Mimine does get out and about and sometimes goes farther afield, says Benoît, but most locals know her and keep the café informed. "I used to worry about her and try to track her down. People call and say they've seen her on such and such a street."

Just across the vast place de la Bastille in Mimine's neighborhood—which is a hotspot for music lovers, night owls, and political demonstrations—the boulevard Henri-IV borders the Marais with its mansions which were commissioned by the nobility in the seventeenth century. When the boulevard was being built, workers came across a black marble tomb with a statue of a cat on top of it. It was the burial site of Ménine, the beloved cat belonging to the seventeenth-century Duchess of Lesdiguières, Paule de Gondi, who lived in the nonextant Hôtel Lesdiguières.

Mimine's street runs across the wide, tree-lined boulevard Richard-Lenoir, a classic creation by Baron Haussmann, who carried out a massive urban planning reform in Paris under Napoleon III. The boulevard actually covers the Canal Saint Martin, which resurfaces near République. Twice a week, it hosts one of Paris's largest and most bountiful open-air markets. Boulevard Richard-Lenoir is also the fictional home address of commissioner Jules Maigret, the unforgettable pipe-smoking, wine-drinking Paris-based detective created by Belgian author Georges Simenon, who has been incarnated in numerous screen and radio adaptations worldwide, best portrayed, perhaps, by iconic actor Jean Gabin in the 1950s and 1960s. It's easy to imagine Maigret, often described by Simenon when he is having a meal in a neighborhood café, sharing a steak tartar with Mimine, who is particularly partial to the dish.

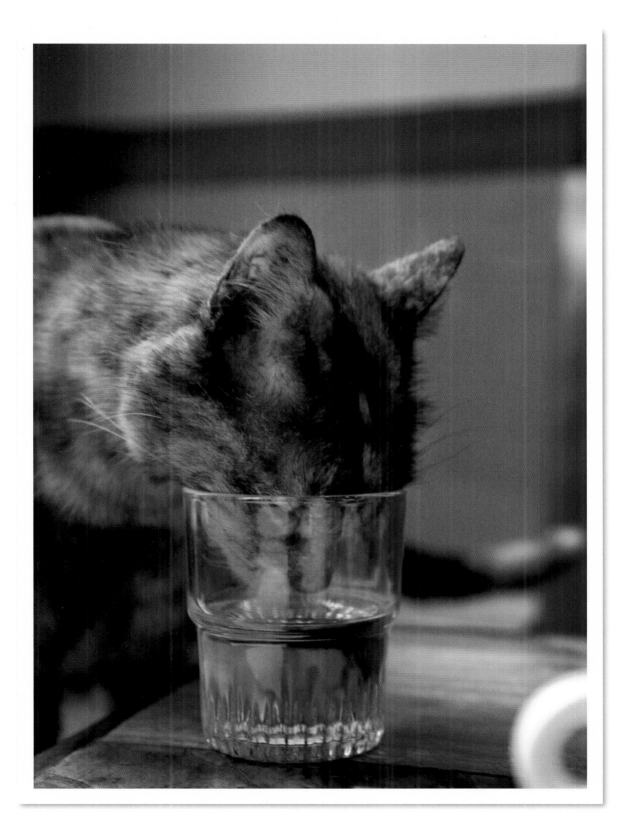

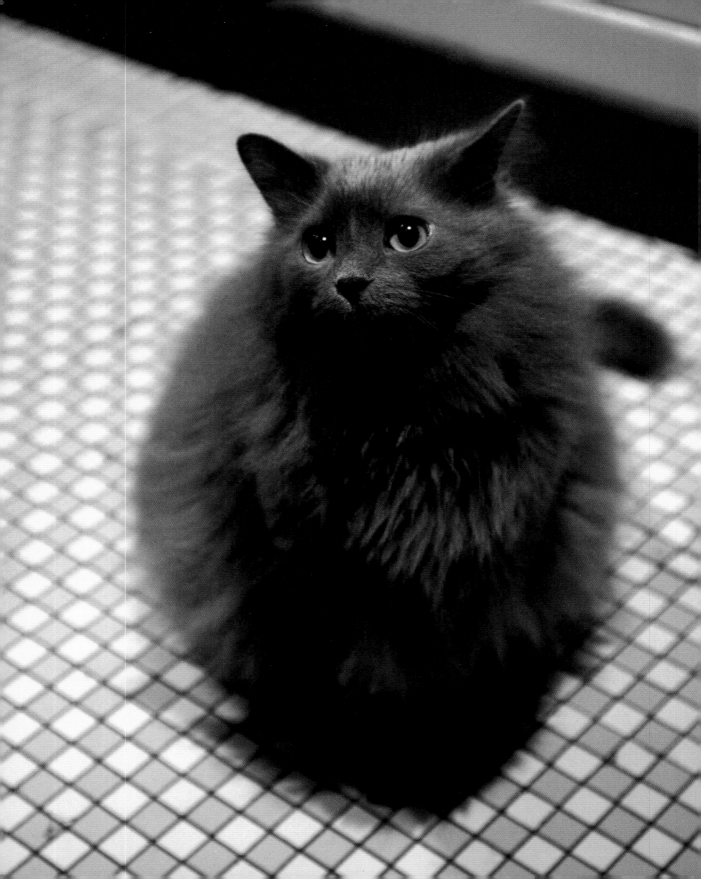

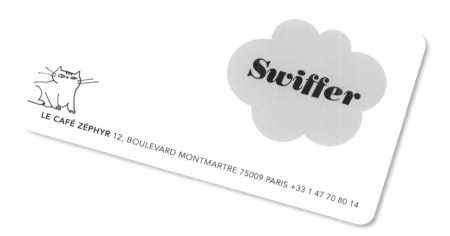

Honoré de Balzac and Guy de Maupassant wrote about them, Fred Astaire visited them in the movie *Funny Face*, and Yves Montand sang about them. They are Paris's "Grands Boulevards," a series of long, straight roads that replaced ancient fortification walls that had been torn down in the seventeenth century. From the eighteenth century onward, Parisians and also tourists adopted these tree-lined boulevards as *the* place to be seen, whether at the Café de la Paix, Café Anglais, or Café Riche, at the Folies Bergère, or at the largest movie theater in Europe, Le Grand Rex.

Le Café Zéphyr, which opened at the turn of the twentieth century, is located on one of the Grands Boulevards and remains a favorite among locals, despite its close proximity to the internationally popular Musée Grévin, the world's oldest waxworks gallery. Inside, the café floors are covered in traditional mosaic tile; the décor is colonial-style; and in the back, there is a billiard table and a few additional café tables on a raised platform covered in plush red carpeting. Outside, a wide terrace area, enclosed during cool weather, is well suited for people-watching on the busy boulevard Montmartre. Early mornings, a dusky gray cat joins patrons on the terrace before the traffic thickens. Passersby stop to pet him, and he poses for tourists with cameras. Swiffer, named a little unjustly after the household duster, is anything but commonplace. A handsome, green-eyed, long-haired male, with intimations of a pedigreed cat, Swiffer is from the Auvergne region of France, like the owner of the café and most of the staff. Although the café is bustling much of the time, during the early morning, there is a sense of being in someone's home—in the kitchen just behind the bar, the prep cooks chop vegetables and swirl chocolate in a bowl for a cake.

"To be precise, he was born on a farm in the Cantal, which explains why he is so fond of eating," says Michael Nicaudie, the manager, who has worked at Le Zéphyr since 2001.

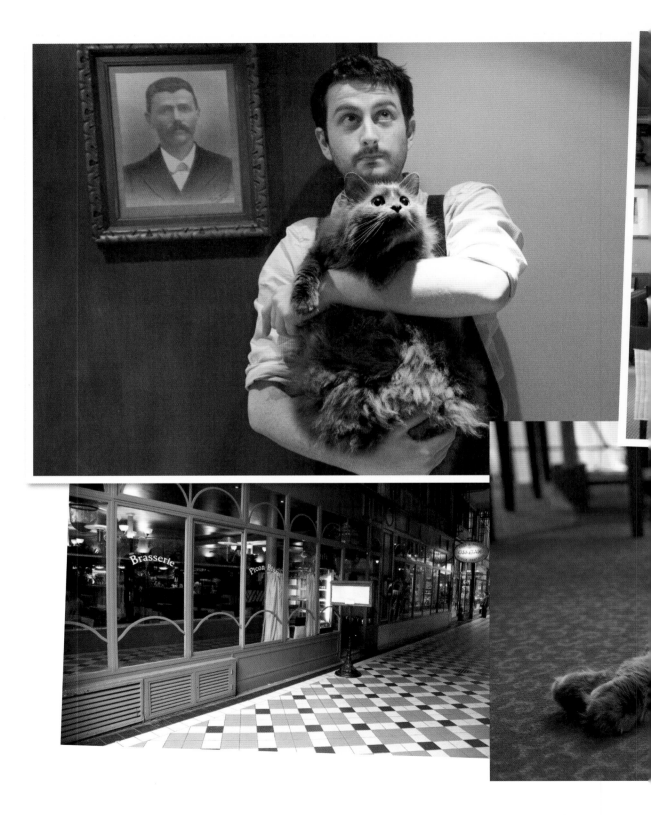

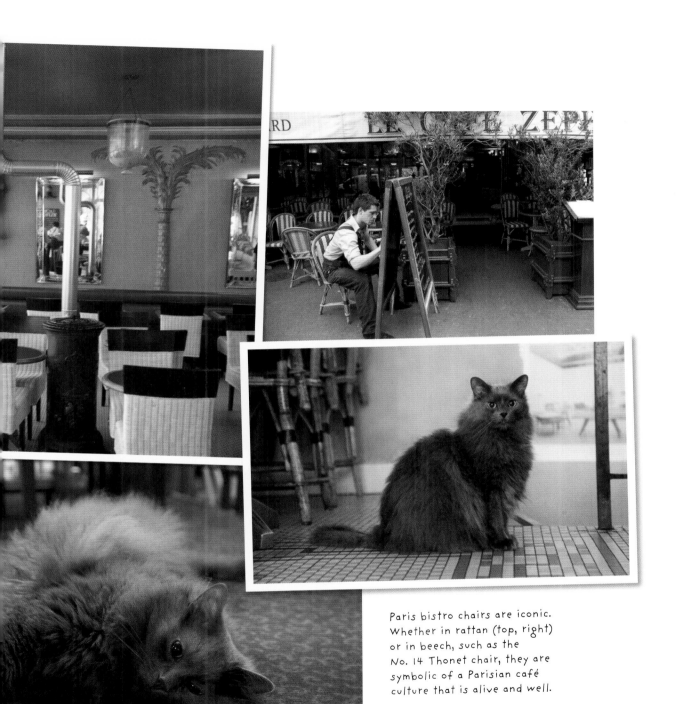

Paris bistro chairs are iconic. Whether in rattan (top, right) or in beech, such as the No. 14 Thonet chair, they are symbolic of a Parisian café culture that is alive and well.

The reason for getting a cat was fairly simple—in Michael's opinion, it is the only deterrent against mice in Parisian cafés and restaurants. As with all the other establishments that acquired a cat for the same reason, once Swiffer arrived in 2008, he quickly became the main attraction.

"He's very popular with clients, and people keep giving him treats, which is why he's a little hefty," adds Michael.

Swiffer is also popular with the staff. Because of his long hair, management decided from the start that he would be brushed twice a week. Everyone, says Michael, takes turns grooming him, and during the session (and otherwise), he will often flop over on to his back for a belly rub.

When the waiters clean and fill the mustard pots, Swiffer lies companionably in a chair at the table. Swiffer also likes to lounge on the soft felt carpet of the billiard table and attempts to sharpen his claws on it when the staff isn't looking.

The side entrance of the café opens directly onto the passage Jouffroy, which dates back to 1847. It is one of the neighborhood's many covered passages that were built in the eighteenth and nineteenth centuries, each with their own particular characteristics. At the time, about sixty passages were built; today, only fifteen or so remain, most of them classified as historic landmarks.

The passage Jouffroy was the first of its kind to be built entirely in iron and glass. The large skylight running along a herringbone-patterned vault covered a dance hall, a puppet theater, and cafés with live music and billiard tables. In 1882, the Musée Grévin—named for Alfred Grévin, a famous caricaturist at the time—opened there, remaining in the same location to this day, renowned not only for its wax figures but also for its extravagant art nouveau décor and wide marble staircase designed by architect Gustave Rives. Swiffer often sits by Le Zéphyr's side entry looking out at the busy passage Jouffroy, just a few doors down from an antique cane shop and a toy store. Although Swiffer is naturally friendly, Le Zéphyr's clients are entertainment enough for him—he rarely crosses the threshold and prefers to stay within the safety of his own café.

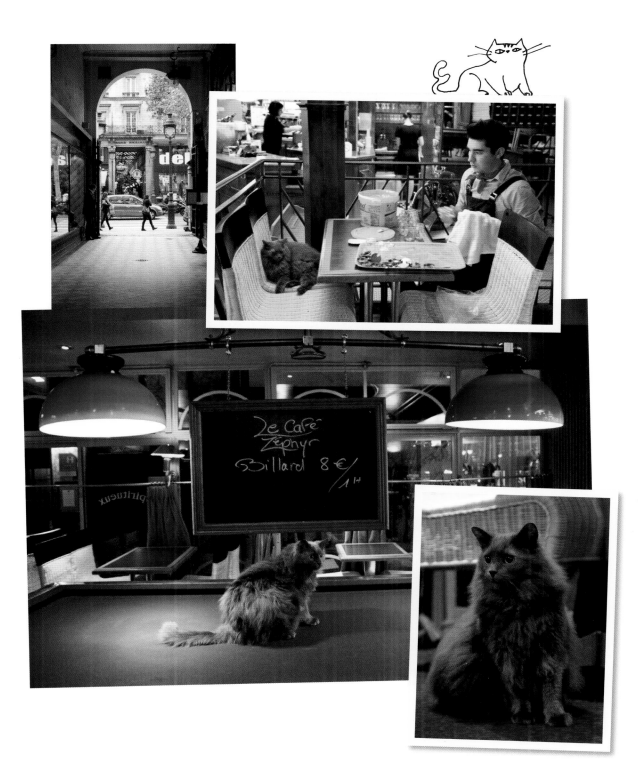

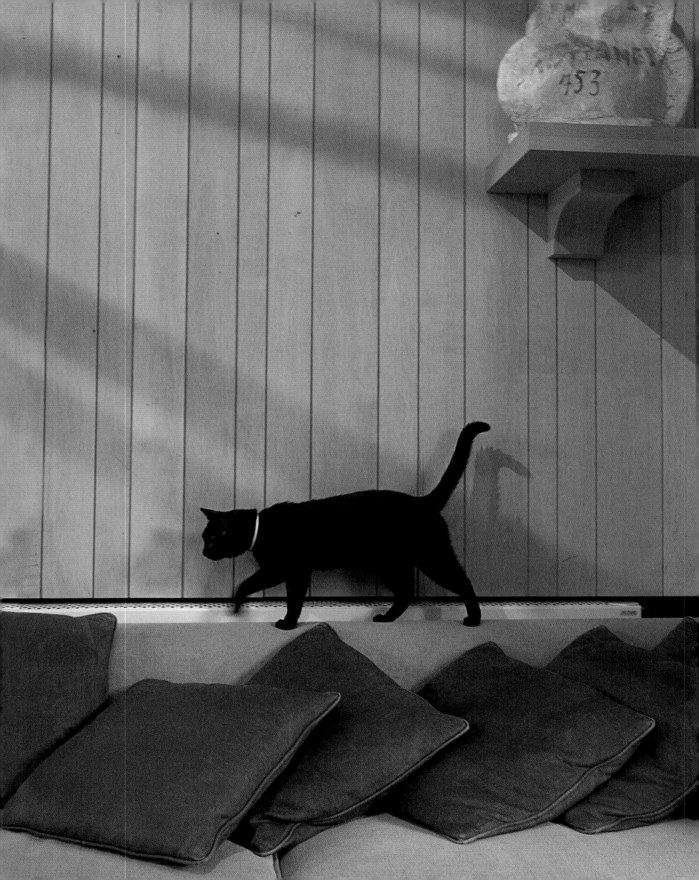

Mini Palais
Grand Palais
Avenue Winston-Churchill
75008 Paris
+33 1 42 56 42 42

During the nineteenth century, the city of Paris regularly organized world's fairs. The Beaux-Arts-style Grand Palais and the adjacent Petit Palais across the street were created for the fair in 1900. The Grand Palais was designed to last, unlike many world's fair structures—including the Eiffel Tower—that were intended to be ephemeral. Four architects were involved in the building, and construction began in 1897. An impressive blend of steel, stone, and glass, the Grand Palais, although classical in its structure, nevertheless shows signs here and there of an art nouveau influence. A few steps away, the Pont Alexandre III is an extravagant celebration of art nouveau with statues of cherubs, nymphs, lions, and winged horses in bronze and gold leaf.

The Mini Palais restaurant opened in the Grand Palais in 2008, under the guidance of three-starred Michelin chef Éric Frechon. At first it was meant to be temporary, but like the Eiffel Tower, it has endured. Its stately entrance with huge bronze doors is to the side of the building, just off the Alexandre III rotunda.

The dining room is immense, with metal beams painted in the Grand Palais's trademark mignonette green highlighting the moldings; huge industrial-style lamps hang from above, diffusing a soft orange light. Ceiling-high arched glass doors lead outside to the terrace lined with mammoth imperial columns and a few elegant statues. Potted palm trees are interspaced among the tables on a beautifully renovated mosaic floor.

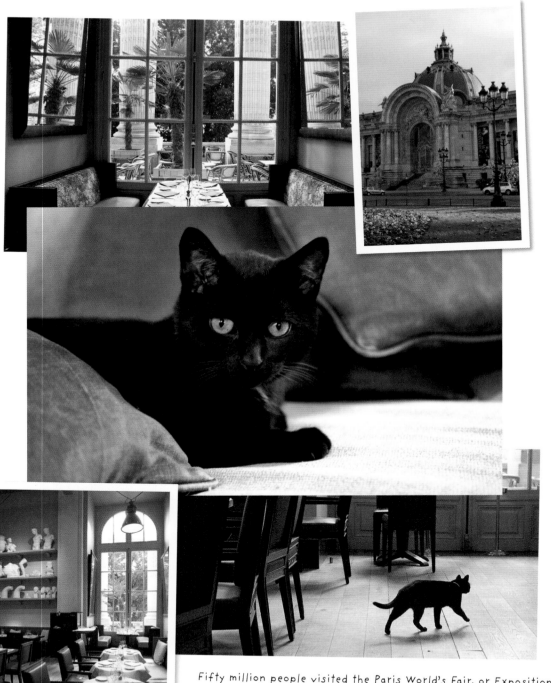

Fifty million people visited the Paris World's Fair, or Exposition Universelle, in 1900, where, among other architectural and mechanical inventions, they were able to see the Grand Palais (p. 39, center), the Petit Palais (top, right), the Eiffel Tower, and the Rue de l'Avenir (Street of the Future)—a two-mile-long (3.5 km), electric, three-tiered moving sidewalk.

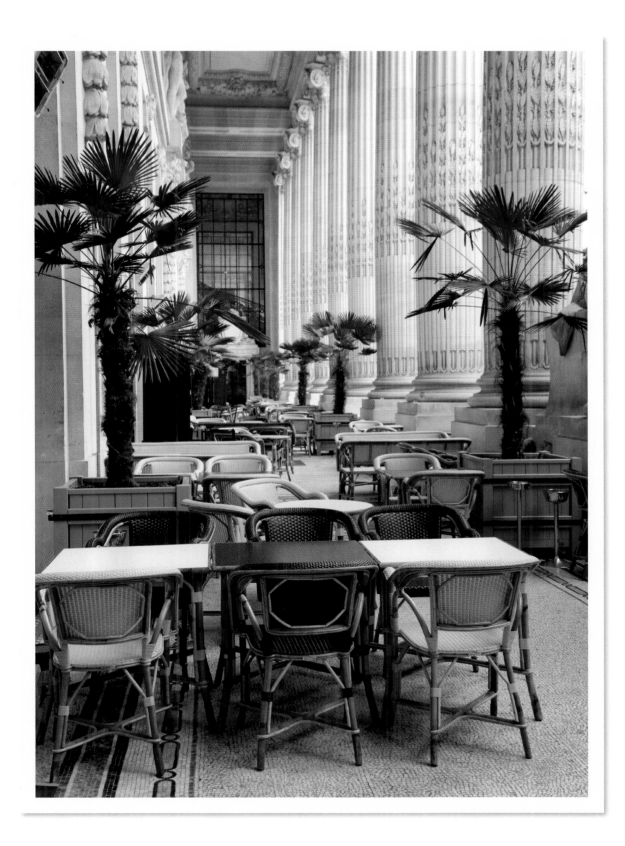

Amid all the grandeur, Narcisse, a small black cat with a tiny patch of white fur under his chin like a bow tie, holds his own, scampering across the floor chasing sunbeams or jumping onto a banquette to play with the edges of a tablecloth. Narcisse will also readily climb onto clients' laps during the lunch and dinner services. Because of the restaurant's proximity to ministries and media outlets, patrons are often politicians or journalists, says Nadia Bisson, the head waitress who has worked at the establishment since it opened. Nadia chose Narcisse for the Mini Palais at an animal shelter in 2011, attracted by his affectionate and sociable nature. It took him three months to adjust to his sizeable domain, she says, but now he is firmly implanted, using the terrace as a self-imposed boundary. The kitchen staff and waiters all interact with Narcisse in varying degrees as they hasten to and fro through the vast dining room, with its plaster molds of museum sculptures on its shelves, and its waiting area with low tables and comfortable taupe-colored sofas with olive-green linen cushions where he likes to nap. The barman tolerates him as long as he doesn't jump on the bar, but Narcisse has better luck with the hostesses, who are happy that he keeps them company at the front door, where he sits on the warm printer next to the computer. Delphine Dubosc says she never liked cats before, but Narcisse has won her over. At the hostesses' station, she demonstrates how he climbs precariously onto a pile of menus in order to drink water out of the tall, black, flower-filled vases.

Through two vertical windows in the waiting area, Narcisse likes to observe the goings-on in the monumental exhibition hall of the Grand Palais where, in 1905, the infamously scandalous Salon d'Automne was held, when Henri Matisse, André Derain, Henri Rousseau, and others exhibited what became known as Fauvist paintings.

"He's just always by our side," says Nadia simply, and as if to prove her point, Narcisse joins the staff as they eat their lunch before the service, seated on leather banquettes under a vast tapestry.

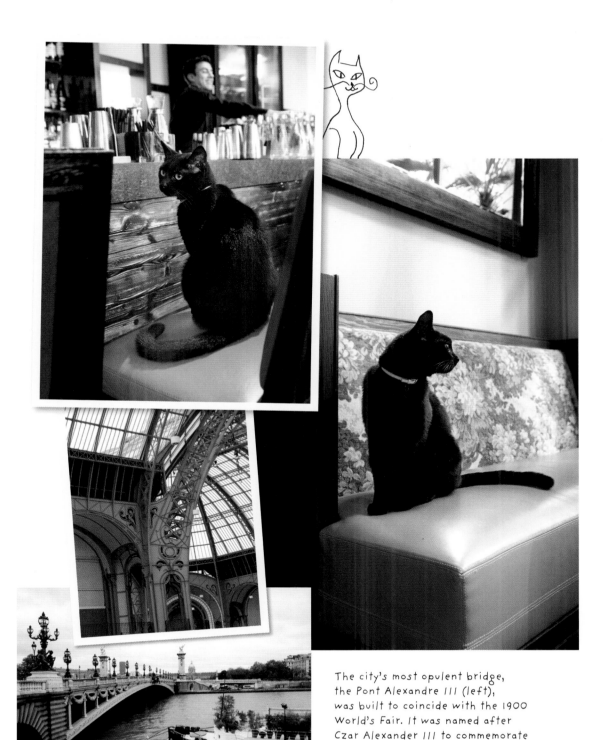

The city's most opulent bridge, the Pont Alexandre III (left), was built to coincide with the 1900 World's Fair. It was named after Czar Alexander III to commemorate the 1892 Franco-Russian alliance.

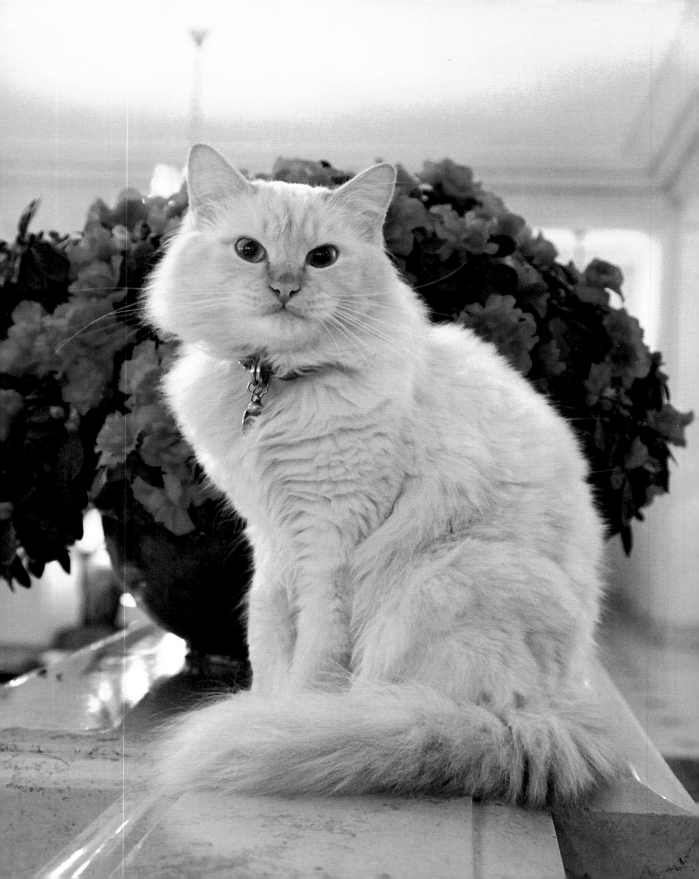

FA-RAON

LE BRISTOL PARIS
112, RUE DU FAUBOURG-SAINT-HONORÉ 75008 PARIS
+33 1 53 43 43 00

When Didier Le Calvez took over as CEO of the celebrated Bristol Hotel in Paris in 2010, he brought years of experience in the luxury industry with him, but the most unexpected innovation was a hotel cat.

That same year, a tiny ball of cream-colored fur with blue eyes arrived in the hotel lobby. The five-star hotel, installed in a mansion that had been owned by nineteenth-century socialite and playboy Count Jules de Castellane, only minutes away from the Elysée Palace, did not settle for just any cat. Fa-raon is a pedigreed Sacred Cat of Burma, also known as a Birman, a breed reputed for its sweet, people-oriented nature. Fa-raon has more than lived up to his reputation: although he is constantly sought out, he is infinitely patient with children and paparazzi alike. Not only has he become an essential member of the Bristol staff, with his own page on its website and numerous photographs on the hotel Facebook page, he has also participated in photo shoots in the hotel for *Harper's Bazaar China* alongside Cate Blanchett and was featured in Japanese documentaries about Paris.

As a kitten, he would curl up in the felt-lined concierge's box where guests left their room keys. As a full-grown cat with points of rust-colored fur, the concierge's desk, with its carved wood paneling softly lit by crystal chandeliers, remains one of Fa-raon's favorite spots. He jabs his paw down the slot of the mailbox or lounges on the dark green Italian marble counter, next to a lit scented candle and a vase filled with roses and peonies, lazily watching clients coming through the revolving doors. Alternately, he will sprawl on the marble floor in the entrance or nibble delicately on the azalea plants placed on low tables in the lobby during the winter season.

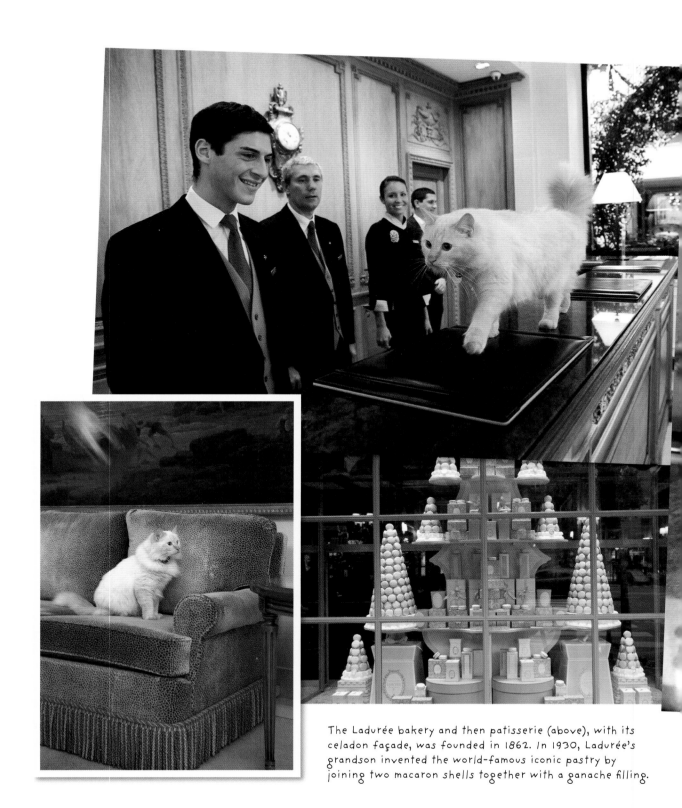

The Ladurée bakery and then patisserie (above), with its celadon façade, was founded in 1862. In 1930, Ladurée's grandson invented the world-famous iconic pastry by joining two macaron shells together with a ganache filling.

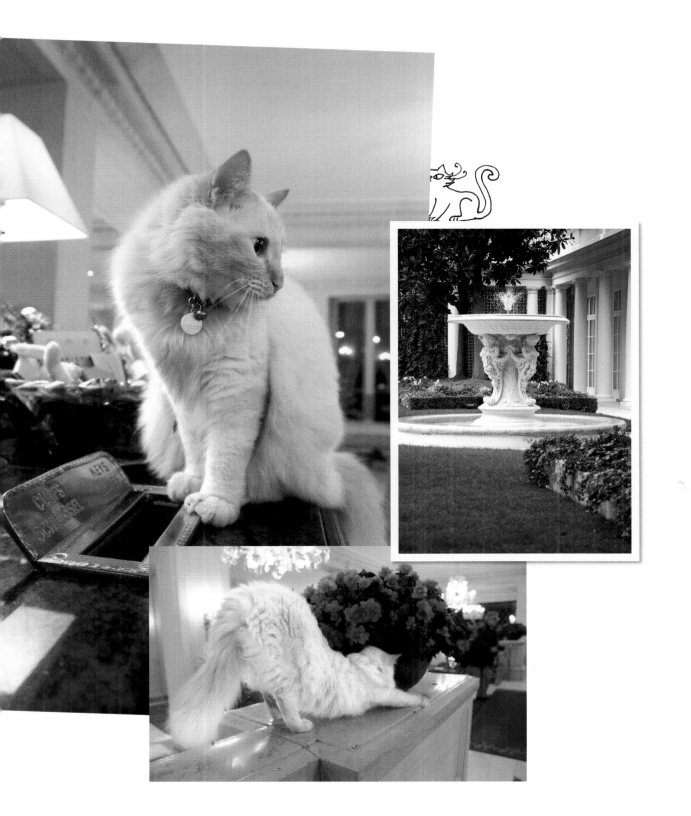

He has several favorite spots for napping: in the business center near the computers (the screensavers feature Fa-raon), where it's particularly warm; or curled up in one of the plush armchairs in the lobby, where cushions are fluffed up regularly by housekeeping; or simply in a corner on the parquet floor of the Castellane banquet hall, decorated with eighteenth-century tapestries, which was the count's private theater in 1835.

Internal hotel email messages buzz around among the staff with missives such as "Don't feed Fa-raon, he has an appointment at the vet's," or "Where's Fa-raon? He has a grooming appointment today."

When Fa-raon is taken to his various engagements outside the hotel, his immediate surroundings are some of Paris's most luxurious. The rue du Faubourg-Saint-Honoré, once a pastoral suburb, developed very quickly once the court left Versailles for Paris in 1715, after the death of Louis XIV. Courtiers and wealthy financiers built luxurious mansions on the street. Adding to the already desirable neighborhood, in 1873 the Elysée Palace, just a few doors down from the Hôtel de Beauvau mansion, already the Ministry of Interior, became the official residence of French presidents. During that same period, the first luxury boutiques appeared, including the saddler Hermès and the dressmaker Jeanne Lanvin. When Hippolyte Jammet, the Bristol Hotel's founder, bought Jules de Castellane's home in 1923, it was the heyday of the Roaring Twenties in Paris where the cultural scene was as vibrant as the arena of fashion and design. Woody Allen appropriately chose to have his main character in the film *Midnight in Paris* stay at the Bristol Hotel—he travels back in time to the 1920s where he runs into, among others, Josephine Baker, Cole Porter, F. Scott and Zelda Fitzgerald, Salvador Dalí, and Man Ray. Fa-raon steered clear of the hubbub during the filming, preferring to remain in the more peaceful lobby and reception area.

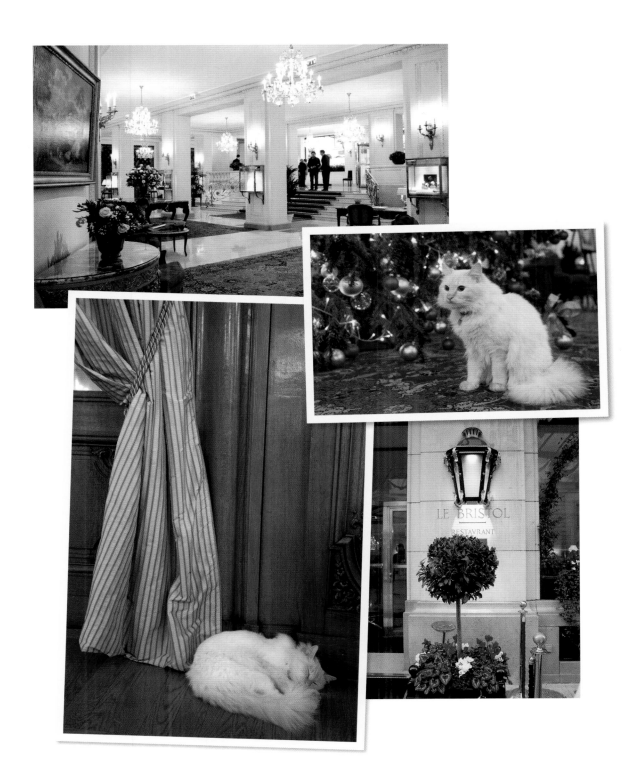

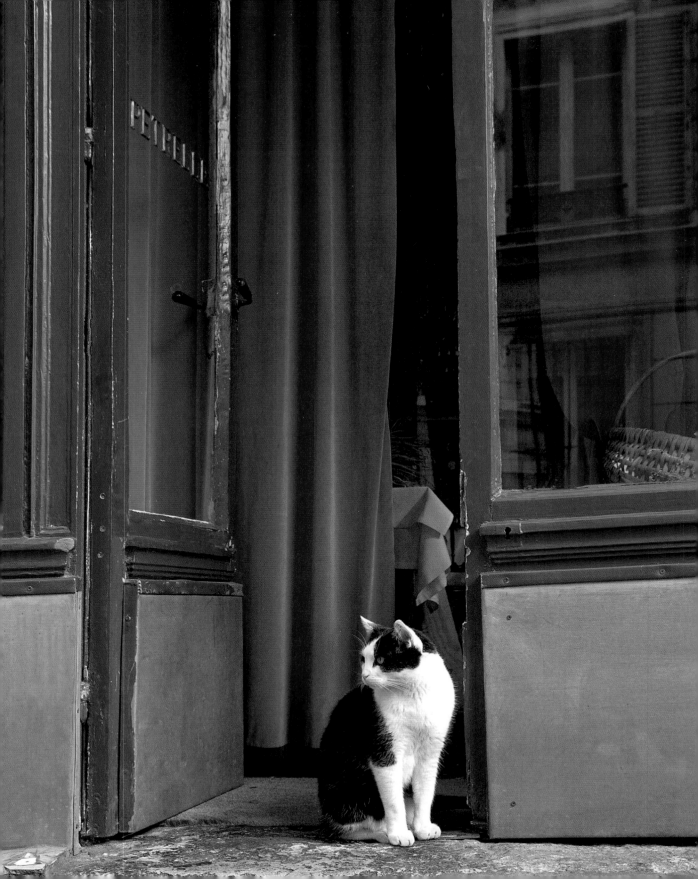

Racaillou

Pétrelle
34, rue Pétrelle
75009 Paris
☎ +33 1 42 82 11 02

he rue Pétrelle is a quiet street in Paris's ninth arrondissement, just off the rue Rochechouart, which winds its way steeply uphill toward Montmartre. The street and neighborhood are named for Marguerite de Rochechouart de Montpipeau, a seventeenth-century abbess who was also a member of an aristocratic lineage of viscounts of the same name. The other end of the rue Pétrelle runs into the rue Faubourg-Poissonière, part of a well-traveled road taken by fishmongers during the Middle Ages on their way to Les Halles market. When Jean-Luc André found the ground-floor location for his restaurant Pétrelle, in 1994, he says he loved it from the start.

Heavy green-and-orange velvet drapes at the door open onto a space that resembles a whimsical stage setting, the décor somewhere between romantic and surrealistic, "a little bit like life," quips Jean-Luc, clad in red sneakers, with a red-and-white-checkered scarf around his neck. He cooks with a deep connection to the terroir, each week receiving deliveries of seasonal vegetables. The fall brings abundant crates of carrots, turnips, radishes, cabbage, chestnuts, mushrooms of all sorts, and flowers that will decorate the tables—bunches of pink heather tied with string and antique roses. In the midst of a delivery, Racaillou, an elderly, dignified, black-and-white tomcat who sleeps at the restaurant, solemnly greets Fernando, an excitable fox terrier who arrives in the morning. Racaillou's name is derived from the French word for riffraff—*racaille*—which Jean-Luc says he was as a youngster, albeit very *nice* riffraff. There are baskets for both Racaillou and Fernando in the restaurant, discreetly placed away from the

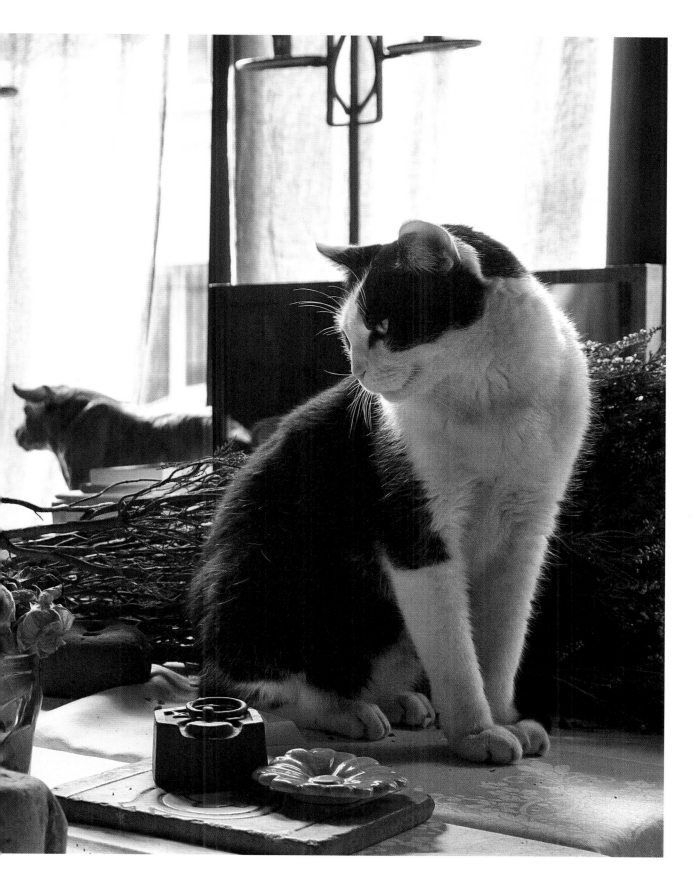

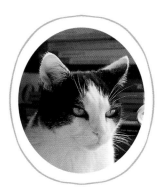

clients, although Racaillou will sit on the chairs that have velvet seat covers, and during the winter, he likes to curl up behind the warm iron stove. Jean-Luc takes both animals to the country regularly but says Racaillou prefers Paris. "He gets depressed in the country. As soon as he gets back to Paris, he starts to fool around again. He likes to be at the restaurant, and he likes being around people."

When Racaillou was younger, says Jean-Luc, he would patrol the street chasing after dogs, even ones as large as German shepherds. He loves children and is visited by a great number of them who walk past the restaurant on their way home from the nearby school.

The neighborhood that is Racaillou's territory was extremely popular during the optimistic and creative period of the Belle Epoque, just preceding World War I, because of the numerous cabarets and dance halls in the area, which included the second incarnation of the celebrated and avant-garde Le Chat Noir cabaret. Thanks to the Belle Epoque's flourishing arts scene, many artists and writers lived in this area, a few streets south of Montmartre.

Inside the restaurant, Racaillou has plenty of nooks and crannies to explore, walking over piles of books on the window sill, inspecting the numerous and varied candles that are lit at night, smelling the enormous bouquet of flowers in a vase near the door, or sniffing at a large white ceramic bowl of homemade meringues tinted violet with the juice of blackberries. For a short while, Racaillou's name was changed to Michelin in jest. Jean-Luc explains: "The Michelin guide people came to Pétrelle for four years in a row. They loved it. But then they told me, there's just one thing: you have to get rid of the cat. I told them to leave. We weren't going to sacrifice the cat for a star."

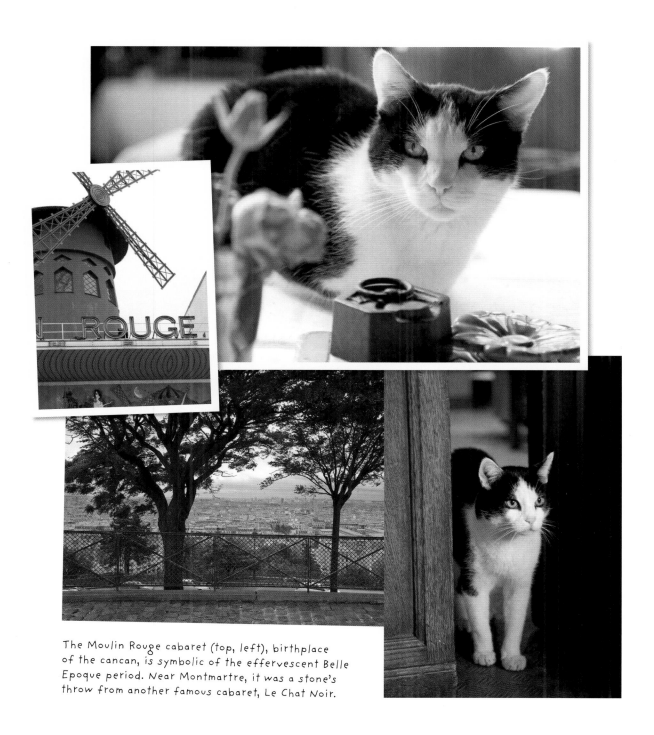

The Moulin Rouge cabaret (top, left), birthplace of the cancan, is symbolic of the effervescent Belle Epoque period. Near Montmartre, it was a stone's throw from another famous cabaret, Le Chat Noir.

The cabaret Au Lapin Agile was a favorite among writers and painters in the late nineteenth century, including the Montmartre-born Maurice Utrillo, who painted the pretty La Maison Rose (The Pink House) just around the corner (right).

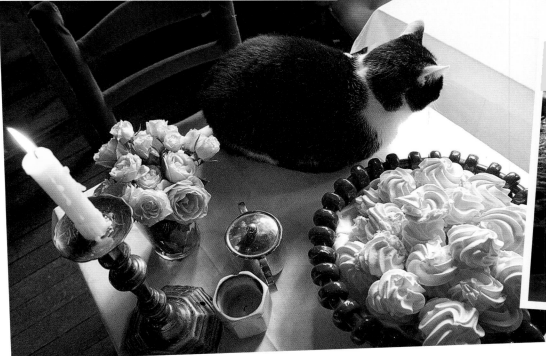

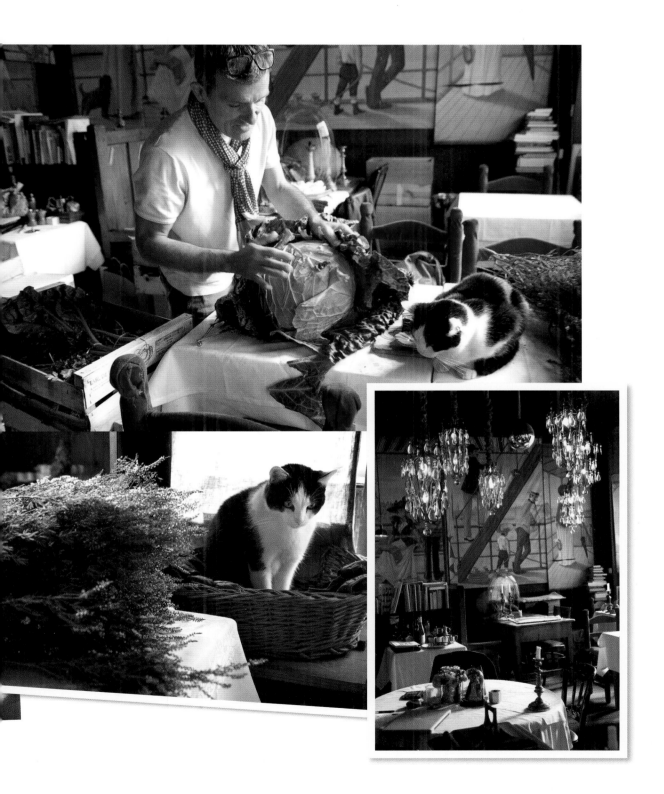

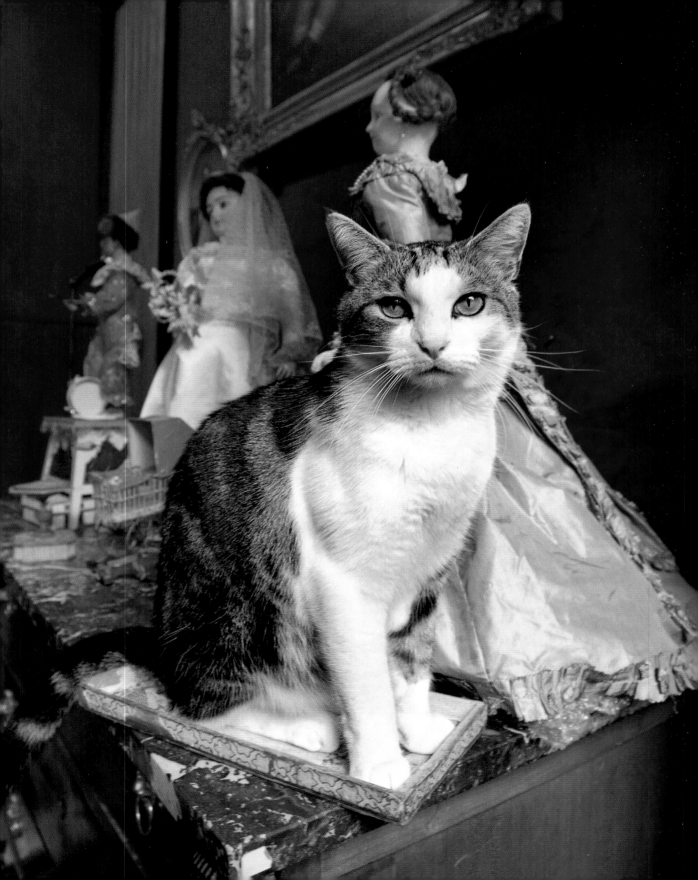

La Maison de Poupée
40, rue de Vaugirard
75006 Paris
+33 1 46 33 74 05

La Maison de Poupée, or The Dollhouse, straddles the corner of the longest street in Paris, rue de Vaugirard, and the rue Servandoni, named after the Italian architect who designed the façade of the nearby Saint-Sulpice church. It is also equidistant from the Senate, housed in the seventeenth-century Luxembourg Palace across the street, and the nineteenth-century Musée du Luxembourg. One of the last shops in Paris to specialize in antique dolls from the eighteenth and nineteenth centuries, it evokes a bygone era, when French dolls were unrivaled in their artistry. But sitting in the wide, storefront window, amidst a retro-chic jumble that includes elegant dolls in papier-mâché, celluloid, and porcelain, is Pilou, very much alive, with tiger stripes on his back and tail, brilliant white fur on his paws and chest, and luminescent green eyes that track the pigeons outside.

Many cats have graced the shop—owner Françoise Vallée says she can't live without them—but Pilou has been the star since 2008, when he was found as a three-week-old kitten in the south of France.

Françoise used to walk past the shop when she was a teenager and would occasionally indulge in small items for her own dolls there. In 1980, she had become an established antiques collector and heard that the shop was for sale; she acquired it that same year, renaming it so that she could include dollhouses. La Maison de Poupée is painted teal

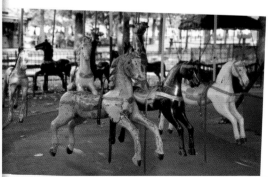

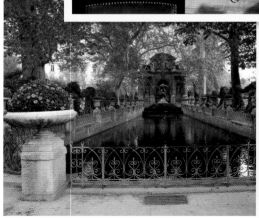

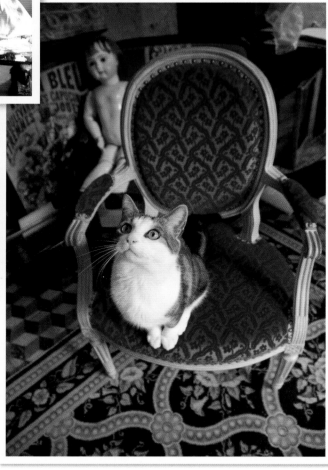

Henri IV's widow, Queen
Marie de' Medici, commissioned
the Medici Fountain (above), built
in 1630. It was modified several times
in the nineteenth century, before being
moved a short distance to its present
location in the Luxembourg Gardens.

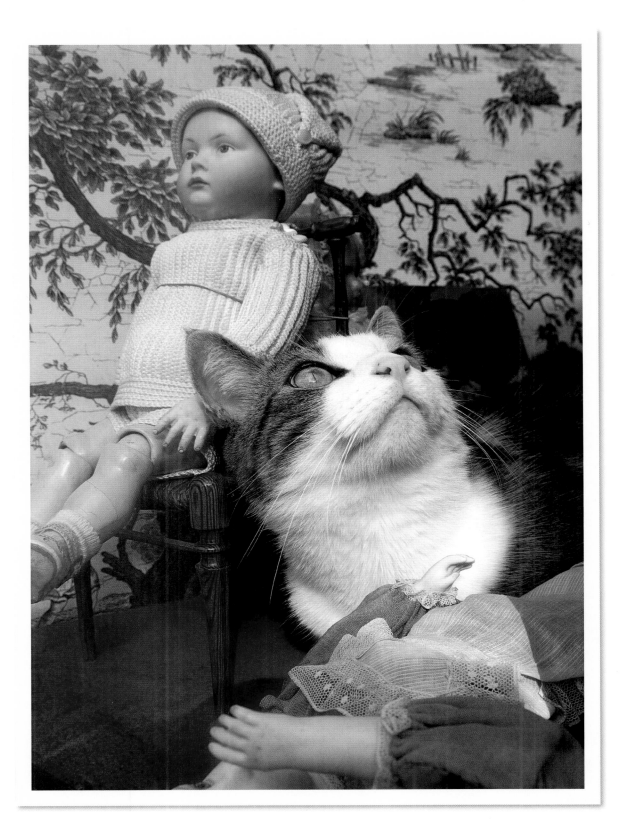

blue on the outside, with limestone walls inside. It specializes in French and German dolls, but also carries dollhouses, accessories for dolls, antique children's furniture, and toys. It is a prodigious discovery for collectors. An enormous doll from 1840, wearing a long, faded green dress with a full skirt, stands on a shelf, her hair arranged in a high bun, while a smaller doll is seated regally on a sedan chair. There are toy kitchen ranges and pots and pans; small bags are filled with tiny dinnerware or replacement Napoleon III–epoch doll's shoes. The shoes are just part of a vast trousseau that belonged to nineteenth-century dolls called "Parisiennes," which emulated the fashionable Parisian women of the time and were unique in the trade for their fashion accessories.

Pilou is particularly passionate about the tiny leather booties, which he loves to fling about on the Escher-style black, white, and gray tiled floor, when he can get hold of them. His preferred throne is a Napoleon III chair for children, perched on a small table from the same era.

"No, no, no, NO," exclaims Françoise as Pilou begins to sharpen his claws on the chair's upholstery.

In general, however, Pilou doesn't wreak much havoc in the shop, except when he tries to empty her writing desk or gets hold of a doll's wig, which Françoise says all her cats have loved unequivocally—hairpieces are trophies for them, similar to mice. They have also enjoyed climbing inside the dollhouses, says Françoise, but only Pilou has proved an art lover; she once saw him sitting on a toy horse, quietly contemplating a landscape painting.

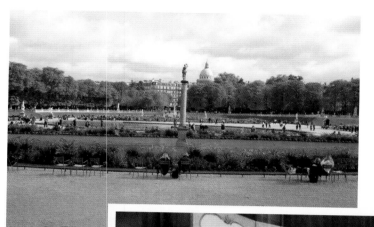

In 1612, Queen Marie de' Medici bought the first parcel of land that was to become the sixty-one-acre (25 ha) public Luxembourg Gardens. They include not only the French Senate, housed in the Luxembourg Palace, but also numerous trees, flowerbeds, fountains, an orangery, a small orchard, and a hothouse containing a collection of tropical orchids.

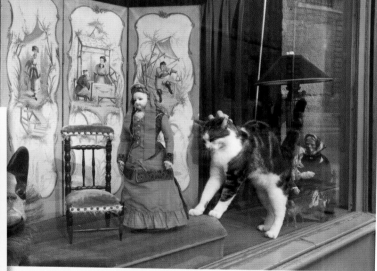

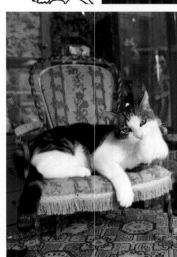

Zwicky

Fleux 39 & 52, rue Sainte-Croix-de-la-Bretonnerie 75004 Paris +33 1 42 78 27 20

The rue Sainte-Croix-de-la-Bretonnerie is one of the oldest streets in the Marais; its name comes from a thirteenth-century convent located there that disappeared during the French Revolution. It was later known for being the street where the chocolate company Menier was founded in 1816.

The Marais, with its wealth of historic relics, has gone through various incarnations throughout history—as marshy farmland in the early Middle Ages, as residence for royalty in the thirteenth century, and then as the area of choice for France's nobility in the seventeenth century. It is epitomized by the place des Vosges, with its high-roofed houses of red brick and stone supported by arcades, and by the numerous mansions such as the Hôtel de Sully or the Hôtel Carnavalet. When the nobility moved out, the Marais became a commercial center before evolving into a working-class area; eventually, many of the buildings were in severe need of renovation. It wasn't until the 1960s, with the support of the writer André Malraux, who was Minister of Cultural Affairs at the time, that the entire sector was protected and rehabilitated. The Marais today is filled with high-end boutiques, galleries, and museums, but traces of a more modest past remain, and Zwicky, an impressively ample cat with tiger stripes and luminous green eyes, is a holdover from that past. Fleux, a quirky and hip concept store that has expanded to four locations on the rue Sainte-Croix-de-la-Bretonnerie, inherited Zwicky from a former haberdashery, Ryckaert, which sold its space to Fleux in 2012. Ryckaert was the oldest shop on the street and the last wholesale haberdashery in Paris. Lucienne Montanari, a longtime Ryckaert employee, found Zwicky and named

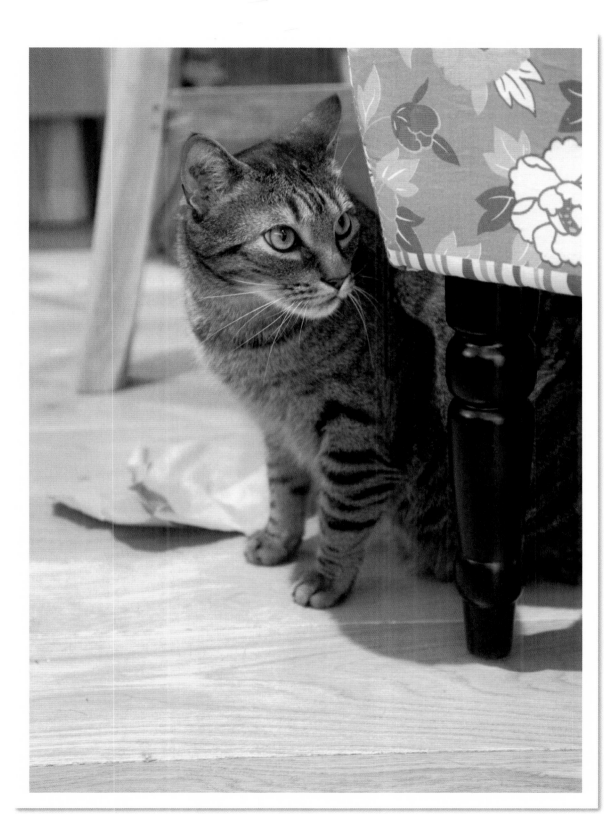

him for a centuries-old Swiss thread company. When Ryckaert closed, Lucienne, in her eighties, was worried about Zwicky's well-being and talked Fleux's owners into adopting him. Lucienne says she visits Zwicky nearly every day, and when she leaves, "he accompanies me to the door."

The shops are veritable treasure troves, filled with singular and wondrous design objects for the home—from chic anthracite-gray sofas to furry, patchwork, or embroidered cushions, or brightly colored nutcrackers in the shape of robots. Zwicky tends to stay in one of the shops in the back of a courtyard, where his former home was located. He reigns from a sky-blue armchair with a $1,000 (€800) price tag on it, which has become "his" chair. "We can't possibly sell it now," quips Gaétan Aucher, one of the owners.

When he first settled into his new home at Fleux, Zwicky had some weight problems because "twenty different people were feeding him," explains Cécile Dromard, one of the managers, who put him on a diet and hung up a chart on which employees keep track of when Zwicky has been fed. Although he is still thickset, Zwicky has no problem leaping into the large cartons that are delivered each day or skidding across the floor to chase a ball of crumpled wrapping paper. Cécile says that not only is he crazy about boxes, but he also loves coffee and will poke his nose into an unattended cup and begin lapping.

"People often mistake him for a stuffed animal," comments Cécile. "He climbs onto the display shelf with the animal cushions and you can't tell the difference."

Zwicky keeps the employees company all day, assisting with the cardboard boxes or unrolling wrapping paper. When they leave in the evening, he usually sits in the shop window to watch passersby.

"Clients often tell us the shop is fabulous, but then they say that the best thing about it is the cat," says Gaétan.

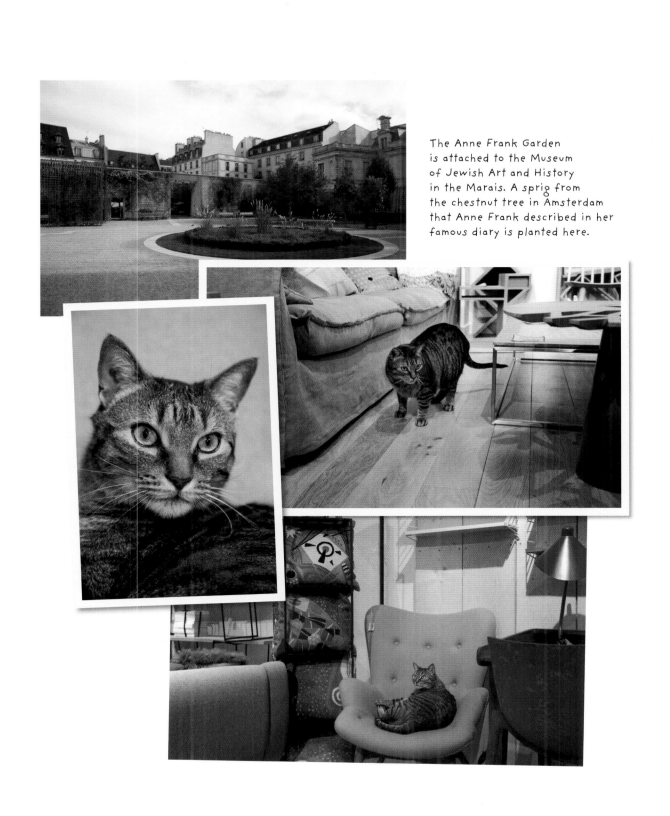

The Anne Frank Garden
is attached to the Museum
of Jewish Art and History
in the Marais. A sprig from
the chestnut tree in Amsterdam
that Anne Frank described in her
famous diary is planted here.

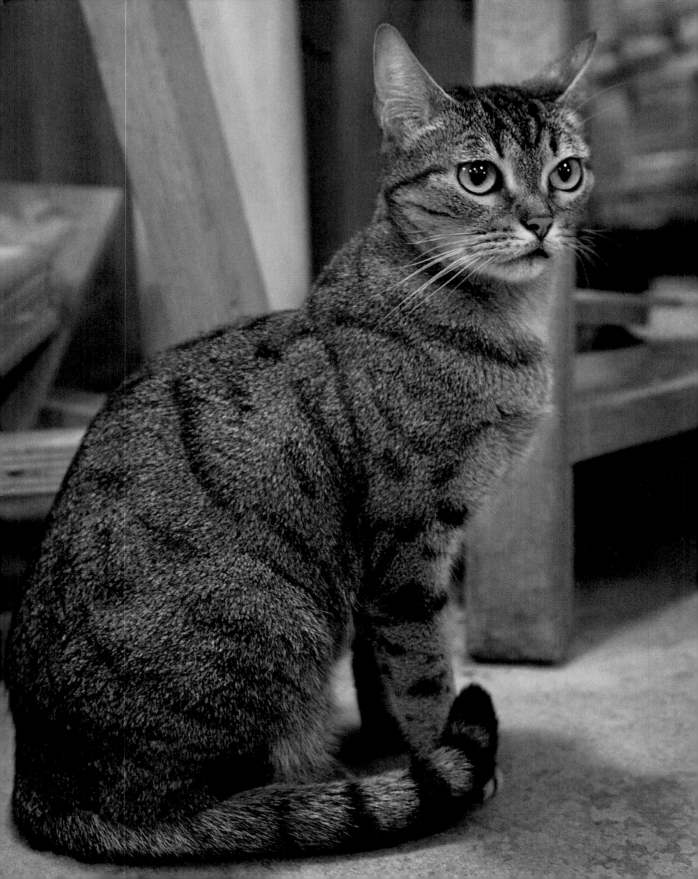

Boule & Baba

ATELIER MARIE LA VARANDE
6 bis, rue Bridaine 75017 Paris +33 1 46 33 02 10

Marie la Varande's sculpture studio on a quiet street in Paris's northern Batignolles neighborhood is a cat's paradise. Classical music plays softly, there are multitudinous stools of varying heights to jump on, toys made from wine corks attached to strings are placed in strategic locations, and a large rectangular sink is perfect for sitting in and lapping at the tap.

Tanned, swathed in scarves, and wearing work boots, Marie la Varande is elegantly disheveled. This sculptor opened her studio in 2004 and brought a kitten from Brittany here four years later: Boule, a tiger-striped female with a round face and posture reminiscent of an Abyssinian's. Baba, also striped but with a white chest and paws, joined her soon after. Both cats often sit in the window, drawing much attention from pedestrians. They have the run of the studio, which is filled with students all day long, for the most part a well-heeled, older crowd. A burly former French navy admiral sculpting a large piece of wood tells us that cats like him, as Boule walks in front of his sculpture, adding as an afterthought, "I like cats as well."

Bookshelves are packed tightly with art books; coffee, tea, and chocolates are laid out on a low table. An antique black telephone hangs on the wall next to a shiny espresso machine. Bottles of wine are stacked in a corner next to jars of pigment.

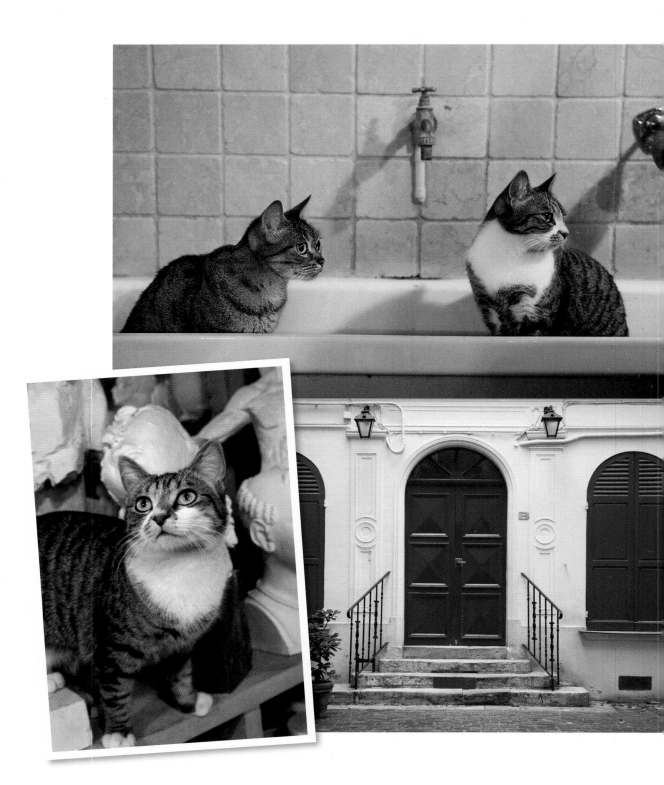

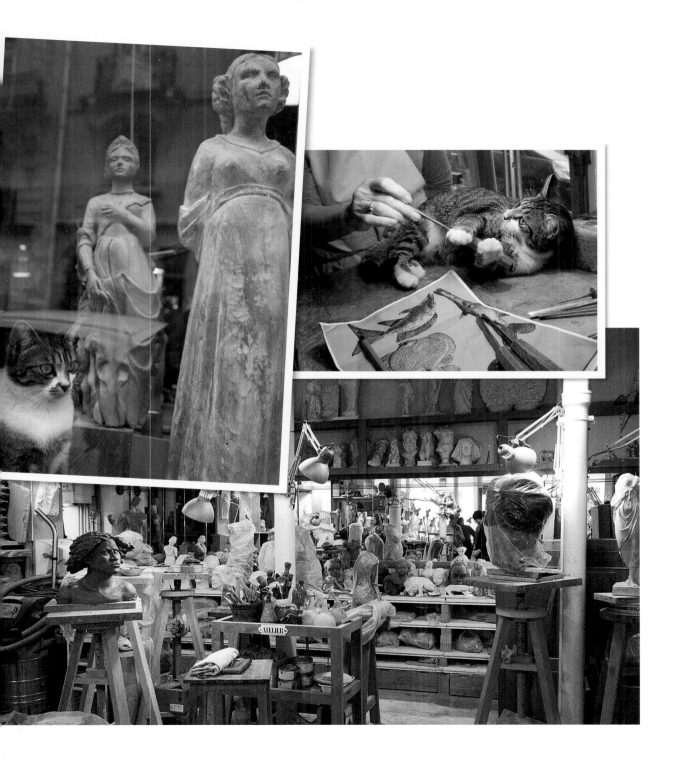

The studio continues a tradition that began in this area—which only became part of Paris in 1860—during the nineteenth century when the painter Édouard Manet created the Batignolles School, known as the "Groupe des Batignolles" in 1863. That same year, Manet's oil painting *Luncheon on the Grass* had scandalized the Parisian art world as much for its depiction of a naked woman sitting with two fully clothed men as for its innovative lack of transition between light and dark elements in the painting. Congregating in the Café Guerbois, not far from Manet's studio, impressionist painters such as Frédéric Bazille, Claude Monet, Pierre-Auguste Renoir, and Alfred Sisley, joined occasionally by Paul Cézanne and Camille Pissarro, would discuss new ways of depicting modern life. Led by Manet, the artists struggled to have their emerging avant-garde work accepted by the conservative art establishment of the time. The writer and journalist Émile Zola often joined them. He had intentionally abandoned the Latin Quarter to move to the Batignolles in 1866 in order to be closer to the group of experimental painters; he described the Café Guerbois as the cradle of a revolution.

In Marie's studio, sculptures can be made in wood or clay, and there are also classes taught in charcoal and pastel drawing. Occasionally, there are live models, and Baba and Boule will sometimes settle against their legs, sinking into the cushions behind the models. When they're not sleeping on the radiators, the cats frolic around the students, playing with their apron strings or pawing at the various tools on the workspaces. Baba often lies under a studio lamp and pulls it closer to her with her paw so that the heat is more intense.

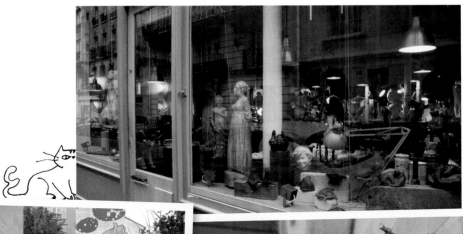

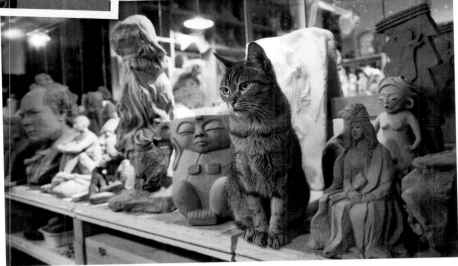

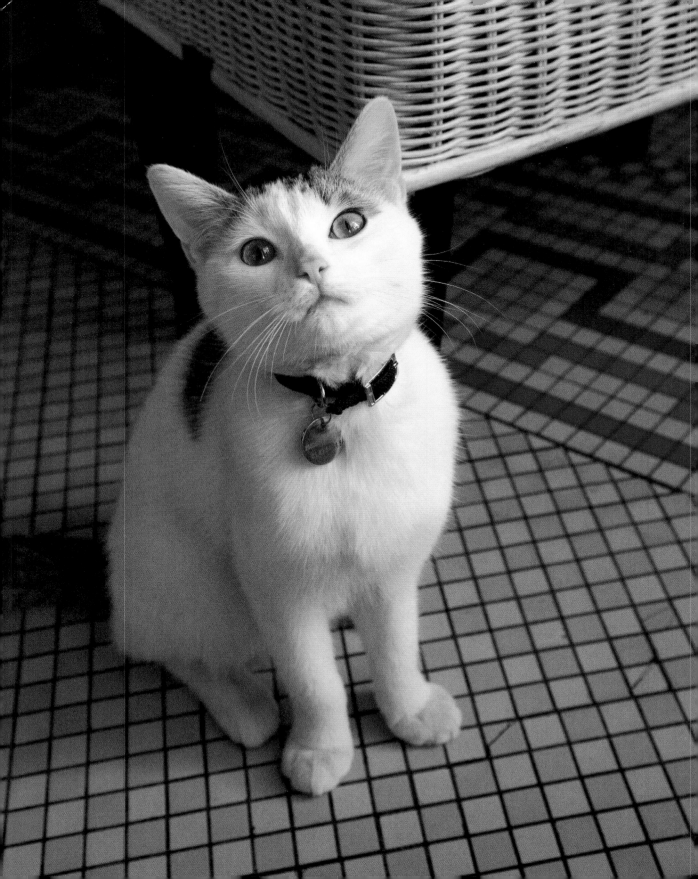

LE ROSTAND
6, place Edmond-Rostand
75006 Paris
+33 1 43 54 61 58

Directly across from one of Paris's loveliest gardens, the Luxembourg, and a short walk from the Sorbonne University and the Panthéon, Le Rostand café and nearby square are named after the neo-romantic poet and playwright Edmond Rostand.

The large café terrace, enclosed during the winter, is bordered with potted palm and olive trees, the corner section perfectly angled to receive the morning sun. The clientele is a mix of university professors, publishers, writers, and tourists, all greeted by Le Rostand's cat-in-residence, the charming young Roxane, who is predominantly white, with a striped brown and gray tail. Her predecessor Cyrano—named in honor of the nineteenth-century writer's best-known play (despite being female)—had been the café's cat for many years, until she disappeared one summer. Roxane, named after Cyrano's love interest in the play, was auspiciously found soon after, hiding on the café terrace, terrified. A kitten, she weighed a mere pound (480 grams) and was injured. Manager Jean-Pierre Berthe, who has run Le Rostand since 1998, nursed her back to health. He says that, for a long time, she would only sleep safely hidden from sight under the rust-colored marble countertop of the wooden bar. Her food bowls are still neatly aligned on the wooden platform below the cash register there, even though she

now sleeps on the more comfortable leather banquettes. Although he asserts that he never gives her leftovers, Jean-Pierre admits that Roxane has a fondness for ham, chicken, and raw meat, but to his dismay, she doesn't like fish at all—he has tried both raw and cooked.

Most mornings, while the clean-shaven Jean-Pierre reads *Le Parisien* and chats with the headwaiter, Roxane sits primly on one of the café tables in a stream of sunlight looking out toward the same trees in the Luxembourg Gardens that Victor Hugo described over one hundred and fifty years ago. Amid the clatter of cups and the steaming espresso machine, Roxane shows little of her previous timidity.

"She is incredibly sociable," Jean-Pierre comments, adding that he has always loved cats, but his wife doesn't want one at home "because of the claws and fur. So I have one here."

Roxane is still cautious around the main café entrance, whose swinging doors lead to the terrace and street, but Jean-Pierre is confident that she will get used to it and slowly expand her territory as Cyrano did—first to the terrace (heated in the winter) and then to the Luxembourg Gardens. When Roxane has finished making her morning rounds of the regular clients, she weaves her way across the mosaic-tiled floor, between the legs of the wicker café chairs toward the back of the café where oriental-style paintings, antique photographs of palm groves, and stucco sculptures of palm trees adorn the walls. She likes to nap under the banquettes, soon to be occupied by lunch patrons.

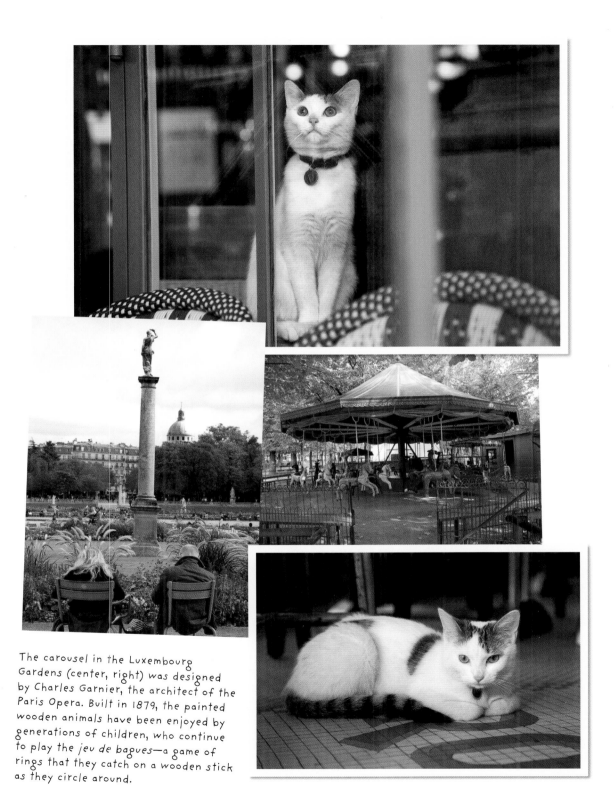

The carousel in the Luxembourg
Gardens (center, right) was designed
by Charles Garnier, the architect of the
Paris Opera. Built in 1879, the painted
wooden animals have been enjoyed by
generations of children, who continue
to play the *jeu de bagues*—a game of
rings that they catch on a wooden stick
as they circle around.

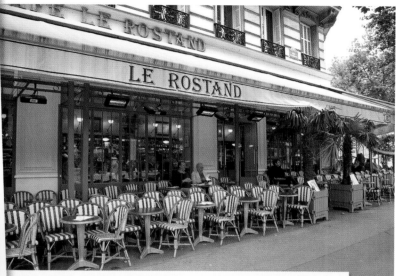
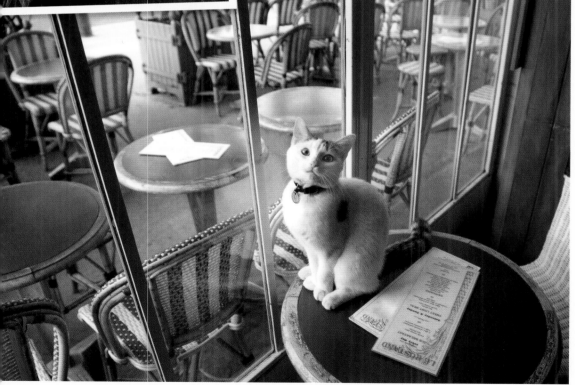

HELYPSE
Le Canu-Millant
56, rue de Rome
75008 Paris
+33 1 42 93 47 40

The rue de Rome has been synonymous with luthiers, or stringed instrument makers, from the early twentieth century onward, when many transferred their workshops to the area to follow the Paris conservatory of music and dance (founded in 1795), which had moved to the nearby rue de Madrid. The conservatory later moved again, but the luthiers remained. The rue de Rome is also conveniently close to the Opéra Garnier.

The storefront window of Le Canu-Millant is decorated with yellowed sheet music and a model of a giant violin bow in front a red velvet curtain. But what makes passersby stop short in their tracks, music professionals or not, is the vision of a majestic, long-haired, tiger-striped feline stretched out in the window: Helypse, the shop's Maine coon. Born in 2013, he is still a kitten, but as a full-grown cat, Helypse will weigh about twenty-six pounds (twelve kilos). He is already larger than the shop's cream-colored dachshund, Chester, with whom he frolics and wrestles on the solid oak, waxed parquet floor.

Loïc Le Canu and his wife Verena, both luthiers, took over the shop in 1989 from the highly respected Bernard Millant, who had opened it in 1934. Millant is a master luthier from a family of luthiers and bow makers going back one hundred and fifty years. Now well into his eighties, he still works in the atelier two afternoons a week. Loïc and Verena have handed over the business to their son, Nicolas, who has been working with his father since 2000, but they still come to the shop three days a week, and Loïc brushes Helypse while he drinks his coffee. Helypse is Nicolas's cat, and he carries him to work every day, draped over his shoulders. His neighborhood is an interesting one, just up the hill from the busy Gare Saint-Lazare, which was France's first train station, built in 1837 and moved to its current location several years later. The station's classical façades are designed in stone; the train platforms are covered with a glass canopy; and a glass-roofed gallery links the main concourse with other buildings. Featured in paintings by the impressionists, who lived close by, the Gare Saint-Lazare was also unforgettably documented by Henri Cartier-Bresson's 1932 photograph of a man leaping over

Boulevard des Batignolles delineates the Batignolles neighborhood of Paris. The pedestrian walkway down its center is lined with trees (below), some of which are several hundred years old.

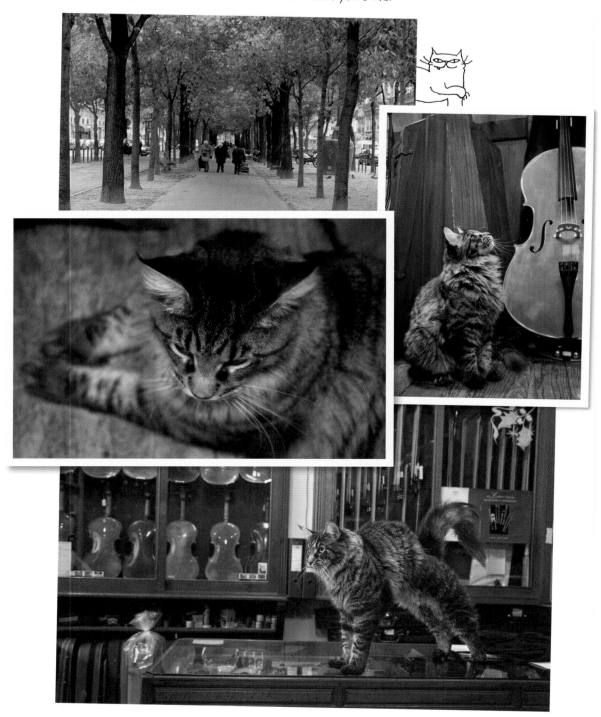

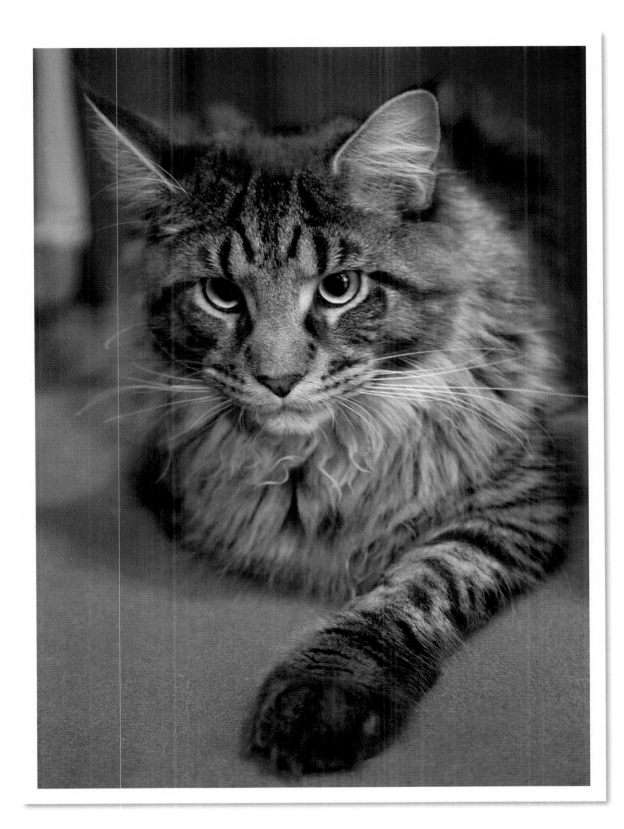

a puddle behind the station. Helypse's street, the rue de Rome, is like many of the streets in the immediate area, named after a city on the European continent—Vienna, Madrid, London—all leading off a square called place de l'Europe, which was built over a viaduct in the nineteenth century.

Inside the shop, photographs of famous violinists and patrons, from French to Russian, line a portion of the wall. There is a glass case on the opposite side of the room containing some thirty violins; the cellos are arranged on another wall. The Le Canu family has close to three or four hundred violins in the shop and rents out about 1,200 instruments a year. The violins are largely French, made in Mirecourt, a village in the Lorraine, where the primary industries are stringed instruments and lace making. In the sixteenth century, the Dukes of Lorraine introduced Italian master luthiers to the village where violin making subsequently became Mirecourt's raison d'être and remains so to this day.

The Le Canu workshop is at the back of a narrow corridor behind the shop's front room. The office space is decorated with a framed photograph of several generations of the Millant family of luthiers, a nineteenth-century safe that Loïc had restored, and a Napoleon III–epoch sofa. In the workshop, bunches of black, white, and beige horsehair used for bows are attached to hooks above food and water bowls for Helypse and Chester; violins hang from the ceiling above, and tools line the walls. Loïc's specialty is bow making, and Helypse's favorite toy is a tuft of bow hair that he chases, skittering about on the parquet. But as a kitten, he was also trained to behave, a necessity because, explains Loïc, "we work with valuable objects."

"Paris is an epicenter for many musicians passing through on the concert circuit," says Loïc. "Musicians are also quite fetishistic about their bows; I have one who stops in Paris to come to the shop on his way to Brazil to have his bows checked."

Most customers love Helypse, says Nicolas. Musicians may be fetishistic; they are also superstitious, he adds. Once, a quartet called Ellypse came into the shop, and following their visit they won a prize. "They were sure that Helypse had brought them good luck."

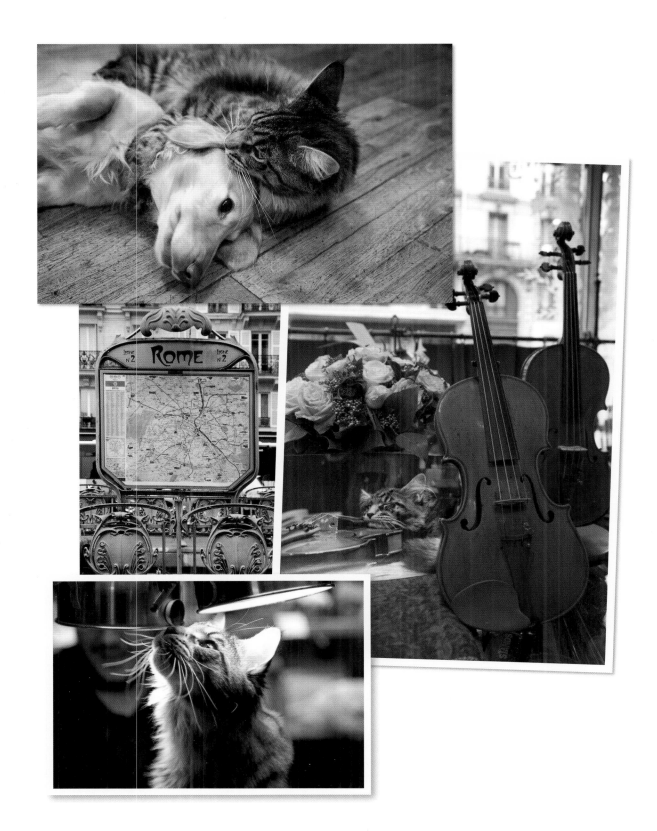

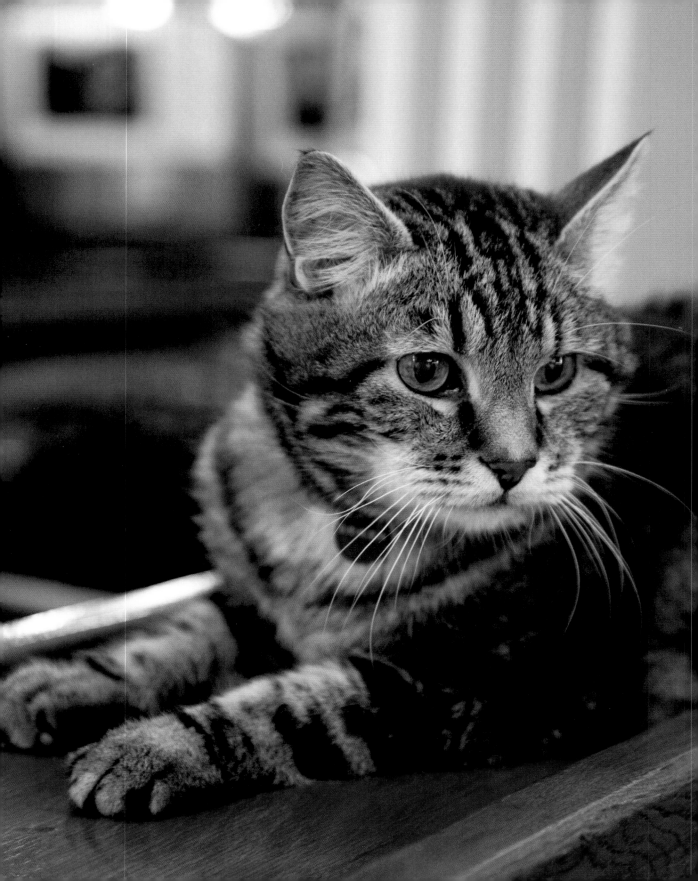

Le Select is one of the best-known brasseries in Montparnasse. With wicker furniture on the terrace and wooden tables with leather banquettes in the front and back rooms, the timeless Le Select opened in 1923 and was a favorite among an artistic crowd that included Picasso, Jean Cocteau, Henry Miller, and Ernest Hemingway. Known as a "Bar Américain" because it served American-style cocktails and had bar stools, it continues to be popular among locals and tourists alike. Artists and writers still spend afternoons nursing cups of coffee in the back room, and regulars gather around the bar conversing with long-time staff throughout the day.

Mickey, Le Select's former cat, was unquestionably contemporary Paris's most famous feline, on an equal footing with the establishment's illustrious and bohemian clientele. Mickey held court like royalty. Mornings found him stretched out on the wooden bar under a gold-tinted photo portrait of himself, taken by René Laguillemie, a self-proclaimed viscount. His afternoons were spent on a banquette in the back room, and his nights on the cashier's desk.

Mickey arrived at Le Select as a young cat, having migrated from the café next door, where he was known as Oscar. A veteran Le Select waiter promptly renamed the new arrival, calling him Mickey, although no one quite knows why. Michel Plégat, Le Select's owner, initially tried to shoo him away in vain. "We didn't know anything about cats at the time," recalls Frédéric Plégat, Michel's son and now one of the managers. But he soon proved useful; during his youth, Mickey was an excellent mouser and would often patrol the terrace.

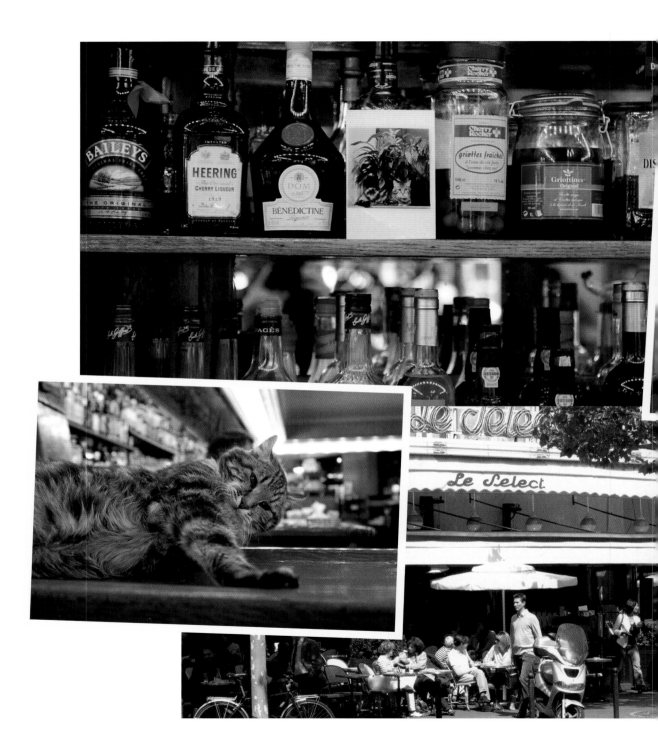

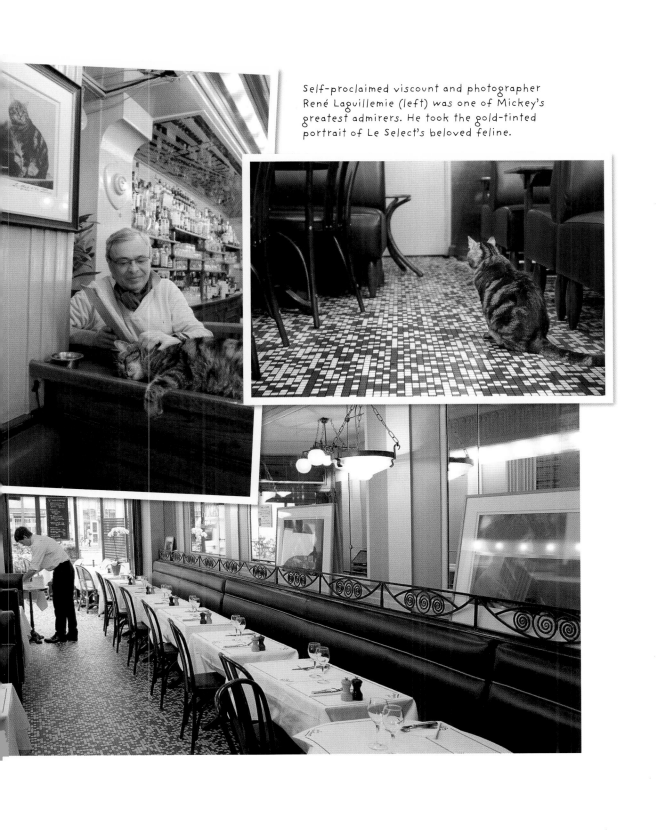

Self-proclaimed viscount and photographer René Laguillemie (left) was one of Mickey's greatest admirers. He took the gold-tinted portrait of Le Select's beloved feline.

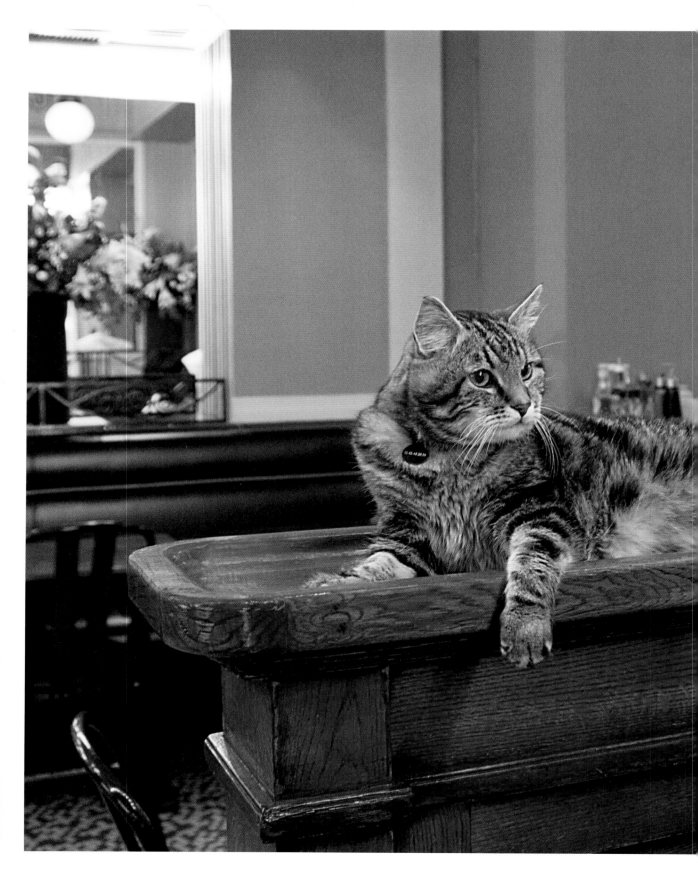

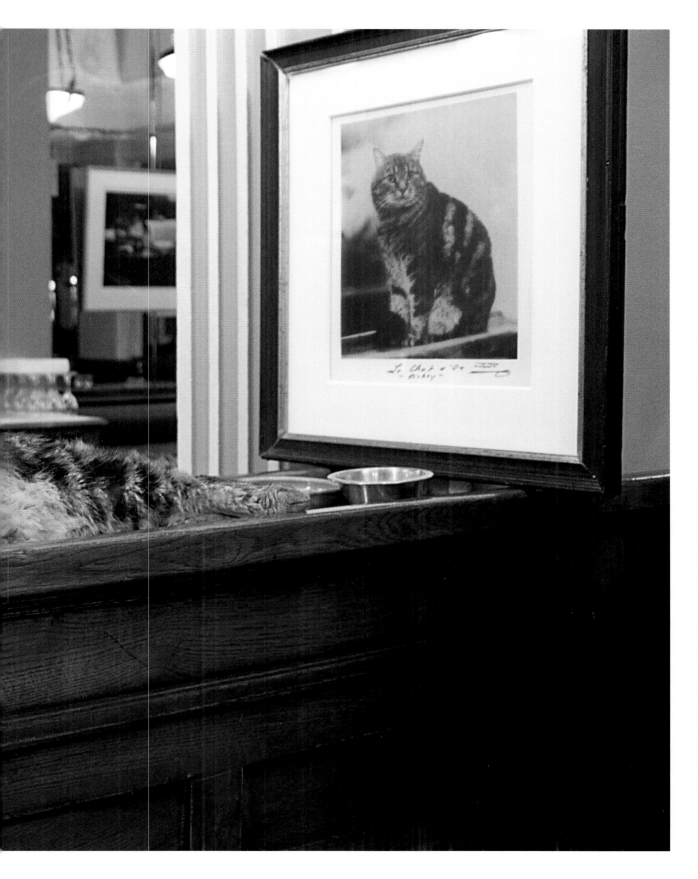

Mickey's fame eventually spread internationally, and on any given day, tourists would stop in to visit and photograph him. "Sometimes I think being Le Select's cat has gone to his head," a patron once remarked. "He received postcards and even care packages from places as far away as Nebraska," recounts Frédéric. "Someone once left him a rose."

Regular customers and the staff would vie for his attention, treating him with affection and respect. Every day, the crime writer Gilles Bornais would bring him a special blanket that Mickey favored for afternoon naps. "Sshh, don't wake him; he's dreaming," a regular would whisper.

Mickey's habits changed somewhat with age—in his younger days he used to go off during the daytime to find lunch somewhere along the nearby rue Stanislas, but in later years he remained closer to home and took all his meals at Le Select. Most days he would stick to dry cat food with tidbits of chicken and fish—he wasn't much of a red meat–eater—and once in a while he would enjoy a lick of Chantilly cream.

The only time Mickey was not a fixture at the bar was when Le Select held its annual Christmas party, and he would take cover in the office until the festivities were over. The next day he would be back at his post on the bar.

When Mickey died at twenty-two years old, the staff decided to break the news to their regulars slowly, and for a while the waiters had less of a spring in their step as they joined in with the clients to swap Mickey anecdotes. But after a few months, the staff welcomed not one but two Mickey successors, when a duo of tiny sisters arrived from the French countryside. "It was important that they be different from Mickey," explains Frédéric. After some bickering among the staff about the choice of names, the siblings were christened after two much-admired Montparnasse celebrities: Zelda, after F. Scott Fitzgerald's wife, and Youki, after Japanese painter Tsuguharu Foujita's model and future wife.

Parisian cemeteries are
filled with works of art and
the Montparnasse cemetery
is no exception. Artist Niki
de Saint Phalle created
this giant cat in mosaic (below)
for her assistant and friend
Ricardo, who died in 1989.

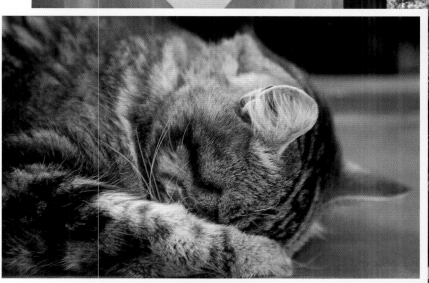

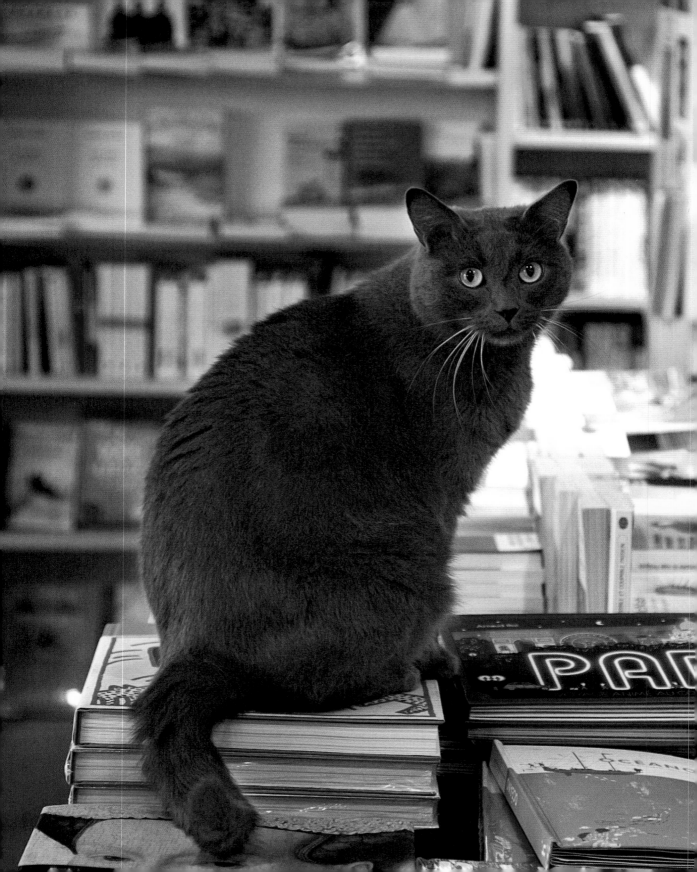

The rue du Faubourg-Saint-Antoine is one of the oldest avenues in Paris and has been a nucleus for artisans and manufacturing since the twelfth century. The courtyards and passageways off this main artery were once filled with workshops—some are still in operation—and they are testament to the hundreds of craftsmen who worked in the area making furniture, in particular for the royal courts. Many of the building entries are disproportionately high, with period lamps lining the passageways, built for when horse-drawn carriages would arrive.

Faced with the creeping gentrification of the nearby Bastille area, the neighborhood has fought hard to retain the atmosphere of its artisanal past. Page 189, an independent bookshop, opened in 1990 and is a polestar in the lively and creative area, mindful of keeping a link to its past.

One step down from street level, Page 189 has low ceilings with exposed beams. Long wooden tables with books neatly stacked on them line the center of the shop. Photographs of writers—Samuel Beckett, Marguerite Duras, and Edward Gorey (surrounded by his cats)—decorate the walls, along with an "I (heart) Dostoevsky" bumper sticker. On most days, a husky gray cat with green eyes sits bolt upright on the table closest to the register, watching the customers come in and out of the shop. Alternately, he naps on the larger photography books on another table. Arthur, named in homage

to Rimbaud, the French poet and one of the founders of symbolism, has lived in the shop since 2009. Owner Alain Caron and his partner Corinne Matras had just lost two longtime bookshop cats to old age, when a friend brought them Arthur, who had been found in a cornfield in the country.

"Arthur, most of all, cares about the bookshop," says Alain. But Arthur does have a best friend, Quignard (for French writer Pascal Quignard), a black-and-white cat who belongs to musician neighbors from the same building. Together, Arthur and Quignard explore the neighborhood, exiting either through the front door of the shop or the residential entrance to the building. The back of the bookshop, which is the children's book section, opens onto the building's courtyard so that the cats can come and go as they please. "Together they've doubled their territory," comments Alain.

Page 189 regularly holds book signings with authors such as Dominique Fernandez, Jim Harrison, or James Ellroy. "Arthur is always there for the events. He tests the writer's chair, then the table where the books will be signed. He wants to be with the author," says Corinne. "Most authors like it. Books and cats go well together."

Some of Page 189's booksellers disagree. They claim that when Arthur has dirty paws he walks intentionally on books by publishers such as P.O.L., Minuit, or Gallimard, the covers of which are traditionally white or cream.

"He has us all trained perfectly," comments Corinne. "The neighbors all know who he is and open the door for him. The baker took him home once when he was locked outside. He sits in the window and does social networking. He has become a central figure in our bookshop."

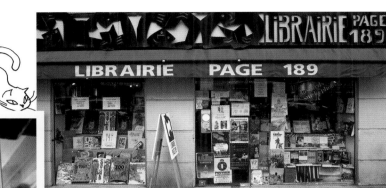

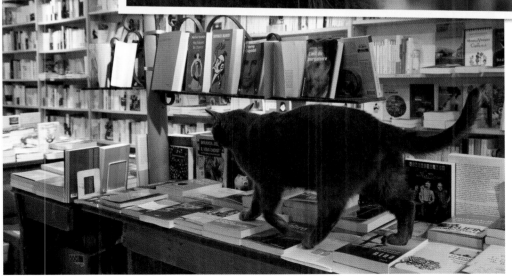

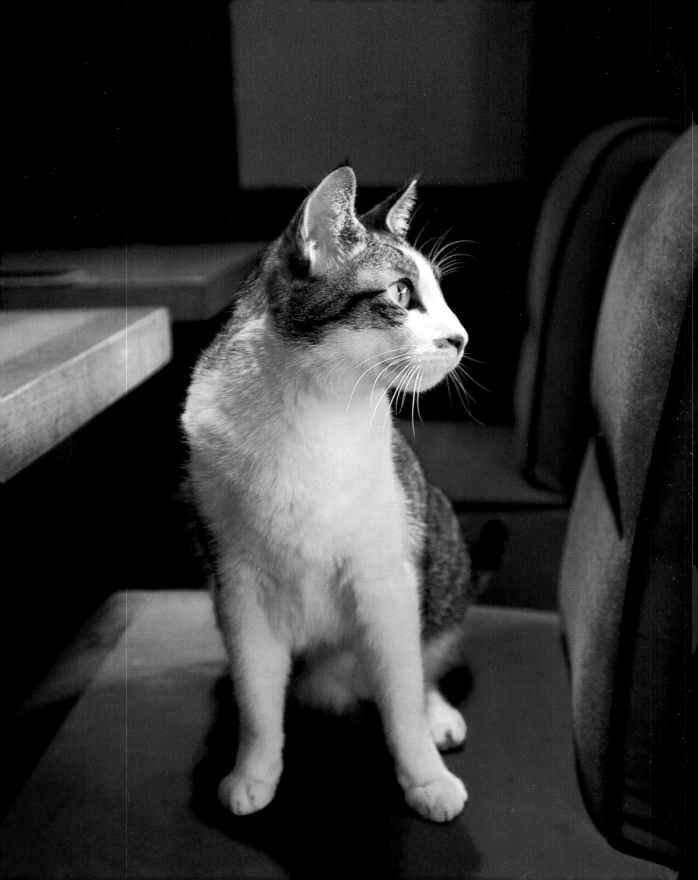

The crossroads at which the sleek Café RUC is located is a dizzying combination of intense traffic, historical landmarks, and entranceways to Parisian treasures. With one's back to the café, to the left is the Comédie-Française theater, founded during Louis XIV's reign; behind it lie the Palais Royal Gardens, part of a royal palace commissioned by Cardinal Richelieu in 1633. Directly opposite the café is the nineteenth-century Hôtel du Louvre where the impressionist Camille Pissarro painted a number of well-known canvases from his window, and to the right are the stone arches of the Pavillon Rohan that lead toward the Louvre museum complex. The striking Palais Royal-Musée du Louvre metro station exit at place Colette is visible from the café as well: in 2000, for the one-hundredth anniversary of the station, artist Jean-Michel Othoniel transformed it into two aluminum cupolas adorned with multicolored glass and silver beads that he called the Kiosque des Noctambules (the Night Owl's Kiosk). Othoniel's cupolas are one of three contemporary structures in the area that are integrated into classical architecture—the others are I.M. Pei's glass and steel pyramids at the Louvre and Daniel Buren's black-and-white striped columns in the Palais Royal's court of honor.

All these landmarks, among Paris's most visited, can be admired from behind a full-length glass window by Rucquette. She has white fur on her chest and tiger stripes on her back and face—in particular over one eye, like a pirate's patch. From her hushed, elegant home inside the Café RUC, she can observe the outdoor bustle from the black-trimmed, padded red velvet chairs by the windows. Relaxed in her plush surroundings,

where pleated lampshades give off a soft golden light and the black marble tiles on the floor are covered in thick patterned carpets, Rucquette, who is especially sweet-natured and calm, has not always had it so easy. She began her current life at the café in 2007 after she was adopted from an animal shelter where she had been brought in as a battered cat; she still limps. Sylvain Deniaux, a waiter who has worked at the RUC since 2001, says customers stop by in the morning on their way to work just to pet her. Occasionally a patron will give her flakes from a croissant. Otherwise, Rucquette is a gentle presence, curling up next to the regulars, who include actors Guillaume Canet, Jean-Paul Belmondo, and Catherine Deneuve. On the walls of the RUC, there are autographed black-and-white photographs of members of the Comédie-Française's troupe, a lineage that reaches back to the seventeenth century when the playwright and actor Molière directed the theater. Archives at the theater show that in 1829, and for the following thirty years, a cat was added to the general expenses each month: the linen supervisor always kept a cat so that the costumes, which were starched and thus appealing to mice, would be protected from them.

Rucquette lives a mere thirty feet (10 m) away from French author Colette's apartment, which overlooked the beautiful Palais Royal Gardens. Colette lived in this apartment from 1938 until 1954 and spent most of her life surrounded by cats, whom she wrote and sang about. Colette's friend and fellow novelist, artist, playwright, and filmmaker Jean Cocteau, lived just around the corner from her and shared Colette's passion for cats—he drew them, sculpted them, and wrote poems about them.

In a collection of Colette's best texts on cats, she famously wrote in the preface, "There are no ordinary cats."

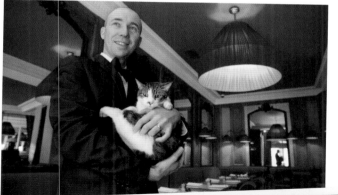

The author Colette could
look out of her window
at the beautiful Palais Royal
Gardens (bottom, left), which
have nearly five hundred trees
lining the walkways,
as well as two vast flowerbeds
separated by a large circular
pool and fountain.

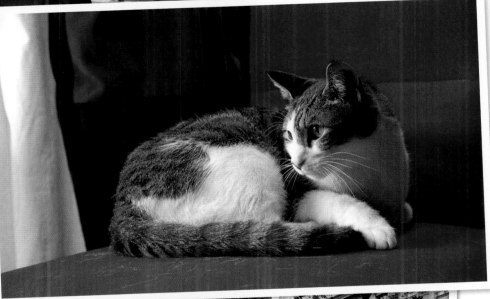

Art nouveau architect Hector Guimard's fluid curvilinear lines grace a number of Paris metro entrances. He designed three different styles of entrance, all in wrought iron, one of which can be seen at the Palais Royal-Musée du Louvre stop near the Palais Royal Gardens, complete with period street lamps (facing page).

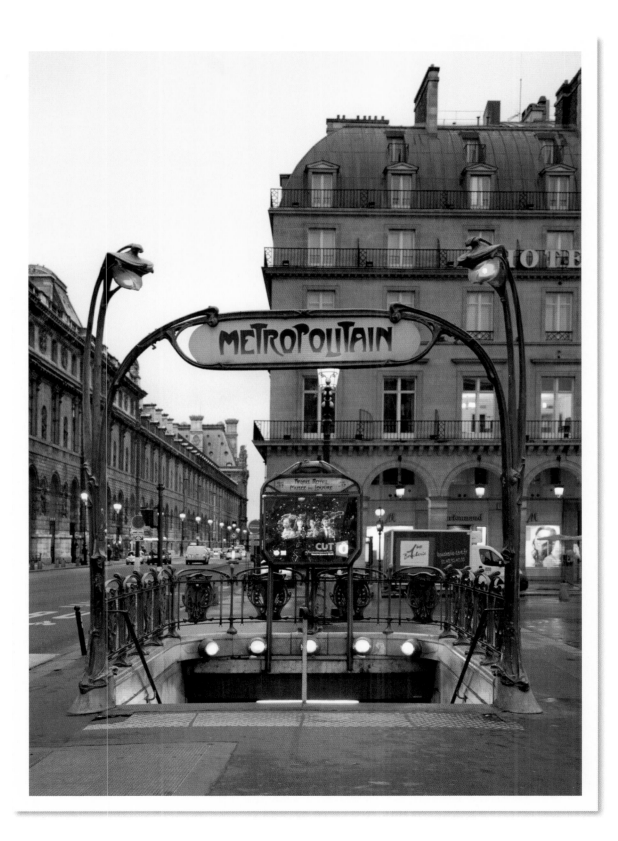

Le Carillon
18, rue Alibert 75010 Paris
+33 1 42 39 81 88

The area around the Canal Saint Martin—immortalized in the 2001 film *Amélie* (*Le Fabuleux Destin d'Amélie Poulain*), when the actress Audrey Tautou, clad in a red dress, skips stones across the canal—has gradually transformed from a working-class neighborhood into a trendy one, with pricey boutiques, bars, and restaurants now lining the streets along the canal. Just off the canal on a side street, the traditional Le Carillon café represents a crossroads of this social transformation—it is just as popular with an older crowd that has lived in the neighborhood for decades as it is with the newcomer hipsters and bobos (bourgeois bohemians). Together they drink aperitifs and shell roasted peanuts as they lounge on the eclectic mix of chairs—some classical wicker, others old school chairs with red metal frames—which are placed around rickety wooden tables outside. Inside, soft jazz plays on the radio throughout the day, contributing to the easygoing, low-key atmosphere.

Le Carillon has been in the hands of the same family for forty years and is managed by the highly energetic Hacén Kemache who also administers to Milou, a pretty tabby with a fiercely independent streak.

Milou sauntered into Le Carillon one day and adopted it as her home. She is perfectly at ease inside the café with its wood paneling, mosaic floors in 1970s tones, and

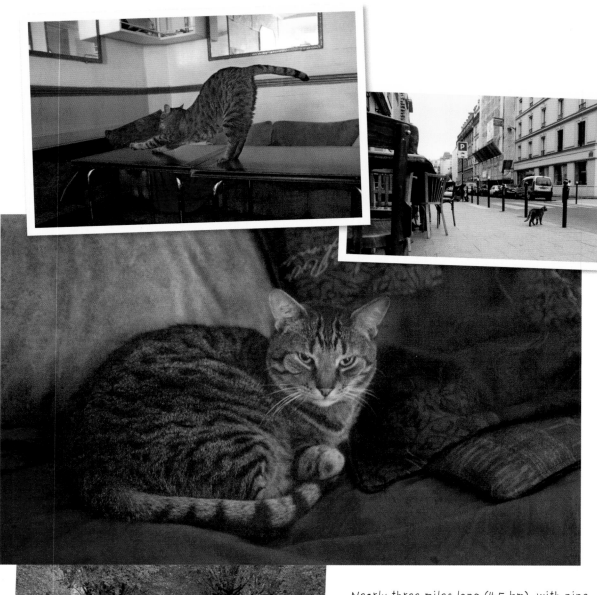

Nearly three miles long (4.5 km), with nine locks, the Canal Saint Martin (left) runs partially underground. It is lined with chestnut and plane trees, interspersed with footbridges, and has often provided the backdrop for movies.

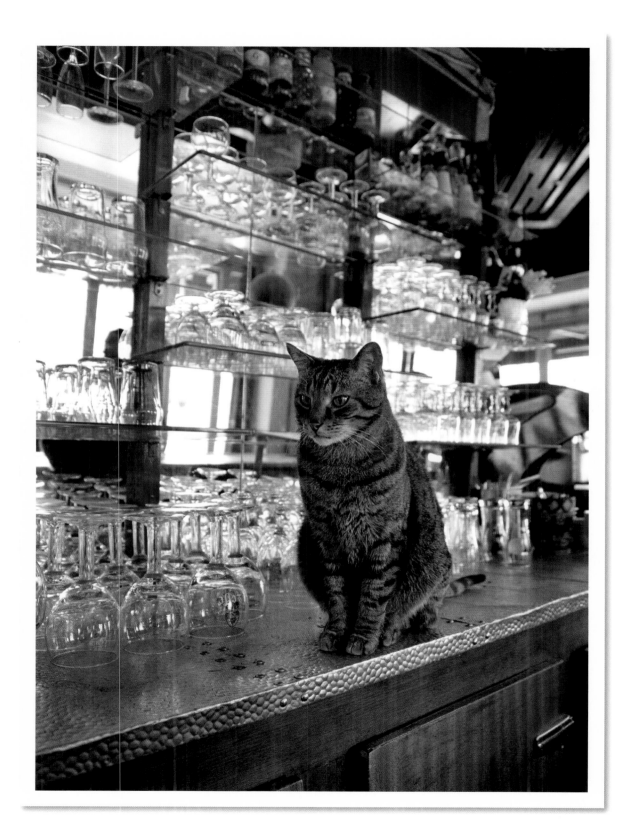

ramshackle but comfortable furniture—she favors in particular the faux leather sofa in the back room where she likes to sleep on an orange plaid cushion.

Footloose Milou doesn't really take after her namesake—Tintin's faithful wire fox terrier, known in English as Snowy—but Le Carillon wouldn't be the same without her, say the regulars. She'll occasionally sit on the zinc bar and mix with the patrons while they drink their morning coffee, and then she is off—mainly to explore the garden inside the nearby seventeenth-century Saint-Louis Hospital, founded by the Bourbon king Henri IV. Milou's choice of garden is a fine one—set in the inner courtyard of the hospital complex, it is one of the least known in Paris and also one of the most beautiful. The same engineer who drew up the plans for the hospital and grounds also designed the place des Vosges. Work began in 1607 after Henri IV laid the first stone for what would become the Saint-Louis chapel, which is still in use, with the royal ciphers of Henri IV and his wife, Marie de' Medici, above the entrance. Slightly farther afield, Milou has the choice of another garden in the Convent of the Recollets, for which Marie de' Medici laid the first stone in 1614.

Despite all the possibilities for exploration in the neighborhood, Milou always comes back to Le Carillon before closing time at 2 a.m. "She has an inner clock," comments the barman, Koko Adjem. Opening time is 7 a.m., and what she really likes for breakfast, says Koko, are a few nice slices of ham.

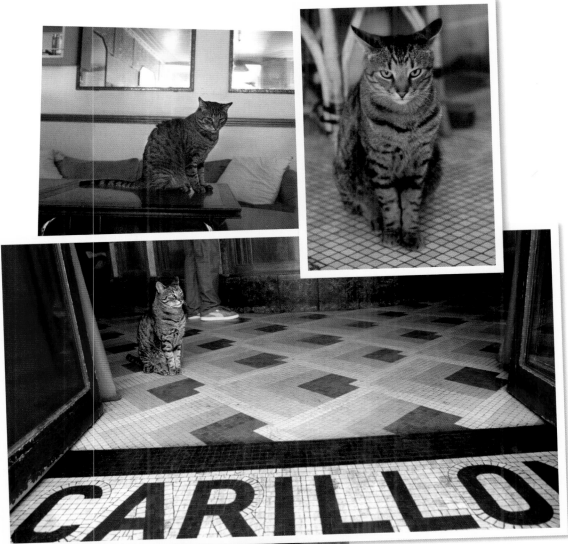

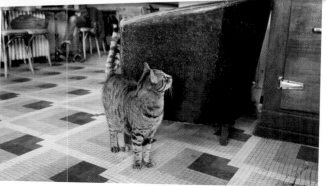

The trend for mosaic floors in Paris cafés began at the turn of the twentieth century with the advent of the art nouveau style. Usually in stoneware, these tiny squares measuring less than an inch (2 cm) are extremely sturdy.

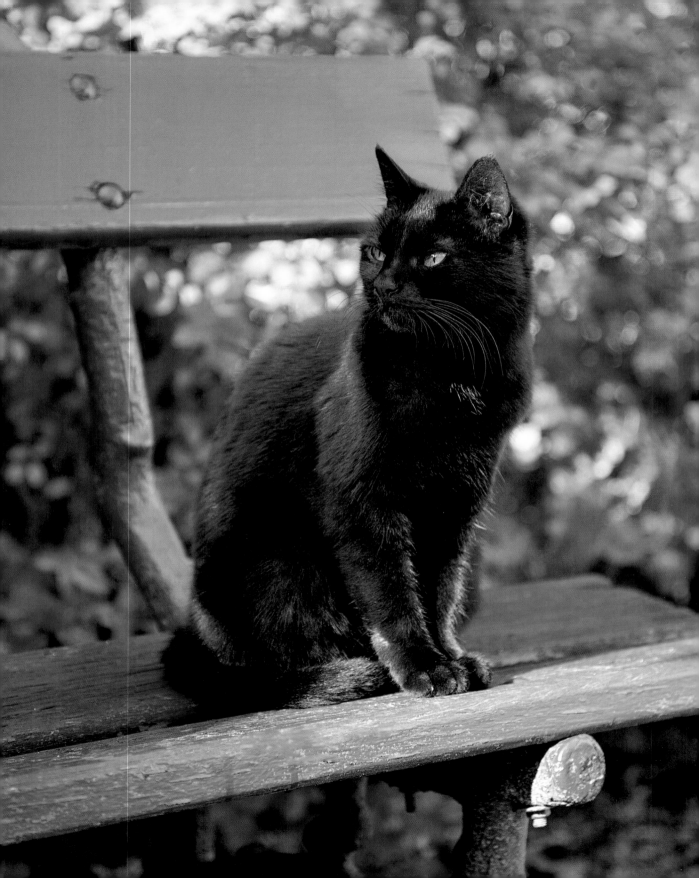

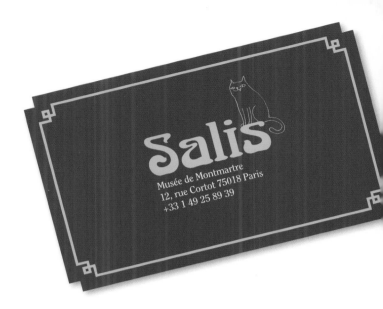

The neighborhood of Montmartre sits atop a hill in northern Paris. Once a rural village with narrow streets, cottages, windmills, and vineyards, it became part of Paris in 1860 and soon, because it was inexpensive, drew students and artists of all sorts. Cafés, dance halls, and cabarets grew rapidly around the area and for a while, between the late nineteenth and early twentieth centuries, the area was vibrant with artistic activity. Perhaps the best place to get a feel for what bohemian Montmartre was like is in the Musée de Montmartre, surprisingly calm after the crush of the place du Tertre. Surrounded by three gardens and the one remaining vineyard in Montmartre, the museum is in a seventeenth-century manor, the oldest house in the area, where Roze de Rosimond, an actor in Molière's theater company, once lived.

To get to the museum, visitors cross the first garden, walking under a pergola covered with wild roses. To their right, a quince tree bows low, supported by a graceful metal sculpture of a lyre; a bed of wildflowers borders a whitewashed wall behind it. To the left are two benches in an L-shape, painted the traditional dark green of Paris benches, and on most days, Salis, the pint-sized, jet-black museum cat lies, sphinx-like, on one of them.

Salis is named after Rodolphe Salis, one of the preeminent figures of Paris's Belle Epoque and founder of the celebrated cabaret Le Chat Noir (The Black Cat), which he opened in 1881, hanging a distinctive painted metal sign of a black cat on a crescent moon by Adolphe Willette outside. Théophile-Alexandre Steinlen's equally famous lithograph of a black cat was painted for one of Salis's cabaret road shows in 1896. Salis was the master of ceremonies in his cabaret, slinging tongue-in-cheek comments to his audience while presenting theater performances, music recitals, and readings that made his cabaret an essential part of the avant-garde artistic and literary scene.

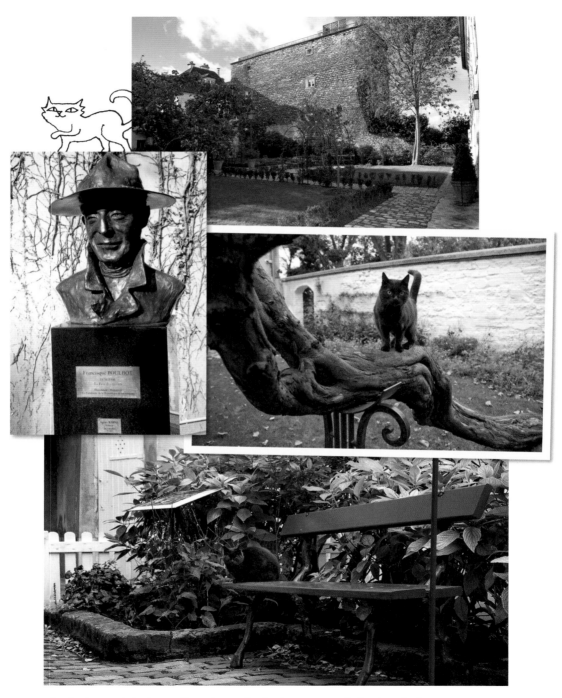

Illustrator and designer Francisque Poulbot was one of Montmartre's most emblematic figures. The bronze bust of Poulbot (center, left) was inaugurated in the Montmartre museum's garden in 2012.

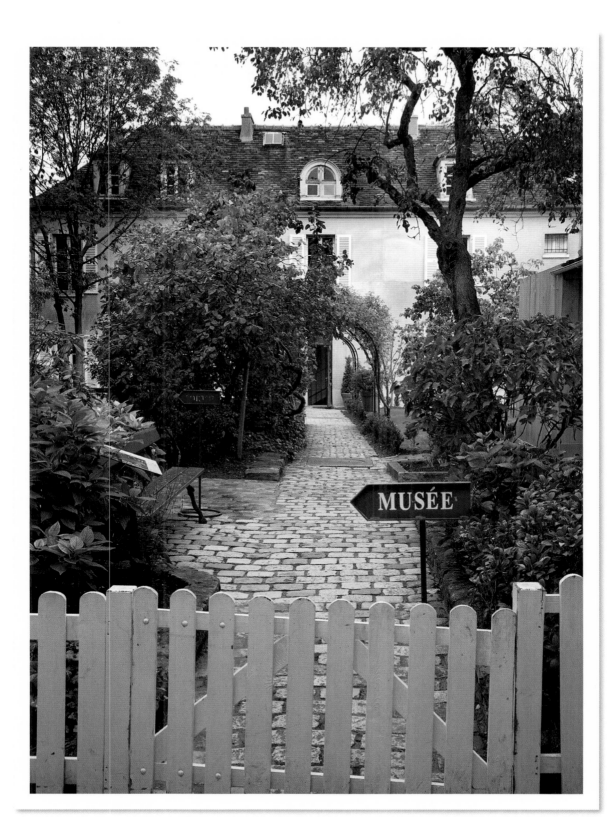

The Musée de Montmartre's collection includes posters, paintings, and photographs that recreate the free-spirited atmosphere of the time, and it has a special room dedicated to Le Chat Noir's celebrated shadow plays.

No one at the museum is quite sure when Salis the cat showed up, but the staff agrees that it must have been around 2007. He spends most of his days in the garden and sleeps in a cloth basket in a cupboard outside, near the museum entrance. The guards and staff feed him three times a day, and management has a budget for his upkeep. "Everyone thinks we did it on purpose, to have a black cat," says Karelle Le Queré, the marketing director. "But he's the one who decided he liked it here. He acts like a star, and people love him."

The museum's manor house and adjacent eighteenth-century Maison Demarne served as dormitories and studios for numerous artists, writers, and musicians, including Raoul Dufy, Suzanne Valadon, and her son Maurice Utrillo. In the early days of impressionism, Auguste Renoir was one of the first residents, and it was here that he completed several of his well-known paintings, including his 1876 *La Balançoire* (*The Swing*). The model for the swing still exists today, hanging from a tree near a pond filled with lotus flowers. Salis likes to rub his head against its wooden slats before running down the steps past a bust of Francisque Poulbot, an illustrator and integral part of the Montmartre scene, toward the lower garden. A large evergreen tree towers over a platform from which there is a panoramic view of the vineyard, the surrounding houses, and the infamous Au Lapin Agile cabaret, still in operation, where writers, poets, musicians, anarchists, and pimps all made merry. Picasso's 1905 oil painting *At the Lapin Agile*, now in the Metropolitan Museum of Art, graced the walls of the cabaret for seven years.

While the fact that the museum cat is black and called Salis delights visitors, he is apparently part of a long Montmartre tradition—French dramatist Maurice Donnay, who wrote plays for the original Le Chat Noir, recalled in his memoirs seeing a live black cat on the premises of the cabaret.

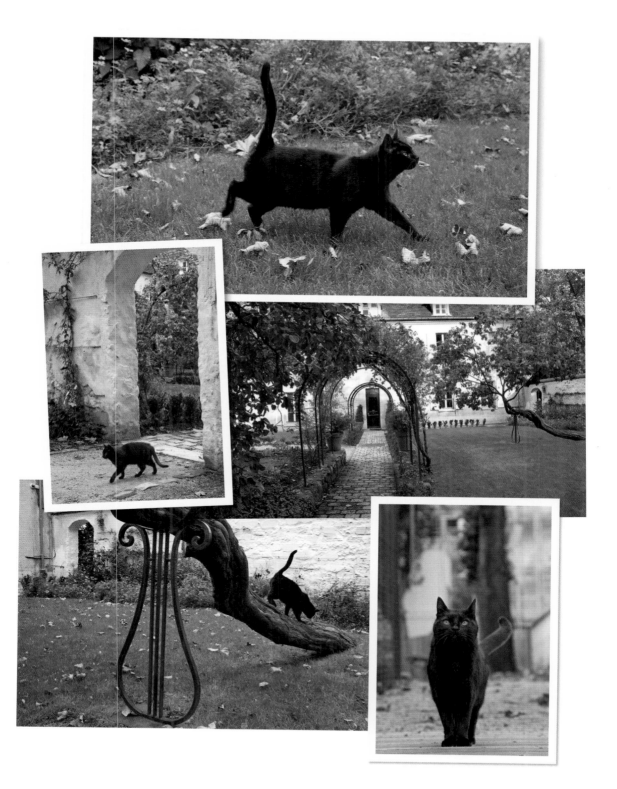

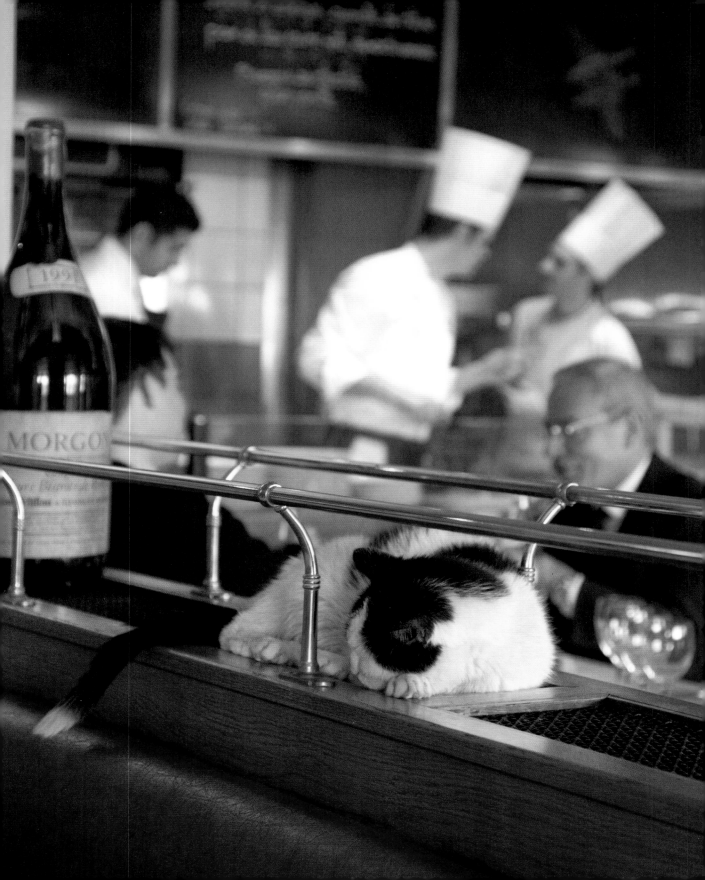

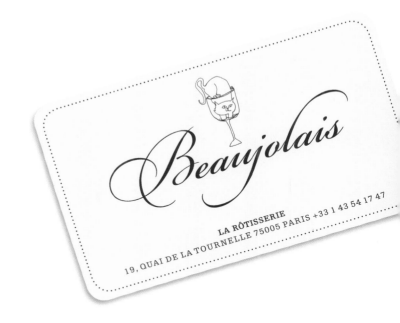

Beaujolais

LA RÔTISSERIE
19, QUAI DE LA TOURNELLE 75005 PARIS +33 1 43 54 17 47

Several bridges down from the crush of tourists around Notre Dame Cathedral, La Rôtisserie is the casual-dining subsidiary of the renowned and very formal La Tour d'Argent restaurant across the street. Founded in the sixteenth century, La Tour d'Argent was a favorite among kings and dukes, and the views of Paris from its sixth-floor restaurant inspired the makers of the animated film *Ratatouille*. Though far less formal, La Rôtisserie is no less gleaming and pristine. Yellow-and-white checkered tablecloths, red leather banquettes, an open rotisserie, and waiters in Bordeaux-colored aprons all make for a cozy atmosphere. A wall displays photographs of clients, such as the French journalists Bernard Pivot and Claude Sarraute, but also of a plump black-and-white cat yawning widely, lying on a table next to the salt and pepper shakers and a mustard pot. The cat is Beaujolais, the restaurant's mascot, now a mature feline with slightly unkempt fur and wise green eyes.

Named for the light, easy-to-drink wine, Beaujolais the cat is similarly approach-able and easygoing. Appropriately enough, he used to sleep on top of the wine barrels at the entrance to the restaurant—La Rôtisserie is known for its selection of thirty to forty wines chosen from La Tour d'Argent's celebrated wine cellar—but as an older gentleman, he has since migrated to warmer areas in the restaurant. He now favors the wooden shelf between two facing banquettes, slightly above customers' shoulder

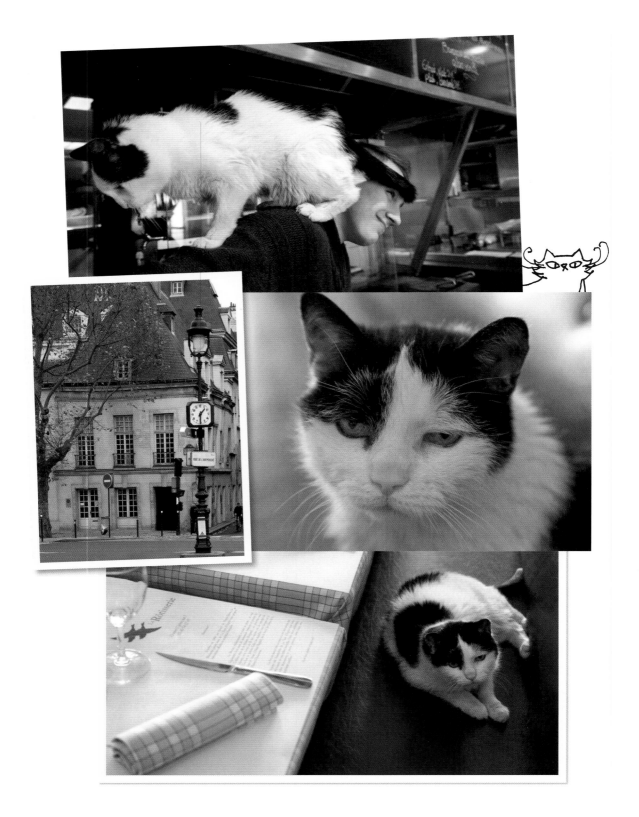

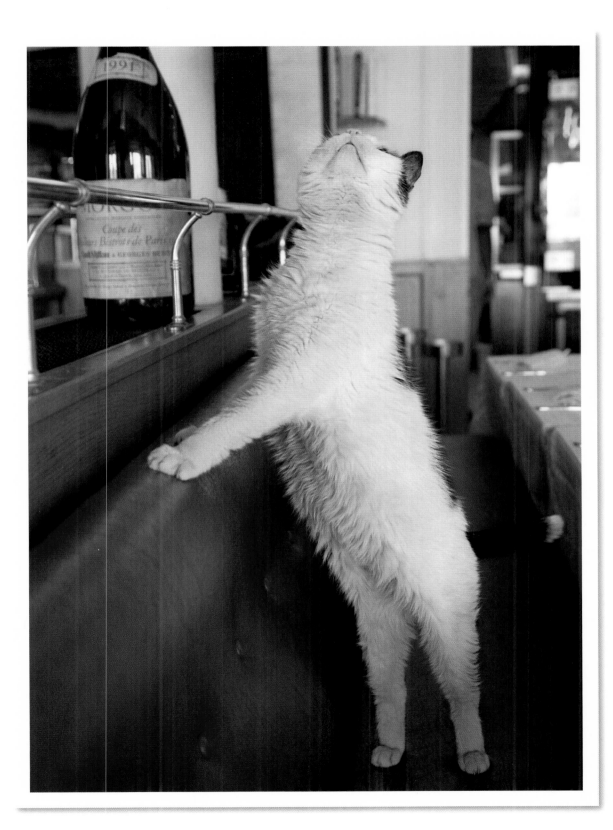

level, or the comfortable leather banquettes themselves, one stretch of which was recently replaced because Beaujolais used it too often as a scratching post.

Patricia Bauthamy, the codirector, has been with La Rôtisserie since 1996, several months before the owners decided to get a cat—the restaurant had been renovated and had a mouse problem. "He did his job," says Patricia, "but by then the clients loved him so much we decided to keep him." He was once nearly lost as a kitten, she recounts, still upset by the memory. He had climbed inside a customer's handbag and had fallen asleep, discovered only as the customer was leaving and lifted her heavier-than-usual bag.

Although Beaujolais is fed first thing in the morning, he also has a snack with the staff when they eat their midday meal before the lunch service. During restaurant hours, the waiters are vigilant and nimble, as Beaujolais may be underfoot. On a sunny day, he ambles outside to the end of the veranda to nibble on the grass growing through the cracks in the pavement opposite the Pont de la Tournelle, where the art deco–style statue of Saint Geneviève, the patron saint of Paris who protected the city from Attila and the Huns in the fifth century, gazes out over the Seine. Like Mickey at Le Select, Beaujolais has achieved star status. Patricia soon discovered, upon launching the restaurant's Facebook page, that people mostly wanted her to post photographs of Beaujolais (she remains resistant). An American client brings him a toy every time she comes to Paris. During the summer, he loves to lick ice cubes in drinks—and most customers allow him to do so. One client takes both his noon and evening meals at La Rôtisserie, and Beaujolais waits for him at his regular table.

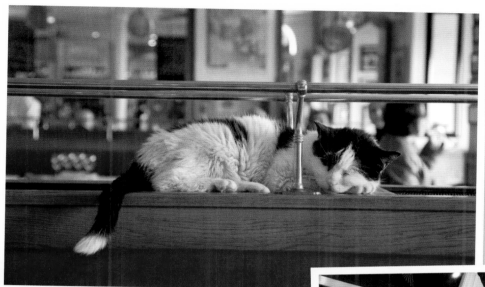

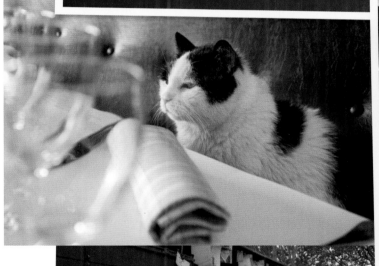

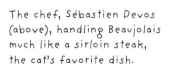

The chef, Sébastien Devos (above), handling Beaujolais much like a sirloin steak, the cat's favorite dish.

Reproductions of Steinlen's celebrated lithograph advertising Le Chat Noir cabaret on tour can be found at the nearby *bouquinistes* (left).

ACKNOWLEDGMENTS

The authors would like to thank their
friends who helped with cat sightings:
Maria Janko, Beatrix de Koster,
Gérard Étienne Mathey, Michèle Mathieu,
Gillian Whitcomb, and La Maison du Vitrail.

Thank you to Mitch Albert,
Stephanie Araud, our agent
Suresh Ariaratnam, and our fantastic
editors and the team at Flammarion:
Sophy Thompson, Kate Mascaro,
Gaëlle Lassée, and Helen Adedotun.

Special thanks to Odile Oudin
and her cats—Chanel, Kenzo, and Dior—
and the team at Misenflore.

Last but not least, we would
like to thank the cats themselves
for their patience and beauty.

Text copyright © 2014 Olivia Snaije
Photography copyright © 2014 Nadia Benchallal

Design: Isabelle Ducat
Illustrations: Vanessa Corlay
Copyediting: Karen Traikovich
Proofreading: Helen Downey
Color Separation: Bussière, Paris
Printed in Portugal by Printer Portuguesa.

Simultaneously published in French as *Chats Parisiens*
© Flammarion, S.A., Paris, 2014

English-language edition
© Flammarion, S.A., Paris, 2014

editions.flammarion.com

14 15 16 4 3 2

ISBN: 978-2-08-020174-4

Dépôt légal: 04/2014

FUN 1
Bible Skits

Ready-to-go scripts & activities
for kids & congregations

David M. Morrow

Activity suggestions
by Rachel S. Gerber

**Faith & Life
Resources**
A division of Mennonite Publishing Network
Mennonite Church USA and
Mennonite Church Canada

Scottdale, Pennsylvania
Waterloo, Ontario

FUN BIBLE SKITS 1
Copyright © 2005 by Faith & Life Resources, Scottdale, PA 15683
Published simultaneously in Canada by Faith & Life Resources, Waterloo, ON N2L 6H7
International Standard Book Number: 0-8361-9322-9
Printed in the United States of America
Design and illustrations by Merrill R. Miller
To order or request information call 1-800-245-7894
Web site: www.mph.org

Table of Contents

How to Use Fun Bible Skits

Fun Bible Skits is a versatile, reproducible resource for multiple settings. These 24 skits will bring new energy to congregational worship, and offer a creative way to provide active Bible learning for a wide range of ages. Use the following suggestions to begin thinking of how *Fun Bible Skits* might serve your congregation!

Fun Bible Skits in Worship Settings

- Use a skit to introduce the children's time or the sermon.

- Invite your youth group to perform a skit as they lead worship.

- Use several skits with related themes to tie together a series of sermons, a retreat, or other worship experiences.

- When possible, use simple props and costumes to enhance presentation of the story.

- If your setting allows, use the questions at the end of the skit for reflection or discussion. Or, make these questions available to adult or youth Sunday school teachers, encouraging them to follow up in their own settings.

Fun Bible Skits for Your Kids' Club Program

- Select the Bible skits in their biblical and chronological order or in any order you wish.

- Find a team of youth or adults to practice the skits before performing for the children, so the Bible content will be presented well. Some junior youth may enjoy being part of a drama group.

- Use the questions provided immediately after the skit is presented, with the whole group of children or as discussion starters with separate age groups. The first questions are generally geared to younger children, while subsequent questions allow older children to dig deeper.

- Use the activities accompanying each skit to reinforce the Bible theme. Select one or more activity, depending on the age of the children, the time available, and the energy level of the participants.*

- Supplement the suggested activities with songs, Bible memory work, or additional craft projects if desired.

*Note: The Christmas play does not have activities. The children could prepare and present the drama at a congregational worship event, as a service project for seniors, or for parents' night at a special Christmas club event.

1

God Cares for Adam and Eve

Genesis 2:15-25

Characters God, Adam, Eve

Props
- Stuffed animals—rabbit, sheep, cat, bear, hippopotamus (If possible, the bear should be a "Winnie the Pooh" bear. If you do not have these animals you may make cardboard cutouts for some or all of them.)
- Microphone for God

Introduction Today's skit is from the beginning of the Bible. It's about the first man, named "Adam." Adam is talking with God . . .

(Adam arranges stuffed animals on the floor before him.)

Adam: *(looking toward ceiling)* God, are you *sure* you don't want to name these animals? You made them.

God: Yes, and I made *you* to take care of them. That starts with giving each one a name.

Adam: All right. Well, here goes. *(He points to the rabbit.)* I name you the furry-animal-with-long-ears-and-a-cute-stubby-tail.

God: Adam, no one will ever remember a long name like that. You need to make the names a lot shorter. Just one or two syllables would be best.

Adam: One or two syllables. Got it. Okay *(pointing to rabbit)*, I name you "rabbit."

God: That's much better.

Adam: *(Pointing to sheep)* I name you "sheep." *(Points to cat.)* I name you "cat." *(Points to Pooh bear.)* I name you "Pooh."

God: Adam, when that animal grows up, it will be 8 feet tall, weigh 500 pounds, and have claws longer than your hand. Don't you think the name "Pooh" is a little . . . I don't know, tame?

Adam: You're right, it is a little tame. I'll call this animal a BEARRRR! *(He points to the hippopotamus and begins to hiccup.)* And this animal . . . *hip!* . . . this animal I'll call . . . *hip!* . . . this animal I'll call a . . . *HIP!*

God: Adam, I've already used the word "hip" to describe the area of your body right below the waist. Maybe you could add another syllable to "hip."

Adam: Hippopotamus!

God: That's adding *four* syllables . . . but never mind!

Adam: God, these are nice animals you made for me, but I'm still lonely. None of them is really like *me*. *(Adam yawns and lies down to rest.)*

God: *(Talking to self)* Adam is right. None of the animals is quite like him. I understand why he feels alone. And it isn't good for Adam to be alone. I care for him and want him to be happy. I know what I'll do. I'll make a friend and helper that's right for him. While he's sleeping, I'll take one of his ribs and make a woman.

(Eve enters stage left. Adam wakes up and takes her hand. Together they look up and listen to God.)

God: Adam, this is a friend and helper just right for you. She is *woman*, Eve. You will take care of her, and she will take care of you. You will live together as husband and wife. And I will take care of you both by giving you food, water, fresh air—everything you need.

Questions

• God gave Adam all the animals in the world, but Adam was still lonely. I wonder why he felt lonely.

• How did God care for Adam and Eve in the garden?

• How do you think Adam and Eve helped each other?

• How does God take care of you?

• Adam and Eve were told to care for the earth and all living things. God still expects people to take care of the earth. How can we do that?

• Have you ever had to take care of someone or something? How did you take care of them (or it)? How does it feel to take care of someone (or something) else?

Activities

1. Brainstorm ways to take care of God's earth—as Adam was instructed to do. Do a "work day" around the church and/or neighborhood, picking up trash, planting flowers, trimming bushes, raking leaves, mulching, etc.

2. Make a "Creation" dessert. Tell the entire creation story as you create this dessert (add ingredients for each day of creation):

- Begin with chocolate pudding in the bottom of a clear container (empty void). Read Genesis 1:1-2.

- Bring forth vanilla pudding (light). Read Genesis 1:3.

- Push the chocolate pudding to one side and pour in the vanilla pudding (separate light/dark). Read Genesis 1:4-5.

- Put a layer of blue finger gelatin on pudding (water below). Read Genesis 1:6-7.

- Put dollops of whipped topping on the gelatin (sky above). Read Genesis 1:8.

- Sprinkle crushed Oreo cookies on top (dirt for dry land). Read Genesis 1:9-10.

- Sprinkle fruit, dried or fresh (for vegetation). Read Genesis 1:11-13.

- Drop on star-shaped sprinkles. Read Genesis 1:14-19.

- Sprinkle gummy fish or fish crackers. Read Genesis 1:20-23.

- Drop on animal crackers. Read Genesis 1:24-25.

- Dish out the dessert to the children to eat. Read Genesis 1:26–2:3 and enjoy!

3. Use play dough to mold a person. Think about how God must have felt while creating humans. What fun God must have had!

4. Care for people who may be lonely. Visit people in a nursing home, or create care packages for those who are away from home, such as college students. Make "Thinking of You" cards.

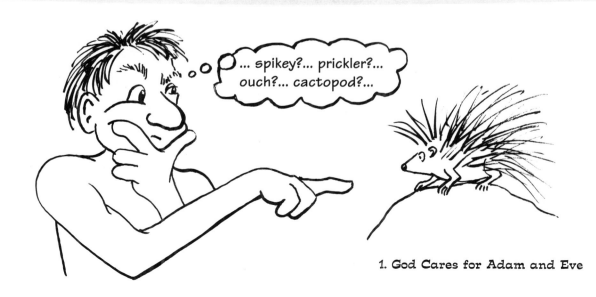

... spikey?... prickler?... ouch?... cactopod?...

God Cares for Noah and the Animals

Genesis 6 & 7

Characters	Noah, Shem (Noah's son)
Props	None required

Introduction In the days of Noah, there was a lot of evil on the earth. People made bad choices and did bad things . . . except for Noah. Noah was the only really good person God could find in all the earth. So God decided to destroy the earth with a big flood and start over. But to save Noah and his family, God told Noah to build a big boat called an "ark." Our skit begins when Noah has almost finished the ark. Noah is talking with his oldest son, Shem . . .

(Noah and Shem are center stage, looking toward an imaginary ark beyond the audience.)

Shem: Dad, you've been working on this boat for 10 years. I guess I finally believe you.

Noah: You mean you finally believe there's going to be a flood?

Shem: I finally believe there's going to be a flood. If you see this gigantic boat in your front yard for ten years, eventually you start to think "flood."

Noah: I'm glad we're starting to think alike, Shem.

Shem: There's one thing I don't get, though. How come the boat's so big? *(He counts on his fingers.)* There's you and Mom, myself, Ham, Japheth, and our wives. That's just eight people. We don't need a boat that size. I mean, is it going to have a gym? A swimming pool? Racquetball courts?

Noah: Shem, I made it that big so we could fit all the animals inside.

Shem: All the *animals*? You mean we're going to take our sheep and goats?

Noah: Sheep, goats, cows, horses. We're going to take two of each animal on earth—one male, one female.

Shem: *(Stunned)* Two of every animal on earth? Squirrels? *(Noah nods after each animal mentioned.)* Rabbits? Armadillos? Wombats? Two-toed sloths? Lions? Tigers? Bears? Oh my! *(pause)* Dad, I don't know how to say this, but I foresee some problems here. What are you going to do when the lions and tigers start eating the sheep?

Noah: God will take care of that.

Shem: Come to think of it, what are you going to do if the lions and tigers try to eat *us*?

Noah: God will take care of that.

Shem: And how are you going to get all these animals into the ark, anyway? Are you going to go out and herd elephants? Wrestle alligators?

Noah: I don't know. God will take care of that.

Shem: "God will take care of that." That's your answer for everything, isn't it?

Noah: *(Puts his hand on Shem's shoulder.)* Shem, this flood will be something horrible. Many people will lose their lives . . . many animals, too. But God has promised to take care of us and two animals of each kind. And God keeps promises. I don't know how it's all going to work. I'm just going to build this boat the way God told me, and trust God to do the rest.

(Noah and Shem pause, looking at each other. Then Noah turns and slowly exits stage right. Shem follows him, talking.)

Shem: Okay, Dad, maybe this is all true about the animals. But if it is, then there are some animals I'd like to leave off the ark. Spiders! I'm deathly afraid of them. Can we just leave off the spiders?

Questions

• Why did God decide to start over?

• Why do you think Noah obeyed God by building a big ark?

• The Bible doesn't say what happened while Noah was building the ark, but we can imagine that it wasn't easy. What might have been hard for Noah while he was building the ark?

• If you were Noah's child, what questions might you have asked Noah?

• How do you think Noah learned to trust in God?

• I wonder how easy or difficult it is to trust that someone else will care for you. Share an experience of being cared for. *(Reassure the children that God is trustworthy.)*

Activities

1. **Play "Barnyard."** Create two identical sets of note cards with an animal's name written on each card. Choose animals for which children can make sounds (cow—moo, bee—buzz, etc.). Shuffle all the cards together and pass them out. Children must find their partner by making the sound of the animal on their card. No talking allowed! Once all partners have been found, you may reshuffle the cards and play again.

2. **Listen to God.** As he was building the ark, Noah probably heard a lot of voices (like his son Shem's), asking him questions and telling him to do this or that. They wondered what Noah was doing. But Noah knew that God had told him to build the ark, and that God would take care of things. Sometimes, it can be hard to listen to God's voice. This activity helps to demonstrate:

 • Lay a long tarp down on the floor.

 • Build towers out of dominoes or Jenga bars, etc., and set them at different places on the tarp.

 • Choose one person to be "Noah." Choose another person to be the "voice of God."

 • Blindfold Noah. Noah's goal is to walk down the tarp without knocking over any towers.

 • The "voice of God" tells Noah where to step. The rest of the children line up on either side of the tarp and give other instructions or make noise. Can Noah avoid the towers? (Invite others to be "Noah" and the "voice of God," and rebuild towers, if necessary.)

 • *Debrief:* Ask Noah how it felt to listen to so many voices. Was it hard to hear God's voice above the noise? Connect this to today … how are we able (or not) to listen to what God wants us to do?

3. **Fingerpaint a rainbow.** Use red, yellow, and blue paints and mix on the paper to create orange, green, indigo and violet. Imagine God's fingers painting the rainbow in the sky, promising to always be with us and take care of us.

4. **Help Noah "herd the animals."** Blow up a lot of balloons and put them into two piles. Line the children up in two teams. Give the first child on each team a broom. They must "herd" one balloon into the "ark" (a cardboard box or basket on its side) at the other end of the room, then run back and hand the broom to the next child. The first team to herd all its "animals" wins. *Option: Use ping-pong balls and toothbrushes.*

God Cares for Abraham and Sarah

Genesis 12:1-5

Characters	Abraham, Sarah
Props	• Small table
	• Rolling pin (or other household item for Sarah to use)

Introduction Abraham and Sarah lived in a place called Haran. One day God spoke to Abraham, telling him to leave his hometown and go with Sarah to a land he would show them. God promised to bless Abraham and Sarah, and that Abraham and Sarah would be a blessing for others.

(Sarah is behind the table, center stage, rolling some imaginary food with the rolling pin. Abraham enters stage left.)

Abraham: Sarah, honey! I'm home. Guess what? We're moving!

Sarah: *Moving*? Really! Abraham, you *did* buy that house over on Sycamore Street!

Abraham: Well . . . no.

Sarah: No? Then you must have bought the one on Cedar Street. I love that one, too!

Abraham: No.

Sarah: We're going to *build*! We're going to build a brand new house!

Abraham: No . . . not really.

Sarah: Well, what house *are* we moving into?

Abraham: Actually, we're not moving into a house. We're moving into a tent.

Sarah: A tent!? A TENT! Are you crazy? What makes you think I'm going to live in a tent?

Abraham: We'll have to live in a tent so we can follow our flocks of sheep and goats.

Sarah: Follow our sheep and goats! *(Angrily)* And just where are "we" going to follow our sheep and goats?

Abraham: I don't know.

Sarah: You don't know.

Abraham: No. God hasn't told me yet.

Sarah: God hasn't told you . . . Wait a minute. What's God got to do with this?

Abraham: Everything. God's the one who told me to move. God said, "Leave your country, your people, and your father's household and go to the land I will show you."

Sarah: *(Pauses)* Abraham, you know we've always been together when it comes to God. The rest of our family still worships those false gods. But you and I worship the one true God. Why would God want us to leave home and move to who-knows-where?

Abraham: To bless us, Sarah. God will show us the land, and if we move there, God will bless us and make us a blessing to all the people of the world.

Sarah: *(Stares at Abraham for a moment.)* God really *did* speak to you, Abraham!

(Abraham nods)

Sarah: But Abraham, I'm an old woman, and you are an old man. How can we leave home at our age? How can we live in a tent? How can we move to somewhere we don't even know?

Abraham: Sarah, this *is* going to be hard. But God isn't telling us to do hard things to be mean. God cares for us. I know it's hard to see now, but this move will be *good* for us—and good for others.

Sarah: But how do we know that?

Abraham: We just have to have faith.

Questions

• Why did Abraham and Sarah move to a strange country?

• What do you think was the hardest part about moving?

• How did God bless Sarah and Abraham?

• How does God bless people today?

• Think of something hard you have experienced. How did God care for you during that time?

• In the skit, Sarah asked Abraham how they could know God would bless them. Abraham answered, "We just have to have faith." What does it mean to have faith? Tell of a time when you needed to have faith.

Activities

1. Create a puzzle together. Ahead of time, write on a piece of posterboard Genesis 12:2 or draw a picture of Abraham and Sarah traveling. Then cut the posterboard apart into puzzle pieces. Give each child a piece of the puzzle, then have the group put the puzzle together. Sometimes what God tells us to do may not seem to make sense, but if we continue to trust and follow God, the pieces will fit together and we'll see the overall picture.

2. Go on a faith walk. Pair up the children, and blindfold one child in each pair. The other child must lead the blindfolded one through an obstacle course.

3. Be a blessing. As a group, brainstorm ways to be a blessing to the church and community. After making a list, choose a few "Random Acts of Kindness." As you do these things (i.e. wash cars in the parking lot, wash windows, etc.), leave a note that says, "You've just been the recipient of a Random Act of Kindness—pass it on!" If you wish, watch a snippet of the movie, "Pass It On," where the boy talks about his vision of what the world would be like if people would pass on blessings to one another.

4. Play "Packing up!" Divide the group into two teams for this relay race. Then divide each team into two parts. Part 1 stays at the starting line, while Part 2 stands at the finish line. Place a large box at the starting line. At the finish line, place household items (clothes, shoes, lamps, toys, etc.). Designate a spot in the room as Canaan (the ultimate destination).

• To begin, the first child in Part 1 races with the box to the finish line and quickly packs all the items into the box.

• The child must then push, drag, or carry the box back to the starting line and unpack it.

• Then the first child in Part 2 runs to the newly unpacked items and repacks them, dragging the box to the other side.

• After the last child has had a turn packing or unpacking (the box should be unpacked now), the entire team repacks the box and pushes, drags, or carries it to the final destination, Canaan. The first team to reach Canaan is the winner.

4 God Cares for Baby Moses

Exodus 2:1-10

Characters Pharaoh, Pharaoh's assistant, Jochebed, Miriam, Princess (Pharaoh's daughter)

Props
- "Throne" for Pharaoh
- Basket
- Baby doll (Moses)
- Chair (to serve as hiding-place for Miriam)

Introduction When Moses was born, the people of Israel were slaves in the country of Egypt. This skit is about the baby Moses; his mother, Jochebed, who was an Israelite slave; and his sister, Miriam. The king, who was called "Pharaoh," was cruel to the Israelite slaves. The story begins in Pharaoh's palace as he talks to one of his helpers . . .

(Pharaoh is seated on the throne, center stage. Assistant is to his right, stage left.)

Pharaoh: Tell me, how many Hebrews do we have here in Egypt? A half million? One million?

Assistant: I don't know, Your Excellency.

Pharaoh: *(Scornfully)* Well, I do. We have too many!

Assistant: But, Your Excellency, we need the Hebrews to work the fields and build the pyramids.

Pharaoh: We don't need a million of them! If war breaks out, they will join our enemies and fight against us. We need to stop this population growth! I order that every baby boy born to the Hebrews be drowned in the Nile River. And I order *you* to carry this out—NOW!

Assistant: Yes, Your Excellency. *(He bows.)*

(Pharaoh and Assistant exit stage left. Jochebed and Miriam enter stage right. Jochebed is holding the baby Moses, pacing back and forth.)

Jochebed: I don't know what to do, Miriam! I can't hide your little brother much longer. Everyone in the neighborhood can hear his crying. He's already three months old. In a few more months he'll be crawling. Someone will find him! Someone will tell Pharaoh's men. Then they'll take him and drown him! *(She kneels to pray.)* Oh, Lord, what shall I do? What shall I do? *(Her anguished expression turns to an expression of calm resolve.)* I know what I'll do. Bring me that basket, Miriam. *(Miriam brings basket to Jochebed, and the mother places the baby in the basket.)* Now, let's take this down to the river!

Miriam: No, Mama, no! Don't drown baby Moses in the river!

Jochebed: Don't be ridiculous, Miriam! I'm not going to drown Moses. We're going to save him.

(Jochebed and Miriam move stage left. Jochebed places basket on the floor.)

Jochebed: We'll just hide him in these reeds at the edge of the water. I believe God will do something to save him. You stay here for a while to watch and see what happens.

(Jochebed exits stage right. Miriam hides behind the chair, stage right. Pharaoh's daughter enters stage left.)

Miriam: *(Whispering)* Oh no, it's Pharaoh's daughter! What if she sees my baby brother?

Princess: *(Sees basket and stoops down to look.)* It's a baby! This must be one of the Hebrew babies. *(She picks up baby Moses)* Poor little thing. I feel so sorry for him. *(Angrily)* I can't believe Dad wanted to kill these poor babies! But I know what *I'll* do. I'll take this baby home with me. *(She pauses.)* But he's just an infant. I'll need someone to nurse him for me.

Miriam: *(Comes out of hiding and bows.)* Your Highness, I see that you found the baby someone left in a basket. I saw him, too. Shall I go and get one of the Hebrew women to nurse the baby for you?

Princess: Yes, go . . . right now.

(Miriam exits stage right and returns, pulling her mother by the hand.)

Princess: *(To Jochebed)* Woman, take this baby and nurse him for me, and I will pay you. *(She hands the baby to Jochebed.)* You may come to the palace this Friday for your first payment.

Jochebed: *(Happily taking baby from the princess)* Yes, Your Highness!

(The princess exits stage left.)

Jochebed: I can't believe it! Pharaoh's daughter! And now she is going to *pay* me to nurse my own baby. I knew God would save this little boy!

Questions

- Why did Pharaoh want to kill the Hebrew babies?

- What did Jochebed (Moses' mother) do to try to save her baby boy?

- Who saved baby Moses?

- Why do you think Pharaoh's daughter wanted to care for Moses?

- Think of the many ways God uses caring people to carry out God's special plans.

- How can you provide loving care for a little child?

Activities

1. A basket full of prayers. Fill a baby pool or large washtub with water and reeds (or long grass). Float a basket (or cut-down plastic jug) on the water. Pass out note cards and ask the children to write down a concern they have that seems impossible. It could be a personal request, or a world request. Invite them to place the card in the floating basket. (Children may share their requests, if they are comfortable doing so.) After everyone has participated, pray for all of the requests. As God took care of Moses in the basket, God cares for each of us and wants to take care of us.

2. Make a basket. Cut 5 inches (12.5 cm.) off the top of a brown paper bag. Finding the natural crease in the bag, fold the top down and tuck it inside. Decorate the "basket" by gluing grass or reeds on the outside, or using markers/crayons. *Option: For older children, cut slits in the sides of the paper-bag "basket," and weave in strips of construction paper (or pieces of grass) to give it a more genuine look.* Or, make a woven yarn basket, using instructions from this web site: www.creativekidsathome.com/activities/activity_73.shtml

3. Play "Save it!" Using various lengths of PVC plumbing pipe cut in half lengthwise, have the children work together to balance a golf ball inside the pipe and carry it to a basket. They must carry the pipe from a starting line and drop the ball into a basket at least 8 feet away, "rocking" the ball the whole way. If the ball falls out, they must go back and start again. This will take some coordination and planning. Tell this story to explain the activity: "This *(hold up the golf ball)* is baby Moses. We are trying to get him to the basket *(point to the basket)*. Baby Moses loves to be rocked, and if we stop rocking him, he'll cry, and we don't want that! So, your job is to work together and get him into the basket quickly and quietly. We don't want the Egyptians to find us!" *Debrief:* Talk about how it felt to work together and to plan together to solve a difficult problem.

5 God Cares for the Israelites in Danger

Exodus 14

Characters Moses, 1st Israelite, 2nd Israelite

Props
• Staff for Moses

(Arrange children's chairs in two sections, with a wide space in the middle to represent the Red Sea.)

Introduction The Israelites were slaves in Egypt. But God didn't want them to be slaves any longer. So God sent Moses to tell Pharaoh to let God's people go. Pharaoh refused to free the Israelite slaves. So God punished Pharaoh until he gave in and agreed to let the Israelites go. Moses and thousands of Israelites left Egypt and headed for Canaan. But after the Israelites left, Pharaoh changed his mind and sent his army after them. That's where our skit begins . . .

(Moses and the two Israelites are center stage, facing stage left.)

1st Israelite: I tell you, Moses, I never thought I'd live to see this day. We're *free*! We're really free!

2nd Israelite: Yes, and not just some of us, but all of us! Every last Israelite is free from slavery!

1st Israelite: There are a lot of us, too. Just look at this line of people—thousands and thousands of people.

2nd Israelite: What do you think, Moses? How many Israelites do you think there are?

Moses: I don't know. I haven't gotten around to counting them yet. It's on my to-do list.

1st Israelite: I'll bet there are half a million—at least! *(Squints and shields his/her eyes.)* I can barely see the last group coming, on chariots.

2nd Israelite: *(Puzzled)* Chariots? I didn't know any Israelites had chariots. *(Recognition and fear show on his/her face.)* Wait a minute! Those aren't Israelites, they're Egyptians! The Egyptians are coming after us!

1st Israelite:	Egyptians! *(Squints eyes to look.)* It *is* them! The Egyptians are coming! They're coming after us! They're going to kill us all!
2nd Israelite:	*(Turns to Moses in anger.)* I thought you said we were free! This was nothing but a trap. A death trap!
1st Israelite:	Yeah! Why did you bring us out here in the first place? I'd rather be a slave back in Egypt than a corpse out here in the desert!
Moses:	Be quiet! Don't panic. Watch and see how God will save you.
2nd Israelite:	Just *how* is God going to save us? The Egyptians are behind us *(points stage left)*, the Red Sea is in front of us *(points toward audience)*, and we're stuck here in the middle—dead sandwich meat!
Moses:	Watch. *(He stretches out his staff toward the space between the chairs.)*
1st Israelite:	What's happening? The water in the sea is rolling back! It's rolling back on two sides *(motions with hands)*.
2nd Israelite:	And there's a big space in the middle—a space for us to escape! We can walk right through the Red Sea! Hey, I told you guys there was nothing to worry about!
	(Moses rolls his eyes and begins to walk through the space between the chairs. 2nd Israelite follows him. 1st Israelite hesitates.)
2nd Israelite:	*(Motions for 1st Israelite to come on.)* Come on! What's wrong?
	(1st Israelite points toward the space between the chairs.)
2nd Israelite:	What is it?
1st Israelite:	The fish—all those fish flopping around on the seabed! I don't want to step on one of those. That totally grosses me out!
2nd Israelite:	Oh, come on! *(2nd Israelite grabs his/her hand and pulls him/her through the "Red Sea.")*

Questions

• Why did the Israelites want to leave Egypt?

• Why did they get mad at Moses?

• Moses told the Israelites to not be afraid, because God would save them. How did God save them? (Does God always use miracles to save people? How did God save Moses when he was a baby?)

• Can you think of other times when God used miracles to save people?

• Has God ever rescued you or someone you know from danger? Tell about it.

• Moses was in charge of leading the people out of danger. What skills did he need to be a leader?

Activities

1. Chariot Race! Divide children into teams of three. Select two persons to be the "horses" and one to be the "chariot driver." Give a large blanket to each team. The horses must hold the blanket behind their backs, letting it sweep to the floor. The driver must sit on the blanket and hold on tight. Line up the chariots, and at the leader's signal, the chariots take off, and the first one to the finish wins.

2. Sing "Pharaoh, Pharaoh" (lyrics at www.dltk-bible.com/pharaoh_song.htm; music at www.higherpraise.com/Midi/kids/MidiKids.htm) and "Wade in the Water" (*Hymnal: A Worship Book,* #446)

3. Israelite Shoe Scramble! As the Israelites were crossing the Red Sea, it must have been a little muddy. As they were drying their shoes out on the other shore, all their shoes got mixed up. Help the Israelites find their shoes! Divide the group into two teams. Have everyone take off their shoes and put them in a large pile in the middle of the room. Then mix them up. Line up teams on either side of the shoe pile. At your signal, the first children in line race to the pile of shoes, recover their own shoes, put them on and race back to their teams. Play continues until everyone has found their own shoes. The team that finishes first wins.

4. Interactive Exodus story. Invite the children to make sound effects as a storyteller tells the complete story of the Exodus (plagues and all)! Storyteller might want to use a simple refrain between each plague, for the children to join in, for example: "But still … Pharaoh would not let the people go!" Here are some possible sound effects:

• Water turned into blood: *Pee-yew!* (kids hold noses)

• Frogs: *Rib-bit*

• Gnats and flies: *Buzz* and swat!

• Livestock: *Moo, baa, neigh*

• Boils: *Scratch, scratch, scratch* (scratch arms and legs)

• Thunder, lightning, and hail: stomp feet, pat legs, snap fingers, then clap loudly one time, while saying *"Boom!"*

• Locusts: *Gobble, gobble, gobble* (kids pretend to eat everything)

• Darkness: cover eyes and say, *"I can't see!"*

• Firstborn: *Wa-aa!*

• Israelites told to leave: *"Pack up and move 'em out!"*

• Crossing Red Sea: *Squish, squish, squish*

6 God Cares for Hannah

1 Samuel 1

Characters	Elkanah, Hannah, Eli
Props	• Baby doll (Samuel)
	• Sign reading "Nine Months Later"

Introduction Elkanah and his wife, Hannah, are going to the Feast of Tabernacles, a special celebration the Israelites held each year. At the feast is the chief priest, an old man named Eli . . .

(Eli sits to the side, stage right. Elkanah and Hannah enter from stage left.)

Elkanah: Don't you just love the Feast of Tabernacles! I *love* coming here to the tabernacle, worshipping God, and especially eating! I can taste that roast beef right now! *(Hannah bursts into tears.)* What's wrong, Hannah? I thought you liked roast beef. *(Hannah continues to sob.)* Well, we don't have to eat roast beef. We can have roast lamb . . .

Hannah: Oh, Elkanah, I don't care whether we have beef or lamb! I don't feel like eating anything. When we come to celebrate the Feast of Tabernacles each year, it just reminds me that another year has gone by and I still have no children. Why can't I have children, Elkanah? *Why?*

Elkanah: I don't know why, Hannah. But it makes me sad to see you so sad. Here, why don't you wait here at the tabernacle and I'll go get us some roast beef! I *know* that will perk you up!

(Elkanah exits stage left. Hannah kneels to pray.)

Hannah: O Lord Almighty, if you will only look upon my sadness and give me a son, then I will give him back to you all the days of his life. *(Hannah continues praying silently with her lips moving. As she prays, she looks toward heaven and waves her hands in the air. Eli observes her for several seconds.)*

Eli: *(Speaking to himself)* What's wrong with that woman? She is acting totally weird. She must be drunk. *(Goes over and speaks to Hannah.)* What's wrong with you, woman? This is the tabernacle of the Lord. This is no place to get drunk!

Hannah: *(Stands up, indignant.)* I am *not* drunk! *(She is suddenly sad.)* I am just very, very sad and troubled. I have been praying to the Lord about my great need!

Eli: Then you may go in peace. And may God give you what you have asked.

Hannah: *(Looks relieved.)* I pray that it will be so. And you pray for me, too!

(Hannah exits stage left, Eli stage right. Someone holds up a sign that reads "Nine Months Later." Hannah and Elkanah enter stage left. Hannah is holding a baby.)

Hannah: What a beautiful baby boy God has given to us! Now I *know* God cares for me, because of the answer to my prayer. We will call the baby "Samuel," because I asked the Lord for him.

Elkanah: You won't be sad *this* year when we celebrate the Feast of Tabernacles!

Hannah: Elkanah, I don't think I will go to the Feast of Tabernacles this year. I'll stay here and take care of Samuel. When he is no longer nursing, *then* I will take him to the tabernacle. I made a promise God: If God gave me a baby I would give him back, to serve God all the days of his life. And I mean to keep my promise.

Elkanah: I understand. If you want to stay here with Samuel, that's okay. But you're going to miss some delicious roast beef!

Questions

• Why was Hannah sad?

• What did Hannah pray for?

• What promise did she give God?

• In many churches, parents still dedicate infants and little children to God. What does it mean to dedicate someone to God?

• Think of a time when God answered your prayer. What did you pray for, and how did God answer?

• Sometimes we don't get what we pray for. Does God still care for us? How do we know God still cares?

Activities

1. **Have a baby shower.** Play games, such as:

 - Taste and guess different kinds of baby food.

 - Race to see who can diaper a baby doll the fastest.

 - Fill a jar with safety pins and guess how many are in it.

 - Place various baby supplies on a tray. Let children look at it for 1 minute, trying to remember all the items. Remove the tray and see how many they can name.

2. **Invite a woman or couple** that has struggled with infertility to come and share their struggle and how God took care of them. *Variation: Invite the children's parents to come and tell about the day the children were born, and how happy it made them. If some parents are not able to attend, they could write a letter to the child, including hopes they have for the child to grow in relationship with God.*

3. **Make baby blankets.** Make comforters and have the children knot them. Or, cut out equal-size pieces of fleece material, making 6-inch (15 cm.) snips all around the outside edge. Lay the two pieces of fleece together, then tie the strips together. (You may use the same colors/patterns or two different ones.)

 Options:

 - Have a dedication service for the blankets. Pray over the blankets, that the children who receive them will know that God cares for them, and that the parents will also feel God's love. During baby dedication services at church, have a child or two present these blankets to the parents. Make it a tradition!

 - Create a "comfort quilt" for those who are sick or sad in your congregation. They may wrap it around them, symbolizing God's love for them and the prayers of others who care. Let the children know who has the quilt and encourage them to pray for that person.

4. **Play the "Telephone Game."** Read the story in I Samuel 3, of when Samuel was a boy and God spoke to him in the temple. Sometimes it is difficult to hear God's voice—to realize that God is "calling" us. Have children sit in a circle. Whisper a message into one child's ear and have the child repeat it (whispering) to the next child. Continue this around the circle, and have the last child say the message out loud. The message may be very different.

God Cares for a Widow and Her Son

1 Kings 17:7-16

Characters Elijah, Widow

Props
- Sticks for firewood
- 2 identical jars of flour
- Roll or other piece of bread
- Chair (for Elijah)
- Table covered with a sheet
- 2 identical jars of oil
- Cup of water

Introduction God told the prophet Elijah that there would be no rain in Israel for a long time, and there wasn't. The crops died, and many people went hungry. When Elijah was hungry and thirsty, God sent him to a town named Zarephath. There was a woman there whose husband had died. She struggled to provide enough food for herself and her son. God had chosen this poor woman to give Elijah food and water. Our skit begins with Elijah looking for the woman . . .

(At stage right are scattered sticks of firewood. The table is center stage, with one jar of flour, one jar of oil, and the cup of water. The other jars and the bread roll are underneath the table. The chair is stage left. Elijah enters stage left and looks out into the audience.)

Elijah: I wonder where she is? I wonder which one of these folks is the woman God told me about? *(Looks up to heaven.)* God, show me which is the right woman!

(Widow enters stage right and slowly picks up sticks.)

Elijah: *(Noticing widow)* That's the one! She's right there! I just know she's the right woman. *(Walks over to widow.)* Excuse me, ma'am, could you bring me a little water? I'm terribly thirsty.

Widow: Aren't we all! But of course I can bring you some water. Water, I have. *(Begins to exit stage right.)*

Elijah: *(when widow is a few steps away)* And with the water, could you bring me a piece of bread . . . please?

Widow: *(turning around slowly)* Like I said, I have water. Bread, I don't have. All I have in my house is a handful of flour in a jar and a little oil in a jug. I'm gathering a few sticks to take home, to build a fire and make one last meal for myself and my son. And then we will wait to die . . . from hunger.

Elijah: Don't be afraid. Go home and make your food, but first make a small cake of bread from that flour and oil. Bring it here to me. Then make something for yourself and your son.

Widow: Look mister, I don't know you from Adam. Why should I give you the last bit of food in my house?

Elijah: Because the Lord, my God, has something for you. God has told me that your jar of flour will not be used up, and your jug of oil will not run dry until the Lord sends rain again.

Widow: *(looking at Elijah suspiciously)* All right, all right, I'll bring you your bread. What difference does it make if I die this week or next?

(Elijah sits on the chair, stage left, to wait. The widow goes to the table, center stage. She pours the flour and oil into the bowl and pantomimes making bread.)

Widow: *(speaking to herself)* I don't know why I'm doing this. I don't know that man. Why should I believe him and his crazy story?

(She puts the empty jars under the table and retrieves the roll. She then takes the roll and a cup of water to Elijah.)

Widow: Here you are. I hope you enjoy your meal.

Elijah: Thank you! Thank you so much! *(Takes a drink of water)* Wow, that sure hits the spot! *(Takes a bite.)* This is great!

Widow: Wonderful. Now, about this promise from your God . . .

Elijah: Don't worry. God always keeps a promise. Your jars of flour and oil are full.

Widow: My jars of flour and oil are empty! I just used everything up!

Elijah: Why don't you check again?

Widow: Okay, whatever . . . *(Goes back to table, looks under it, and retrieves the full jars. She is amazed.)* The jars are full! I still have oil! And flour too! Praise the Lord, your God! Praise the Lord, your God!

Elijah: I think the Lord is your God, too.

Questions

- I wonder how God talked to Elijah?

- I wonder if it was hard for Elijah to trust that God would provide for his needs.

- Elijah told the widow to bake some bread for him before baking some for herself and her son. How do you think the widow felt about this?

- I wonder if it was hard for the widow to trust Elijah.

- Did you ever give something that you really needed or wanted to someone else? Was it easy or hard? Why did you do it?

- God took care of Elijah and the widow and made sure they both had enough to eat. Does God make sure that we have enough to eat? How can we help people who don't have enough food?

Activities

1. Make bread together. Discuss how it might have felt to be the widow and see that the jar of flour and oil did not run out! Here is a recipe for Middle Eastern pita bread:

1 ½ cups / 375 ml all-purpose flour	1 cup / 250 ml whole wheat flour
1 teaspoon (almost ½ pkg.) dry yeast	1 tablespoon sugar
1 teaspoon salt	2 tablespoons olive oil
1 egg	1 cup / 250 ml water

Combine all ingredients in mixing bowl to make a firm, smooth dough. Let sit for 1 hour undisturbed. Heat oven to broil or 550F / 280C. Divide dough into 8 equal balls. Place on cookie sheet and press into flat disks. Bake 4-5 minutes or until lightly toasted. Remove quickly to avoid burning. Makes 8 pitas.

2. Decorate a napkin or tea towel for the bread. Use a square piece of light-colored fabric or a white heavy-duty napkin. Draw on it with markers, glue beads, thread different colored threads through it. Wrap bread in the napkin to take home.

3. Ahead of time, invite children to bring a non-perishable food item with them. Go to a food bank and help organize the food. Learn about children and families in your community who are hungry. Discuss ways your group might be able to care for these children and families. *Option: Visit Mennonite Central Committee's web site, www.mcc.org/globalfamily/gfabout.html, and learn about the Global Family Program—helping people around the world. Discuss ways that your group might be able to reach out and care.*

8 God Cares for Naaman

2 Kings 5:1-19

Characters	Naaman, servant girl, Elisha
Props	• Letter (scroll with tie or wax seal)
	• Bag filled with "gold" (coins or rocks)

Introduction Elisha was one of God's prophets. One day he met a man named Naaman, who lived in Syria. Naaman was a powerful man, a commander of the army, but he had a terrible skin disease called leprosy. Let's listen as Naaman talks to one of his servant girls....

(Naaman and servant girl are center stage.)

Naaman: *(looks under his arm)* Oh no! I found another patch of leprosy!

Servant: Where, master?

Naaman: Right here, under my arm. That's the third new patch this week! Soon it will be all over my body. I already can barely walk because of the pain in my feet and my legs. It's just a matter of time before the king gets rid of me!

Servant: Gets rid of *you*? No, master! You are the greatest commander the army of Syria has ever had! You have won dozens of battles. The king would never get rid of you!

Naaman: Who needs a soldier who can't walk? *(Slumps over, with his head in his hands.)*

Servant: Master, I wish you could see the prophet who is in Israel! *He* could cure you of your leprosy.

Naaman: Prophet? In Israel? Who is this man? And why do you think he could cure me?

Servant: He is the prophet Elisha, and he has done many great miracles. He even raised a little boy from the dead!

Naaman: Raised a little boy from the dead? I find that a little hard to believe. But at this point, I'll try anything! Go and find him. I am willing to pay gold and silver to be cured of this awful disease!

(Naaman exits stage left. Servant girl bows and exits stage right. Elisha enters stage left. Servant re-enters stage right with bag of gold.)

Servant: *(bowing before Elisha)* O man of God, receive this letter from the king of Syria. *(hands him letter)*

Elisha: *(reading the letter)* "With this letter I am sending my servant, Naaman, to you that you may cure him of his leprosy. When you receive this letter he will already be near your house." *(Elisha speaks to servant.)* Your master does not need to enter the house. Tell him to go and wash seven times in the Jordan River. His flesh will be restored and he will be cured of his leprosy.

(Servant bows and turns toward stage right as Naaman enters that way. Servant speaks to Naaman.)

Servant: Master, the prophet Elisha sends you this word: "Go and wash seven times in the Jordan River. Your flesh will be restored and you will be cured of your leprosy."

Naaman: *(with expression of disgust)* Wash seven times in the Jordan River! That muddy ditch? What kind of cure is that? I thought he would come out here and call on his God, wave his hand, and cure me like that! But all he says is to go take a mud bath? Syria has wider, cleaner rivers than the Jordan! Why can't I wash in one of those to be cleansed?

(Naaman begins to stomp off, but the servant calls to him.)

Servant: Master! If the prophet had told you to do some great thing, wouldn't you have done it? So why can't you just go wash yourself in the river?

Naaman: Okay, whatever! I'll go take a bath in the ditch! *(Moves stage right and "washes" seven times, counting each time. Actor can "ham it up" during this bath.)* Now I'll have to go somewhere else to wash *(looks at himself)* . . . this . . . mud . . . off . . . me . . . It's gone! My leprosy is gone! *(He runs to Elisha and bows.)* Thank you, thank you, O man of God! Now I know there is no God in all the world except the God you serve. Please accept a gift from your servant *(takes bag of gold from servant and offers it to Elisha)*.

Elisha: Keep your money. I don't need it or deserve it. Because I didn't heal you; the Lord did. God cares for you.

Questions

- Why did Naaman become angry when Elisha told him to go and wash seven times in the Jordan River?

- Why do you think he did it anyway?

- After Naaman was cured he said to Elisha, "Now I know that there is no God in all the world except the God in Israel." What did Naaman mean by that?

- Why wouldn't Elisha accept the gift from Naaman?

- Has God ever cured you, or someone you know, of an illness?

- God helped Naaman in a way he did not expect. Has God ever helped you in ways you didn't expect? If so, how?

Activities

1. **Play "Naaman's Jordan River."** This game is best done outside, wearing old clothes. Divide children into teams and choose one person to be Naaman. Naaman goes to the other side and sits in a folding chair. Next to him is a 5-gallon bucket of water and a cup. At the leader's signal, the first person in line for each team runs to the bucket and fills the cup with water, dumping it over Naaman's head. Repeat this seven times (symbolizing the number of times Naaman dunked in the Jordan). The team can help count. Continue until all team members have "dunked Naaman in the Jordan." When the last person is back, Naaman must get up and run back to his/her team. First team back wins. *Option: Use confetti in the bucket instead of water.*

2. **Write a thank-you note to God.** Naaman was thankful to God that he was healed. Invite the children to write a thank-you note to God for all the ways God takes care of them. Decorate the outside of the card with various markers and craft supplies.

3. **Naaman was healed in a way that he didn't expect!** Help the children brainstorm ways that they can help care for people in ways they might not expect. What are some things they can do personally or as a group to help someone? Examples might include:

 - Pick up toys without being asked

 - Play with a little sibling so parent(s) can do something

 - Mow an older person's lawn

 - Make parent(s) breakfast in bed, with a note that says how much they are loved and appreciated

God Cares for Daniel

Daniel 6

Characters 1st Administrator, 2nd Administrator, King Darius, Daniel

Props
- Chair (for king's throne)
- Clipboard with "law" and pen
- Stuffed animal lions (or cutouts)

Introduction Daniel was an Israelite, but he didn't live in Israel. When Daniel was a young man, the nation of Babylon invaded Israel and carried off many of the people. Daniel was good and honest, and was given a job working for the king of Babylon. Later, another country, Persia, invaded Babylon, and Daniel worked for the Persian king, Darius. Daniel was one of three people, called administrators, in charge over the whole kingdom. The other two administrators were jealous of Daniel. Our story begins as they are talking about Daniel . . .

(Throne is stage right. Stuffed lions are center stage, at the back. Daniel sits at desk working, stage left. Administrators #1 and #2 enter stage right.)

Admin. #1: Have you heard the latest? King Darius is going to make Daniel administrator over the whole kingdom of Babylon.

Admin. #2: *Daniel?* He's not even a Babylonian, much less a Persian, like you and me! He's a Jew!

Admin. #1: Well, we're going to have a Jew for our boss.

Admin. #2: Not if I can help it! If we could just catch Daniel doing something wrong, we could convince the king to get rid of him.

Admin. #1: Good luck! Mr. Perfect never does anything wrong.

Admin. #2: Nonsense! He's got to do *something* wrong *sometime*. Let's just think a minute.

(They pause to think.)

Admin. #1: I've got it! One time I saw Daniel eat his dessert *before* he ate all his vegetables.

Admin. #2: Don't be ridiculous! King Darius isn't going to get rid of Daniel for that!

(They think some more.)

Admin. #1: I've got it! Sometimes he doesn't keep his fingernails neatly trimmed.

Admin. #2: Get serious!

Admin. #1: I am serious. One time they were really long!

Admin. #2: Listen, if we don't think of something, that Jew is going to be our boss! We might even lose our jobs!

(Daniel kneels to pray. Administrators notice him.)

Admin. #2: Wait a minute. What's that he's doing there?

Admin. #1: He's praying to his God. He does it every day, three times a day.

Admin. #2: That's it! We'll convince King Darius to make a law that no one in the kingdom can pray to any god or anyone except the king!

(Daniel goes back to work at his desk. Administrators exit stage right. Administrator #1 gets the clipboard with the law. Darius enters stage right and sits on throne. Administrators re-enter stage right and bow before the king.)

Admin. 1 & 2: O King Darius, great and most excellent king, may you live forever!

Darius: Yeah, yeah. What do you want?

Admin. #1: O, King, we have a law for you to sign. *(Hands Darius the law.)*

Darius: *(reading)* "I, King Darius, hereby decree that everyone in the kingdom shall pray to me as a god for the next 30 days. Anyone who prays to any god or any person but me for the next 30 days shall be thrown into a den of lions." So, what is this? King Darius-the-God Month? One problem: I'm not a god.

Admin. #2: Oh, but King Darius, you are like a god to us. You are wise, and powerful, and humble!

Darius: Hmm . . . I am pretty humble, aren't I? Well, if you insist, I'll sign your law. *(Takes clipboard and signs law.)* Now go away and quit bothering me!

(Administrator # 1 takes law. Administrators move to center stage and face audience.)

Admin. #1: All right! We've got it *(holding up law)*! Now hear this, citizens of Babylon! *(Reads law to audience and Daniel.)* "I, King Darius, hereby decree that everyone in the kingdom shall pray to me as a god for the next 30 days. Anyone who prays to any god or any person but me for the next 30 days shall be thrown into a den of lions."

Daniel: *(kneeling to pray)* Thank you God, for giving me life and health. O God, you have heard this law. I always obey the laws of the king, but I cannot obey this one. I pray to you and you alone. Help me now to be strong and courageous.

Admin. #2: *(pointing to Daniel)* Look, there he is, praying again. We've got him!

(Administrators turn toward king and bow.)

Admin. 1 & 2: O, King Darius, great and most excellent king . . .

Darius: What? I told you not to bother me!

Admin. #1: O King, I am most sorry to report that we have already found someone who is deliberately disobeying your law. It is Daniel!

Darius: Daniel! Daniel, my top administrator? He never disobeys me in anything!

Admin. #2: He is now, O my King. Daniel prays to his God three times a day.

Admin. #1: And he continues to do this, even after hearing your law!

Darius: But I can't throw *Daniel* in the lion's den! He's my most trusted helper.

Admin. #2: I am sorry, my king. But according to the law of the Medes and the Persians, no law that you sign can ever be changed . . . *not even by you!*

Darius: *(groaning)* Why did I ever sign that stupid law? But I *must* obey the law myself. Go, arrest Daniel and throw him into the lion's den!

(Administrators seize Daniel and throw him into the den, which is center stage. They pretend to roll a stone across the entrance to the den.)

Darius: *(approaching the lion's den)* Daniel! May your God rescue you from the lions!

(Administrators exit stage left. Darius paces back and forth stage right. Daniel pets stuffed animal lions.)

Darius: It's almost sunrise. Daniel has been in the lion's den for more than 8 hours. I pray that his God has saved him . . . but that's hard to imagine. What god could save someone from hungry lions? *(He goes over to lion's den, rolls back stone, and in a scared voice calls out to Daniel.)* Daniel? Daniel, has your God been able to rescue you from the lions?

Daniel: O King, my God sent [his] angels and God [he] shut the mouths of the lions. They haven't even hurt me!

Darius: *(giving a hand to "lift" Daniel out of the den.)* Why, you don't even have a scratch! I will make a new law. From now on, everyone in my kingdom must worship the God of Daniel. For God [he] is the *living* God!

Questions
- Why didn't the two administrators like Daniel? *(Jealousy and prejudice against Jews)*

- What did the administrators do to get Daniel in trouble?

- Daniel broke the law and continued to pray to God. Did he do wrong by breaking this law? Why or why not?

- How did God rescue Daniel from the lions?

- Daniel got in trouble for doing something right. Tell about a time when you got in trouble for doing the right thing.

- Some people mistreat others just because of their color or where they are from, or because they are different in some way. How does God want us to treat people who are different from us?

Activities

1. **"Daniel and the Lions."** Divide the group up into two teams. Have them stand along two lines, approximately 25 feet apart. Name one group Lions and the other group Daniel. At the leader's signal, both groups will run to the other line. However, the Lions will be trying to tag a Daniel, whereas the Daniels will be trying to avoid being tagged. When everyone reaches the opposite line, all Daniels who were tagged must now join the Lion line. Play continues until there is only one Daniel left. Play the game a second time, switching roles to allow those who started as Lions to be Daniels.

2. **"Rescue Daniel!"** Take a lifesaver ring (like a lifeguard's) and toss it over a pole. Keep stepping back and throwing the lifesaver. See who can get it over the pole from farthest away. Discuss how God saves and rescues lives—like a lifeguard.

3. **Tell a story from *Martyrs Mirror*** about an Anabaptist leader who was persecuted because of their faith. Connect with how Daniel was persecuted for his faith. Then tell stories of how some Christians today are being persecuted because of their faith in Jesus (present-day Daniels). A good source is the web site of Release International: The Voice of the Persecuted Church, www.releaseinternational.org. Spread a map on the floor and point out countries where there is persecution. Have a time of prayer for those around the world who are being treated harshly for their faith in God. Invite children to pray, as well.

4. **Make a "decree scroll."** After King Darius saw that God had saved Daniel from the mouths of the lions, he declared that God was the greatest God! Read Daniel 6:25-28. Have the children make a scroll with this "declaration" on it. Tear a piece of paper around the edges. Soak it in tea, to stain it an antique color. To speed up drying, use a hair dryer. When the paper is dry, write King Darius' decree on it, or have the children write their own "decree" about how great God is! Roll it up and tie it with a ribbon.

10 God Cares for Sinners

Jonah

Characters God, Jonah, 1st sailor, 2nd sailor

Props
- Microphone for God

- Large fish (Cut sheets of newsprint or cardboard the length and height of a table. Tape newsprint or cardboard to table and use a marker to draw the fish which swallows Jonah.)

Introduction Jonah was a prophet. God told Jonah to go and preach to the people of a city called Nineveh, but Jonah didn't want to go. He didn't like the people of Nineveh. They were evil and their country was Israel's enemy. So Jonah disobeyed God. He decided not to go to Nineveh. Instead, he would go to Tarshish, a faraway land in the other direction.

(The "fish" is stage left. Jonah is center stage. Sailors enter stage left, pretending to row a boat. They stop at center stage.)

Jonah: One-way ticket to Tarshish, please.

Sailor #1: That'll be 10 shekels, mister.

Jonah: Ten shekels! For a one-way ticket? Maybe I *should've* gone to Nineveh. It would have been cheaper!

Sailor #2: Nineveh? Why in the world would you want to go to Nineveh?

Jonah: I *didn't* want to go to Nineveh. My God wanted me to go there, to preach to the people. But I don't want anything to do with those wicked people. I'm going the other way, to Tarshish.

Sailor #1: Hey, we don't care *why* you're going to Tarshish. We just want the 10 shekels. *(Holds out hand.)*

Jonah: All right, all right! Here you are. *(Hands money to Sailor #1 and lies down between two sailors.)* It's going to be a long trip. I'd better get some shut-eye.

(Sailors begin to "row the boat," but remain stationary.)

Sailor #2: I don't like the looks of those storm clouds up there. Do you think we should turn back?

Sailor #1: Turn back! And lose all this money? No way! We can make it through that storm.

(God makes the sound of wind through the microphone. Sailors begin swaying back and forth, and are then tossed about on the deck of the ship.)

Sailor #2: This is terrible! The worst storm I've ever seen! The gods must be angry!

Sailor #1: Let's have everyone on board pray to their gods. Go get that Jew that's asleep below deck.

Sailor #2: *(Wakes up Jonah.)* How can you sleep at a time like this! We're all about to die! Get up and pray to your god.

Jonah: *(Stands up and begins to be tossed around.)* Pray to my God? My God is the one causing this storm! There's only one way to calm the storm: throw me overboard.

Sailor #1: Throw you overboard!? Are you crazy? We can't throw you overboard! We'll just row harder.

(Sailors try to row hard but they keep getting tossed around.)

Jonah: It's no use. No one is stronger than God. Throw me overboard, and the sea will become calm again.

Sailor #2: O God, please forgive us for taking this man's life. We're just trying to save everyone else.

(Sailors "throw" Jonah off the back of the "boat," toward stage left. Suddenly the tossing-about stops.)

Sailor #1: Why . . . the sea is perfectly calm! That man was right!

(Sailors resume rowing the "boat" and exit stage right. Jonah is swallowed by the fish, stage left.)

Jonah: *(Hint: This line can be written on the inside of the fish.)* O Lord, you threw me into the deep, into the very heart of the seas. At first I knew I would die. But then you sent a fish to swallow me up. Thank you, O Lord, for saving my life. *(pause)* But, Lord, I've been inside this fish for three days now. It's getting kind of cramped . . . *(Fish spits Jonah out onto "land," center stage.)* Oh, thank you, Lord! Thank you, thank you!

God: *(speaking through microphone)* Jonah, let's see if you can get it right this time. Go to Nineveh and preach the message I give you.

Jonah: Yes, Lord. Believe me, I'll get it right this time! *(Walks around center stage a couple of times.)* Hear this, citizens of Nineveh, the Lord God has seen and heard how wicked and evil you are! In 40 days, God will come down from heaven and destroy every last one of you! Do you hear me? Forty days and you're all toast! *(pause)* Well, I guess I told them!

God: I guess you did, Jonah. They have all repented.

Jonah: What?

God: All the people of Nineveh have said they were sorry for their sins. They have all decided to stop doing evil and start doing good.

Jonah: But . . . but . . . that doesn't make up for all the bad stuff they've done! You're still going to destroy them, right?

God: Wrong. I'm going to forgive them.

Jonah: What? You can't forgive them! They don't *deserve* to be forgiven! They're Ninevites! *(He fusses and fumes.)* You know, this is exactly what I *thought* would happen. This is why I didn't want to come here in the first place! I knew that as soon as I threatened these folks with destruction you'd go all soft on me. Well, I want to see some action! I'm going to sit right here until I see some action. I want some fire! I want some destruction!

God: Jonah, I cared about you, even when you disobeyed me. I cared about you, even though you are just one person. Now, there are more than 120,000 people in the city of Nineveh, people who barely understand right from wrong. Shouldn't I care about them, too?

Questions

- Why didn't Jonah want to go to Nineveh?

- Is it possible to run away from God?

- When the sailors threw Jonah into the sea, he was swallowed by a big fish. Was that a good thing to happen to Jonah or a bad thing? Why?

- Jonah told the people of Nineveh that God would destroy them because they were evil. Why do you think God did not destroy them?

- Why did Jonah become so angry when God did not punish the people of Nineveh? Was God being fair?

- How did God care for Jonah and the people of Nineveh? How does God care for you?

Activities

1. **"Blob Tag."** God pursued Jonah without stopping! The harder Jonah tried to run from God, the bigger God's call seemed to be. This game is like traditional "tag," beginning with one person who is "It." (It is easiest if you create boundaries for where the children can run.) At the leader's command, play begins with It trying to tag as many people as possible. However, when a player is tagged, instead of being "out," they join hands with It and become the Blob. The Blob grows, as more and more people are tagged. Only the outside hands of the Blob can be used for tagging. Blob may split itself up, to catch more players. The last player caught becomes the new It. ***Option:*** *For younger children, play hide-and-seek.*

2. **Create a "God loves everyone" poster.** Cut out pictures of all different types of people to glue on the poster. Then use paints of many different "skin tones" to make handprints. Discuss how God loves the entire world and all different peoples. This is a good time to talk about our prejudices toward those who are different from us. How might God be asking us to think differently about them?

3. **"Belly of the fish."** If possible, pile everyone into a dark closet. Imagine what it would be like in the belly of a fish. Make sounds, talk about smells and feelings, etc. What would you pray if you were caught in a big fish? Pray for people who need to be rescued by God.

4. **"From Stormy Seas to Dry Land."** Make paper people cutouts ahead of time. Invite children to take a cutout and write down something they have done that wasn't what God would have wanted them to do. How did this make them feel "stormy" inside? Spread a blue sheet on the floor and have the children put their cutout person on the sheet (sea). Pick up the sheet together, like a parachute, and jostle the cutouts on the sea. Discuss: What would God have wanted you to do instead? What would calm the storm inside? Connect this with Jonah, and how he tried to run away from God. Have the children retrieve their cutouts and write what they would do differently. Then put the cutouts on "dry land" (perhaps tack them to a bulletin board that says "Nineveh"). Assure the children that God loves all of them very much and will forgive them when they say they're sorry.

11 The Boy Jesus in the Temple

Luke 2:41-52

Characters Mary, Joseph, Hannah, Teacher, Jesus *(Jesus may be played by a child)*

Props Chair

Introduction When Jesus was 12 years old, he and his parents, Joseph and Mary, traveled to the capital city of Jerusalem and celebrated the religious holiday called the Passover. Now the group was walking back to their hometown of Nazareth . . .

(Chair is stage right. Mary and Joseph enter stage left and walk slowly toward the right.)

Joseph: This was one of the best Passover celebrations I remember. It's a long, hard trip from Nazareth to Jerusalem, but it sure was worth it.

Mary: For me, it was worth it just to see Jesus taking such an interest in everything—the Passover feast, the temple celebrations.

Joseph: Speaking of Jesus, where is he?

Mary: He's with your cousin Hannah, isn't he? Remember, he said he wanted to walk with her and her boys.

Joseph: But Hannah decided to stay back in Jerusalem one more day. *(He peers back toward stage left.)* Oh no! Jesus isn't here!

Mary: We'd better head back to Jerusalem now.

(Mary and Joseph move to stage left. Hannah is waiting at the edge of the stage behind an imaginary door. Mary knocks on the imaginary door. Hannah answers.)

Hannah: Mary, Joseph, what are you doing here?

Joseph: We've lost Jesus. Is he still here with you?

Hannah: No, the last time I saw him, he was headed to the temple. I thought you were going to meet him there before you headed back to Nazareth.

Mary: No, we didn't know he was going back to the temple! Why did he do that?

Joseph: Who knows? I guess we'd better go look in the temple.

(Hannah exits stage left. Jesus and Teacher enter stage right. Teacher sits on the chair and Jesus sits at his feet. They are talking as Joseph and Mary walk slowly toward stage right.)

Teacher: Leviticus 19:18 says, "Do not seek revenge or bear a grudge against one of your people, but love your neighbor as yourself." Now when it says "your people" and "neighbor," that means us Jews. We should love our fellow Jews and not take revenge against them.

Jesus: Are Jews the only people who are our neighbors? Wouldn't God want us to love other people, too?

Teacher: That's an excellent question, young man . . .

(Mary runs up and hugs Jesus.)

Mary: Son, why have you treated us like this? Your father and I have been worried sick! We've been looking all over for you!

Jesus: Why were you looking for me? Didn't you know I had to be in my Father's house?

(Mary and Joseph give each other a puzzled look.)

Joseph: We're just glad we found you. Let's go home.

Questions

• Joseph, Mary, and Jesus were in Jerusalem to celebrate the Passover, a religious holiday. What are some religious holidays we celebrate in this country? Why do we celebrate those holidays? *(Some children may not understand the term "religious holiday." This question is intended to discuss why we celebrate religious holidays and realize that Jesus participated in similar celebrations. Explain that many people still celebrate the Passover.)*

• What was Jesus doing in the temple when Joseph and Mary found him?

• When his parents told Jesus they had been searching for him, he said, "Why were you looking for me? Didn't you know I had to be in my Father's house?" What do you think he meant by that?

• Where can you go to ask questions about God and the Bible? *(Assure the children that they can come to you to ask questions.)*

• What are some questions you have about this story?

• Jesus went home with his parents and was obedient to them. Why is it important to be obedient to your parents or caregivers?

Activities

1. Have a scavenger hunt. Mary and Joseph were searching for Jesus and finally found him in the temple. Hide various objects of a religious nature (Bible, hymn book, cross, offering plate, etc.) around the room, church, or outside. Make a list of the items and invite the children to search for the hidden objects. When the items have been found, talk about how it felt to find something. Connect this to how Mary and Joseph felt when they found Jesus.

2. Question time. When Mary and Joseph found Jesus in the temple, he was asking the leaders questions. Invite the children to think of questions about the Bible or God, and to ask them. You might provide index cards for writing the questions, then put the cards in a hat. Pull out a few cards and discuss the questions together. ***Option:*** *Invite a pastor to come and answer questions.*

3. Play "Guess Who!" Growing up is something to celebrate, as Jesus did when he went to the temple for the first time with his parents. For this activity, invite children ahead of time to bring envelopes with baby pictures of themselves. Do not open the envelopes until time for the activity. Then show the pictures and have the children try to guess who the baby is.

4. Growing inside and out. Discuss how the children have grown since they were babies. Outline each child's body on a large sheet of paper. Have the children illustrate the bodies with face, hair, clothing, etc. On the "inside" of the body, invite them to write ways that they have grown, things they have learned to do, etc. Do this in one color. Then in another color, invite them to think about ways that they want to keep growing and learning. End with prayer, thanking God for each child, and their ability to learn and grow. Pray that the children might learn to know God more, and grow in God.

12 Jesus Calls Levi (Matthew)

Luke 5:27-32

Characters Jesus, Matthew, 1st traveler (non-speaking), 2nd traveler, Pharisee

Props
- Small table
- Pen and paper
- Bag
- Bag with imaginary food
- 2 chairs
- Backpack
- Robe for Jesus

Introduction When Jesus began preaching and teaching, he chose twelve special followers, called "disciples." One of these disciples was named Matthew. He was a tax-collector who collected money for the Roman Empire—the foreign country that ruled over Israel. Most people didn't like tax-collectors because they worked for the Roman Empire, and because they cheated. Let's see what happens when Matthew meets Jesus . . .

(The table and two chairs are center stage. The pen and paper are on the table, and the bag of imaginary food is beside it, on the floor. Matthew sits at the table, facing stage left. 1st traveler enters stage left and walks toward the "tax-collector's booth.")

Matthew: Okay, let's see what's in the backpack. *(1st traveler opens up backpack and shows its contents.)* That'll be $3.47 in tax. *(1st traveler pretends to pay Matthew, and then exits stage right.)*

(2nd traveler enters with bag, stage left, and tries to sneak by Matthew.)

Matthew: Hold it! Where do you think you're going? Let's see what you've got in the bag there. *(2nd traveler opens up bag and shows contents.)* That'll be $7.63 in tax.

2nd traveler: $7.63! You've got to be kidding! All I've got in here is a little flour and a little oil!

Matthew: Hey, if you don't like the way I do my job you can complain to the Roman lieutenant in Capernaum! I'm sure he would be glad to hear your complaint . . . *before he throws you in jail*!

2nd traveler: All right, all right. Here's your dumb tax. *(2nd traveler pretends to pay Matthew, then mutters as she exits stage right.)* I hate those tax-collectors!

(Jesus enters from stage left, approaches tax booth.)

Matthew: *(talking to himself)* Hmm . . . He's not really carrying anything. I guess I'll have to charge him tax on his clothes. Hey you! That'll be $1.25 in tax for the blue *(or whatever color it is)* robe.

(Jesus stops in front of the tax booth but says nothing.)

Matthew: *(Recognizes Jesus and becomes a little more respectful.)* Oh, I know who you are. You're that teacher, Jesus of Nazareth. I've heard all about you. I'll tell you what, just forget about the buck twenty-five. I'll let you get by free today.

(Jesus continues to stand there silently.)

Matthew: *(looking puzzled)* I'm sorry, is there something wrong?

Jesus: Matthew, come follow me. I want you to be one of my disciples.

Matthew: What? You want me to be one of your disciples? You want me, a tax-collector, to be one of your disciples? This is a joke, right? Everybody knows that tax-collectors are sinners.

Jesus: Matthew, I know all about your sins. But I also know you would like to stop sinning and change your life. I know you want to repent. Why don't we sit down, have some lunch, and talk about it?

Matthew: Okay, why don't we? I have a little lunch to share, right here.

(Jesus and Matthew sit at the tax-collector's table. Matthew takes out a bag and shares some imaginary food with Jesus. The Pharisee enters stage right and observes them at a distance.)

Matthew: Jesus, I'll be honest with you. You're absolutely right. I don't like what I do. I'm tired of cheating people; I'm tired of lying. Most of all, I'm tired of everybody hating me.

Jesus: I don't hate you. And God doesn't hate you. God loves you and wants to forgive you.

Pharisee: *(speaking to audience)* Can you believe that? Jesus is eating with a tax-collector! He's eating with a sinner!

Jesus: *(speaking to Pharisee)* Who is it that needs a doctor? Those who are healthy? No, the ones who need a doctor are those who are sick. Well, I'm the doctor. I have come for those who need me, not to call the do-gooders. I have come to call sinners to change their ways and follow me.

Questions

- Why did people not like tax collectors?

- How did Jesus treat Matthew differently?

- Why do you think Matthew decided to follow Jesus?

- Why were the Pharisees angry when they saw Jesus hanging out with Matthew?

- What about you? Is it okay to hang out with kids who are doing bad things? *(Help the children think about choosing friends. How can they be friendly without joining others in "bad" behavior?)*

- Have you ever felt that other kids did not like you? What did you do? What can you do about it? *(Be sure to affirm God's love for all kids.)*

Activities

1. **Make music.** Create a kid-friendly rendition of the song, "I have decided to follow Jesus." Bring buckets and wooden sticks for drums, and other simple instruments. Some of the children can create the rhythm; others can choreograph movements; and others can create additional verses to the song.

2. **Create "Matthew's coins."** Cut out circles, 5 inches (12.5 cm.) in diameter. These represent coins. Discuss how Matthew, before he knew Jesus, didn't treat people very kindly. We, also, sometimes do things that aren't kind. Write on the coins some of these things. Create a prayer station, with a cross on a table, surrounded by some food. Invite the children to take their coins and put them before the cross. Assure them that Jesus forgives them and loves them unconditionally. After laying their coins by the cross, children may choose a piece of food from the table, to symbolize that Jesus still loves them and "wants to eat with them," as he ate with Matthew.

3. **Find a picture of Caravaggio's "The Calling of St. Matthew."** (One source is www.art.com.) The painting shows Jesus calling Matthew from his tax-collector's table. The artist's use of lighting is intriguing, as well as the facial expressions of the people. Invite the children to look carefully at the painting. What people draw their attention? Why?

13 Jesus Feeds the 5000

John 6:1-15

Characters Peter, Jesus, Philip, John, Boy

Props
- Basket
- 5 small loaves of bread (or rolls)
- 2 fish shapes cut out of cardboard

Introduction Jesus and his disciples traveled around the country. Wherever they went, Jesus taught and preached. He became popular and big crowds of people came to see him. Let's see what happened one time when Jesus was teaching a large crowd of people . . .

(Jesus stands stage right, and pantomimes preaching. Peter, Philip, and John are center stage, facing the audience.)

Peter: Wow, would you look at that crowd! There must be 5000 men out there . . . plus women and children. That's 15 . . . 20,000 people!

Philip: It's a big crowd, all right. But I doubt they're getting much out of Jesus's teaching.

John: Why? *(pointing to audience)* You think they're not paying attention?

Philip: I think they can't hear. Go back about ten rows and you can't hear anything. *(He walks over to Jesus.)* Aren't you concerned about that, Jesus?

Jesus: Not really, Philip. I'm concerned that these people are hungry. They've been here all day, with nothing to eat. Where shall we buy bread for these people?

Philip: Buy bread? You've got to be kidding, Jesus. Eight months' wages wouldn't buy enough bread for each one to have a bite!

(Boy with basket enters stage left. John escorts boy to Jesus.)

John: Here, I found this boy who has five small loaves of bread and two small fish. But how far will that go among so many people?

Jesus: *(speaking to the boy)* Would you be willing to share your bread and fish with some other hungry people? *(Boy nods. Jesus takes the basket, raises it, and gives thanks.)* Thank you, O Lord, for this food and for this little boy who is willing to share it. *(Speaks to Peter, Philip, and John.)* Have the people sit down and start passing out the food. *(He hands the basket to Philip.)*

Philip: Just start passing it out? That's it?

Jesus: That's it.

Philip: *(speaking to Peter and John)* Okay, that's it. He's lost it! Jesus wants to feed 20,000 people with this amount of food? What'll happen when we run out?

John: I'll tell you what will happen. Those who don't get anything (and that's about 99% of this crowd) are going to be pretty mad! We could have a riot on our hands!

Peter: I know it sounds crazy . . . even dangerous. But I've learned from experience, if Jesus tells you to do something, just do it. Let's start passing out food.

(Peter, Philip, and John each take a loaf and pass out bits of bread to the audience. When they have almost passed out all of the three loaves, Philip speaks.)

Philip: Okay, that's my last piece of . . . Wait, here's some more! Where did this come from?

John: Yeah, where did this come from? About the time I give out the last bit of bread, more appears!

(Peter, Philip, and John pass out the remaining bread and return to the stage.)

Peter: I can't believe it, Jesus! We fed every last person in the crowd. I ran out of food just after I fed the last person!

Jesus: Now gather all the pieces that are left over. Let nothing be wasted.

(Peter, Philip, and John begin to gather up the leftovers.)

Philip: I wonder who's going to eat all these leftovers?

John: *We* are. Jesus wants us to have something to eat, too!

Questions

- Why do you think the child was willing to share food?

- Why did Jesus give thanks to God?

- What do you think happened to the leftovers?

- This story tells about God doing a miracle. What other miracle stories do you know?

• Can you think of a time you shared something with others? How did you feel about sharing? How did others feel about it?

• Jesus showed one way to feed hungry people. What could we do to help feed hungry people?

Activities

1. Make cookies. Using any cookie recipe, gather the ingredients (in pre-measured quantities) and seal each in a zip-close plastic bag. Depending on the number of children present, quantities may need to be separated into smaller portions (for example, 3 cups of flour divided into 3 bags of 1 cup each). Put plastic bags in a brown bag or basket, and ask the children to each choose one. Each ingredient on its own isn't much, but what happens when everyone puts their ingredients together? Invite the children to give up their ingredients for the sake of the group. Surprise—together, the ingredients make something yummy to feed everyone! Children may pour their ingredient into a large mixing bowl and take turns stirring the cookie mix. Together, make the cookies and bake according to directions. Eat and enjoy the plenty! *Option: Take leftover cookies to a shelter or to hungry people in the community/church.*

2. Play "Leftovers." Divide the group into teams for this relay race. Scatter slices of bread and/or fake fish (or fish crackers) at one end of the room. Each team has its own basket, which must remain at the starting line. Line up teammates behind the starting line. To begin, the first player in line must race down to the bread/fish and gather up (at most) 1 piece of bread and 1 fish, run back to the starting line and deposit it in the basket. When the food is in the basket, the next teammate can go and do the same. The first team to completely fill up their basket (to the very top) is the winner!

3. Read personal stories of Christians who seemed to do "crazy things" (things that didn't make sense to the world) to help others, because Jesus told them to do it. Or, have a sponsor share his or her faith story. Some possibilities from books:

• "Bonnie, Follower of Jesus" (p. 42, *Walking with Jesus*, Herald Press, 1992)

• "The Golden Ring" (p. 89, *I Heard Good News Today*, Faith & Life Press, 1983)

• "The Christmas Money" (p. 85, *Peace Be with You*, Faith & Life Press, 1980)

Ask, "What did Jesus want this person to do? What was the challenge? How did it turn out?" In the Bible story, the disciples thought Jesus was telling them to do some "crazy things," but in the end, Jesus knew what he was doing!

14 Jesus Walks on the Water

Matthew 14:22-33

Characters	Peter, John, Jesus
Props	2 chairs for Peter and John

Introduction After Jesus miraculously fed a large crowd using five loaves of bread and two fish, he went up on a mountain to pray. The disciples got in a boat to cross a big lake called the Sea of Galilee. In our skit, we will see two of these disciples, Peter and John, as they are crossing the lake . . .

(Peter and John are seated stage left, facing stage right. John is seated in front of Peter. Both are pretending to row a boat.)

John: Wow, what a meal! Twelve baskets of leftover bread and fish, one for each of us disciples.

Peter: Yeah, John, I'm completely stuffed. But, you know, I was thinking: Each of us got a basket of leftovers, but what about Jesus? What did he eat?

John: I don't know, Peter. Maybe Philip or Bartholomew gave him some of theirs. I saw him over there with them. Then he just took off. Where'd he go, anyway?

Peter: Up on the mountain, to pray. Said he would be up there all night.

John: Man, he's always doing that. I believe in prayer, but don't you think he overdoes it?

Peter: I don't know. Maybe that's what gives him so much faith. *(pause)* You know, I think the wind's picking up a little.

(Both begin to row harder.)

John: A *little*? It's picking up a lot! It's getting rougher by the minute.

Peter: Yeah, the wind's against us, but I don't want to turn around. It's too dark to see, but I think we're a lot closer to land going this way.

John: *(moaning)* Oh-h-h, I hate these waves. I think I'm getting seasick.

Peter: Seasick! John, you're a fisherman! What kind of fisherman gets seasick?

John: *(Stops rowing, puts his hand to his mouth, and moans.)* One who just ate a whole basketful of bread and fish!

Peter: Quit moaning and start rowing—hard!

(Jesus slowly enters stage right.)

John: *(with a sudden look of terror)* Oh, Peter! It's a ghost! Look, a ghost, on the water! *(He points toward Jesus.)*

Peter: O Lord, help us! A storm, a ghost . . . what next?

Jesus: Calm down. Don't be afraid. It is I, Jesus.

John: Jesus?

Peter: *(with a look of suspicion)* Jesus! Lord, if it really is you, let me come to you, walking on the water like you are.

Jesus: *(reaching out his hand)* Come.

Peter: *(Climbs out of the "boat" and begins to walk gingerly toward Jesus.)* Hey! I'm doing it!

John: Look out, Peter! Here comes a big wave!

Peter: *(Begins to sway back and forth. With a look of panic, he starts to "sink" by slowly dropping to his knees.)* Lord, save me!

Jesus: *(Reaches out, grabs Peter's hand, and lifts him up.)* What happened to your faith, Peter? Why did you doubt? *(He leads Peter by the hand back to the boat, and they both "climb in." Peter sits down. Jesus stands in the front of the boat, facing John and Peter.)*

John: Whoa! What happened to the wind? It's gone, just like that!

Peter: *(with a look of amazement)* You really *must* be the Son of God.

Questions

• When the disciples began crossing the lake, Jesus was praying. Why do you think Jesus spent so much time praying?

• When Peter saw Jesus walking toward him he said, "Lord, if it's you, tell me to come to you on the water." Why do you think Peter wanted to walk on the water?

• Why did Jesus tell Peter that he didn't have enough faith?

• Would you have been more like Peter or John in this story?

• What does it mean to have faith?

• Tell about someone you know who has strong faith in God. How can we strengthen our faith in God?

Activities

1. **Make a Trust Circle.** This game of building trust is best played in groups of 9-15. Choose one person to be "It." With the remaining players, form a tight circle (shoulder to shoulder) around the person. It is important to not have any spaces in the circle. Alternate bigger children and smaller children. "It" must cross their arms on their chest, stiffen and fall backwards, keeping feet planted together in the middle of the circle. Players in the circle must work together to catch the person and pass him/her back and forth around the circle. (Catch around the arms and shoulders, and gently push the person back.) *Debrief:* Was it difficult for the person in the middle to trust the group? How did the group feel? How might Peter have felt as he walked on the lake?

 Safety note: Instruct person in the middle to say, "Ready to fall." The group responds, "Ready to catch," with their arms and hands positioned in front of them. Then the middle person says, "Falling," and the group replies, "Catching." Only then does the middle person fall.

2. **Create storm pictures.** Use crayons to draw a picture of the Matthew 14 story. Then use watercolors to "wash" over the entire drawing, like the storm that came upon the disciples on the sea. The paint will not cover the crayon drawing and will give a stormy effect.

3. **On fabric or pieces of paper that look like waves,** invite children to draw a picture or write about times when they were scared. Discuss how God helped them to "calm the storm."

4. **Play "The Sea is Rough!"** This game works best in a large open area. One player is "the Sea," and the others become "sea creatures." (They may choose what kind they want to be). Have each creature choose a spot on the playing field. This is their home, or safety base. They must try to get back to that same spot by the end of the game. The Sea runs past each creature, and calls out their name. The creature must follow the Sea wherever it goes. The Sea runs faster and becomes "rougher," winding in circles, etc. Then the Sea yells, "The sea is rough!" When the creatures hear this, they must run back to their home as fast as possible, without being caught by the Sea. If they are tagged, they follow the Sea as it chases the other creatures, until there is only one creature left.

15

Jesus Tells the Story of the Good Samaritan

Luke 10:25-37

This skit begins with a dialogue between Jesus and a teacher of the law. Then Jesus tells the Parable of the Good Samaritan. As he does, children act out the parable silently. The skit concludes with a short interchange between Jesus and the teacher.

Characters Jesus, teacher of the law, 7 non-speaking characters of the parable (2 robbers, victim, priest, Levite, Good Samaritan, innkeeper)

Props • 2 chairs • 2 money bags (for victim and Samaritan)

Introduction One of the ways Jesus taught was to tell short stories called "parables." In this skit, Jesus answers another teacher's question by telling a parable. The characters in the story are a man, some robbers, a priest, and a Levite. Priests and Levites worked in the temple, helping people to worship God. They were supposed to be good. The man in the parable is from Samaria. Most people from Jesus's country (Israel) thought Samaritans were bad. Our skit begins when a teacher comes to Jesus with a question . . .

(Jesus is seated stage right, facing the audience. The teacher of the law is seated on the floor in front of him.)

Jesus: And so, if you really want to know God, you must know God's Son . . .

Teacher: Teacher, I have a question for you—a personal question. What must I do to live forever with God?

Jesus: Well, you're a teacher of the Bible. What does the Bible tell you?

Teacher: It says to love the Lord your God will all your heart, soul, mind, and strength. And to love your neighbor as you love yourself.

Jesus: Correct. If you do what you just said, you will live.

Teacher: *(Pauses for a moment, thinking.)* But who *is* my neighbor?

Jesus: I'll answer that by telling you a story. One time, a man was traveling from Jerusalem to Jericho. *(Non-speaking characters pantomime the action, stage left, as Jesus tells the story.)* Some robbers attacked him. They beat him up, stole his money, and left him half-dead, by the road.

(Victim enters stage left with a money bag. Two robbers sneak up behind him. They pretend to knock him over the head and beat him. Victim falls down. The robbers take victim's money bag and quickly exit stage left.)

Jesus: Now a priest was going down that same road. When he saw the man lying there, he passed by on the other side of the road. Another religious leader, a Levite, also came down that road. He, too, passed by on the other side of the road.

(The priest enters stage left. When he sees the man, he looks at him with disgust and quickly exits stage right, walking right past Jesus and the teacher of the law. The Levite does the same.)

Jesus: *(Speaks slowly, giving time for the Samaritan to pantomime these actions.)* Then a Samaritan came down the road. When he saw the man, he felt sorry for him. He knelt down and cleaned his wounds with wine, soothed them with oil, and bandaged them.

(Good Samaritan enters stage left and pantomimes these actions. Then the innkeeper enters stage left, but remains at the edge of the stage.)

Jesus: The Samaritan took the man to an inn, to take care of him. He paid the innkeeper what he owed and said, "I need to go on to Jericho now. But I'm leaving this poor man here with you. Please keep track of the expenses and I'll pay you when I get back."

(Samaritan leads limping victim to the innkeeper and helps the victim lie down. Then he pays the innkeeper. When they have completed this action, the Samaritan, innkeeper, and victim all exit stage left. The audience's attention should shift back to Jesus and the teacher of the law.)

Jesus: Which of the three people—the priest, the Levite, or the Samaritan—was a neighbor to the man who was robbed and beaten?

Teacher: The one who was kind to him.

Jesus: You're right. You've got it. Now go and do the same.

Questions

• What does it mean to "love the Lord your God with all your heart, soul, mind, and strength"?

• What does it mean to "love your neighbor as yourself"?

• In the parable or story Jesus told, who was the good neighbor?

• In Jesus's day, priests and Levites were thought to be "good people" and Samaritans "bad people." Why do you think Jesus told a story about a Samaritan being a "good person"?

• If you were the injured person, who would you expect to help you? Who would be the Good Samaritan for you?

• Imagine that you are the Good Samaritan. Who would you help? In what situation?

Activities

1. Create band-aids out of paper. Invite children to think about ways they can help care for those in the community. They may write these ways on the band-aids.

2. Learn Luke 10:27 by singing it, to the tune of "Head and Shoulders, Knees, and Toes." Stand in a circle to sing and do the motions.

> *(2 x)* Love the Lord with all your heart *(point to heart)*
>
> mind *(point to head)* and strength *(make "muscles")*
>
> And your neighbor *(hold hands and sway back and forth)* as yourself.
>
> Love the Lord with all your heart *(point to heart)*,
>
> mind *(point to mind)* and strength *(make "muscles")*.

Sing the song faster and faster. See how fast you can do it!

3. Play "Bandage Relay." Divide the group into two teams. At the other end of the room, place ace bandages, crutches, a neck brace, knee brace, air cast, etc. Players must run down to the items and put them on, and then hobble back to the starting line and take them off. The next teammate in line quickly puts on all the items, hobbles to the other end and takes them off again. Continue until everyone has had a chance to put on the items and take them off. The team that completes this first, and are all sitting down, wins.

4. Pin the bandage on the injured. This is a variation on "pin the tail on the donkey." Hang up a large picture of a person with a "hurt." Blindfold the children, and have them, one at a time, try to put a band-aid closest to the "hurt."

5. Do a caring project. Ahead of time, ask children to bring items for a care packet to give to someone who is ill or in need. Or, collect items for one or several Mennonite Central Committee health kits. For details about health kits and items to collect, visit the web site, www.mcc.org/respond/kits/health_kits.html, or call 1-888-563-4676 (U.S.) or 1-888-622-6337 (Canada).

16 Jesus Tells the Story of the Prodigal Son

Luke 15:11-32

In this skit, Jesus tells the parable directly to the audience. The narration is limited; most of the parable is acted out, with dialogue. It will be most effective if the actor playing Jesus gives the Introduction.

Characters Jesus (as narrator), father, younger son, hog farmer, older son

Props
- Costume for Jesus
- Sandals for younger son
- Bucket
- Robe
- Money bag with coin
- Ring
- Dice

Introduction "My name is *Jesus*. I have a story to tell you today. It's about a man, his two sons, and their inheritance. Who knows what the word 'inheritance' means? An inheritance is what sons and daughters get from their parents after their parents die—things like money and furniture and land. In this story, one of the sons asks for his share of the inheritance before his father dies. It's a selfish thing to do, and rude. It's like telling his dad, 'I wish you were already dead!' Let's see what happens to this young man . . ." *(Jesus withdraws to the corner of stage right.)*

(Bucket is center stage, toward the back. The money bag, robe, sandals, and ring are somewhere off stage left. Younger son storms in from stage left, followed by his father.)

Younger: I'm sick and tired of this hick town! I'm sick and tired of this farm, and I'm sick and tired of this family and all its stupid rules! I want my share of the inheritance and I want out of here!

Father: Son, you'll get your share of the inheritance when I die. I've always been fair to you, and you will be treated fairly when I die.

Younger: When you die, I'll be long gone from here! I want my share of the inheritance now!

Father: Now! *(long pause)* Very well. I can see it will do no good to try and keep you here. *(He exits stage left, gets the money bag, and brings it to the younger son. Then he remains at the corner of stage left, watching and waiting.)*

Younger: *(grabbing the money bag)* I'm outta here! *(He exits stage right.)*

Jesus: *(Walks to center stage and addresses the audience.)* The younger son went off to a faraway country, where he wasted all his inheritance money in a wild life of drinking and gambling. Before long, he was down to his last dime . . . *(Jesus again withdraws to the corner of stage right.)*

(The hog farmer enters stage right and kneels at center stage. The younger son follows him, barefoot, with the dice and the money bag. There is just one dime in the bag. Before he kneels, he speaks to himself.)

Younger: This is it! If I don't win this round, I don't eat! *(He kneels and rolls the dice. He should shield the dice from the audience . . . in case he rolls 12! He's not supposed to win. He reacts to the roll in frustration, pounding the ground.)*

Hog farmer: Woo-hoo! *(Feigns sadness.)* I am so, so sorry for your string of bad luck. But I am so, so happy for my string of . . . *(rolls the dice)* . . . twelves! *All right!* That's 50 bucks you owe me!

Younger: I don't have 50 bucks. All I have left . . . *(looking in his money bag and retrieving dime)* . . . is one dime.

Hog farmer: One dime! *(He jumps up and pulls younger son up by the collar.)* Listen, buddy. You owe me 50 bucks. And if you don't pay me now, you can earn it by slopping my hogs. *(He retrieves the bucket and hands it to the younger son, then points toward stage right.)* There they are; have at it! *(Storms off, stage right.)*

Younger son: *(pretending to feed hogs)* I haven't eaten in five days! I'm so hungry I could eat that hog slop! Back home, Dad's hired hands get three meals a day, and here I am, starving to death. *(pause)* I know what I'm going to do! I'll go back home and say, "Father, I have sinned against God and against you. I don't deserve to be your son. Please, just give me a job as one of your hired hands."

(Younger son walks, head down, toward his father, who is waiting stage left. The father runs up to him and hugs him.)

Younger son: *(with his head still down)* Father, I have sinned against God and against you. I don't deserve to be your son . . .

Father: Son, I can't believe you're here! I can't believe you're home! Here, let me get you something to put on. *(Exits stage left and returns with robe, sandals, and ring)* Son, here is a robe for you *(puts robe on him)* . . . and sandals for your feet *(puts sandals on his feet)* . . . and a ring for your hand *(puts ring on him)*. Welcome home, son! We'll kill a calf and have a big feast tonight! Go inside and rest, while I get things ready.

Younger son: Dad, I . . . I don't know what to say. I'm just so glad to be home!

(Younger son exits stage left as older son enters from that direction.)

Older son: *(Gives a disgusted look as younger son exits.)* So, he's back.

Father: Yes, isn't it wonderful!

Older son: Wonderful for *him*, but not wonderful for me! Dad, all these years I've worked for you, day in and day out. Never once have I disobeyed you! But you've never thrown a party for me and my friends. But when this . . . this son of yours who insulted you and wasted your money shows up, you throw a party for him!

Father: Son, I know you will always be with me. Yes, your brother's inheritance is spent. That means that one day you will inherit everything I have. But can't you see the wonderful thing that has happened? As far as we knew, your brother was dead. But now he's alive! Once he was lost. But now he's found!

Questions

- Why did the younger son come back home?

- The father was so glad to see his younger son that he threw him a big party. The older son was not happy to see his brother. Why was the older brother unhappy about a big party?

- Which brother do you like better? Why?

- Which person in this story represents God? (Give a reason for your answer.)

- Can you think of a time when someone loved you even when you didn't expect it, like the younger brother in the parable?

- Can you think of a situation in which you can act like the father in this story?

Activities

1. Look at Rembrandt's painting of "The Prodigal Son." (One source is www.art.com.) Each person in the painting has a different facial expression. Try to identify who the people are in the painting, based on the biblical story. Ask the children with whom they identify most in the painting.

2. Play "Feed the pigs." Divide the group into teams and give each team a bucket. In the middle of the playing field, put a "slop station" (pile of hay, rocks, etc.). One player from each team must take the bucket to the slop station, fill the bucket, and then run to "the pigs," a designated place with a trough or box into which they dump the contents. Then players must run back and give the bucket to the next player. The first team to have be done "feeding the pigs" wins. *Option: Celebrate the winning team's accomplishment by putting robes on the winners, or rings on their fingers. Then ask how the other team(s) feel about this show of affection.*

3. Create a skit. Older children can develop a modern-day skit based on this story. Develop the plot line and characters, then act it out!

17 Jesus Visits Martha and Mary

Luke 10:38-42

Characters Martha, Mary, Jesus

Props
- Pots, pans, spoon, or other kitchen utensils for Martha
- Small table • Chair • Broom

Introduction Martha and Mary were sisters who were followers of Jesus. They often invited Jesus into their home. Our story begins as Martha and Mary are waiting for Jesus to arrive.....

(Kitchen utensils are on the table, stage left. Chair is stage right facing the audience. Martha and Mary are center stage, Mary with the broom in her hand.)

Martha: Mary, sweep the dirt off that floor! Jesus will be here any minute!

Mary: Martha, it's a dirt floor. How am I going to sweep the dirt off it?

Martha: Uh . . . I don't know! Just sweep the . . . the really dirty dirt.

Mary: All right, whatever. Just calm down. *(She sweeps the floor.)*

Martha: *(pacing back and forth)* I *can't* calm down. I'm so excited! It's been so long since Jesus was here!

(Jesus enters stage right. Suddenly Mary looks up and sees him.)

Mary: Jesus, you're here! *(She lays broom down, takes Jesus's hand, and leads him inside.)* Jesus, we're so glad to see you again! Come in, come in . . .

Martha: Jesus! Welcome. We are so honored to have you visit us.

Jesus: And I am honored to be your guest.

Martha: I know you must be tired and hungry. Why don't you have a seat and rest? We'll have dinner ready in just a bit. If you'll excuse us, Mary and I will finish preparing the meal.

Jesus: Thank you, Martha. I remember that you're a wonderful cook.

(Jesus sits in the chair. Martha goes over to table and pantomimes food preparation using the utensils. Mary sits on the floor in front of Jesus, facing stage right. As Mary and Jesus talk, Martha shows increasing frustration.)

Mary: Jesus, before I go help Martha, I have a question for you. I was at the synagogue the other day when you told the parable about the Samaritan. What were you really trying to say to that teacher?

Jesus: What do you think? What was the point of my story?

Mary: Well, you told the teacher that the point was to go and do like the Samaritan.

Jesus: That's true. But what did that mean for *that teacher*?

Mary: Maybe it meant he should quit trying to figure out who his neighbor is, and who his neighbor isn't, and just start loving whoever needs help!

Jesus: Exactly! I wish my other disciples were so quick to understand my teaching!

Martha: *(leaving "kitchen" and approaching Jesus)* "Lord, don't you care that my sister has left me to do all the work by myself? Tell her to help me!" *(NIV)*

Jesus: Martha, Martha, you are worried about many things. I know you've been working hard to prepare a meal for me, but there's no need to get upset with Mary.

Martha: But all she's doing is sitting there!

Jesus: Martha, I appreciate what you're doing. I know the meal you prepare will be wonderful. But Mary has chosen a better food—my teaching. A few hours after we eat your food, we will all be hungry again. But those who receive *my* food, my teaching, will never go hungry. What Mary is getting will never be taken away from her.

Martha: I know it says in the Bible, "We do not live by bread alone, but by every word that comes from the mouth of the Lord." Is that what you're saying? We all need to eat, but we need God's teaching even more?

Jesus: Exactly. Without God's teaching, we do not know how to live.

Questions

• How did Mary and Martha welcome Jesus in different ways?

• If you are like Martha, how would you feel about working while your sister was sitting around, talking with Jesus?

• If you are like Mary, what would you do about dinner?

• If you were Jesus, what would you have done or said?

• What do you think Jesus meant when he said that Mary had chosen the better part?

• Think of ways you can show your love for God, both by sitting quietly and by being active.

Activities

1. **What makes a good friend?** Divide the group into smaller ones and give each group a large sheet of paper. Then have them trace one person's outline and cut it out. Ask, "What characteristics make a good friend?" Invite the children to write down these qualities on the paper cutout.

2. **Create friendship bracelets/necklaces.** Using embroidery floss, braid or wrap the strands together to create a friendship bracelet/necklace. Invite children to give them to one another, as a symbol of their friendship. Think about what it might mean to be Jesus's friend. Would Jesus like to have a friendship bracelet/necklace? *Option: For younger children, thread beads on a piece of yarn.*

3. **Play, "Martha in the Kitchen."** At one end of the room, place a table, a rag, a bowl full of flour, and a broom. (If you have more than one group, set up a table and items for each one.) Line up the children at the starting line, where you have placed a handkerchief and an apron. At the leader's signal, the first player must tie the handkerchief on their head and put on the apron. Then the player must race down to the table, stir the flour in the bowl, pat some flour on their cheeks, wipe off the table, and swish the broom five times. Then they may run back to the line, take off the apron and handkerchief, and pass it to the next person. Continue until everyone has had a turn. You may want to time the game and see if the children can beat their time in the next round. Talk about how it felt to be so "busy."

18 Jesus Heals a Crippled Woman

Luke 13:10-17

Characters Jesus, synagogue ruler, crippled woman

Props • Chair

Introduction Jesus healed many people who were sick. He didn't heal them with medicine, but through the power of God. This skit about Jesus the healer takes place in a *synagogue*. A synagogue was a building where the Jews gathered on the Sabbath (the last day of the week) to hear the Bible and worship God. On this Sabbath day, Jesus was in the synagogue, teaching and preaching.

(Jesus is seated in the chair, center stage. The synagogue ruler is seated on the floor, stage right, listening to him.)

Jesus: The Scriptures say in Psalm 103, "Praise the Lord, O my soul . . . who forgives all your sins and heals all your diseases, who redeems your life from the pit and crowns you with love and compassion." God is *compassionate*. God cares for us, especially when we are sick, or weak, or hurt.

(While Jesus is speaking, the crippled woman enters stage left, limping and bent over. Jesus stops speaking and notices her.)

Jesus: Woman, I can see that you are sick or hurt. *(Beckoning)* Come over here.

Woman: Me?

(Jesus nods, and woman comes forward.)

Jesus: How long have you been crippled by this sickness?

Woman: Eighteen years.

Jesus: Those eighteen years are over. You are freed from your illness!

(Jesus touches the woman and she immediately straightens up. She begins walking back and forth without limping, with an amazed expression.)

Woman: I can't believe it! I'm healed! The pain is gone! *(She kneels in front of Jesus.)* Thank you, thank you! Praise God! What you said was right. God does forgive all my sins and heal all my diseases!

Ruler: *(Stands up and speaks to the audience.)* Wait a minute! I'm the ruler of this synagogue! Today is the Sabbath. God said not to do any work on the Sabbath, and healing someone is work! There are six days a week for work. Come and be healed on one of those days, not the Sabbath!

Jesus: *(to the ruler)* If you are the ruler of this synagogue, then you surely know the answer to this question: If your ox or donkey needs a drink on the Sabbath, is it okay to untie it and give it a drink?

Ruler: Well, of course. The law allows us to untie our animals on the Sabbath.

Jesus: Listen, this poor woman has been tied up by Satan for 18 long years! I'm not talking one Sabbath day, I'm talking 18 *years*. Shouldn't she be "untied"? Shouldn't she be set free from her illness? She is much more important than an ox or a donkey! And the Sabbath, the day on which we worship the God of compassion, is a good day to set her free!

(Ruler, with an angry expression, stomps off and exits stage right. Woman, skipping and clapping her hands, exits stage left.)

Questions

• How did Jesus heal the woman?

• The woman was happy because Jesus healed her. Why was the ruler so unhappy?

• What does "compassion" mean? Who showed compassion? Who did not have compassion?

• It seems strange that religious leaders would be angry with Jesus for healing someone. Why do you think they were so upset?

• When might it be okay to break the rules in order to show compassion?

• Share a time when you received compassion from someone.

Activities

1. **Play "Human Pretzel."** Sometimes we feel "all tied up" and need God to help straighten us out. This activity works best in groups of 6-8 people. Have the children stand in a circle and hold one hand with someone who is not directly next to them. Do the same for the other hand. Now everyone should be all mixed up. Have the children try to untie themselves by working together. *Option: Place one person outside the pretzel, to direct the children where to go. Sometimes this can take a while!*

2. **Invite a chaplain or hospice nurse to talk about healing.** Sometimes sick people today are not physically healed by God, even though we pray for them. Have a chaplain or hospice nurse share about other types of healing that they see in their profession—how God's healing is still visible, even if it is not physical (i.e. spiritual, emotional, family comes together, etc.).

3. **Create "Get well" cards** for those who are sick in the congregation. Then pray for the people who will receive them. If possible, try to hand-deliver the cards.

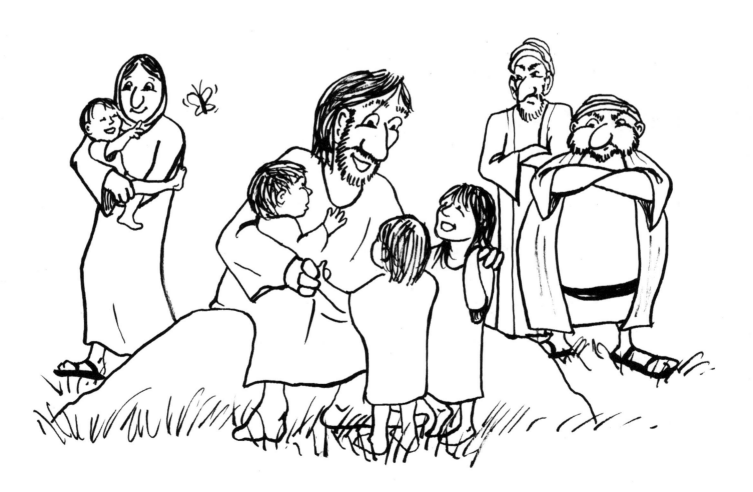

19 Jesus Wants Children to Come to Him

Mark 10:13-16

Characters Jesus, Peter, John, mother, child

Props • None required

Introduction Jesus had special compassion for those people whom others hated or ignored. He invited Matthew, the hated tax-collector, to be his disciple. He healed the crippled woman who was ignored by others. In today's skit, Jesus has compassion on another group of people . . .

(Jesus is stage right, gesturing as if preaching to the audience. Peter and John are center stage.)

Peter: John, can you believe how many people who have come out to see Jesus? *(He points to audience.)* Sometimes I think I don't do anything but crowd control!

John: Peter, I don't mind the crowds if they're people who really need Jesus—people who need to be healed, or fed, or taught. What bugs me is when mothers bring their babies to Jesus. I mean, big deal! So Jesus touches a bunch of babies! It's not like he's healing them or anything. And what are they going to learn from his teaching? Nothing!

Peter: To tell you the truth I don't mind the infants. It's the older kids who tag along that I can't stand! They always yelling, and fighting, and carrying on. And they keep interrupting Jesus when he's doing something important!

John: I hear you! Jesus could do a whole lot more if there weren't so many noisy kids around here!

(Mother and child enter stage left and walk toward Jesus.)

Peter: *(to mother)* Great! More kids! Hey, just move along, will you?

John: Yeah, Jesus has more important things to do than deal with you!

Jesus: *(to disciples)* Listen, both of you! Let the little children come to me! Don't stop them! The kingdom of God is for people like these children. I tell you the truth: You cannot be in God's kingdom unless you accept it like a little child.

(Peter and John look stunned. Jesus lays his hands on the mother and child.)

Jesus: Dear God, bless this child. Bless her mother. And thank you for all the mothers and fathers and children in the world.

Questions

- Why did the disciples not want the mothers and children to be around Jesus?

- Why did mothers and fathers bring their children to Jesus? If you lived in Jesus's day, would you want your parents to bring you to Jesus? Why or why not?

- Why did Jesus want the little children to come to him? Why does he want you to come to him?

- How do you feel when adults lose patience with you?

- What do you think Jesus meant when he said, "The kingdom of God is for people like these children"? *(Most of us would find it difficult to answer these questions. But it is good to hear the children's answers.)*

- How do children spend time with Jesus today?

Activities

1. Play, "Red Light, Green Light." You will need an open space with lots of room to move around. Designate a final destination on the far side. Line up the children at the starting line. When the leader says, "Green light," they may walk (quickly is fine) until they the leader says, "Red light." Then they must stop. If someone keeps walking, they must take 2 giant steps backwards. The winner is the one who reaches the final destination first. Ask, "How did it feel to be stopped, when you were trying to get to your final destination? How do you think the little children felt when the disciples stopped them from coming to Jesus? Assure the children that Jesus wants them to come to him."

2. Receive a blessing. Invite a pastor to come and to give a blessing to each child. The pastor might gently touch the child's head and tell them how much Jesus loves them and cares for them. The pastor might also say a quick prayer for each child and then give each one a snack.

3. Create a "Jesus welcomes me!" poster. Give each child a large sheet of paper or posterboard. Have them cut out a circle on the left side, large enough to put their face through. Then they may draw their body with Jesus next to them and write the words, "Jesus loves and welcomes me!" When the posters are completed, ask the children to put their faces through the holes. Take a picture of them with Jesus. Hang up the pictures as a reminder of Jesus's love for each child.

20

Jesus Eats the Passover Supper with His Disciples

Luke 22:14-27

Characters Jesus, John, Andrew, Peter, unnamed disciple (non-speaking)

Props
- Bread on a plate
- Cup of grape juice
- Table and chairs (unless you prefer to do this reclining on the floor)

Introduction For the Jewish people, Passover was the most important religious celebration. Part of that celebration included a special meal, the Passover meal. This story takes place when Jesus is 33 years old. He is in Jerusalem to celebrate the Passover with his disciples, his followers.

(All characters are seated at the table facing the audience. The unnamed disciple is at the right end of the table, facing the audience. Jesus is to his left. John is to Jesus's left, Andrew to John's left, Peter to Andrew's left. The bread and the cup are in front of Jesus.)

Jesus: I've been looking forward to eating this Passover meal with you. I told you before that the time would come when I would have to suffer and die. Well, that time is almost here. In fact, this is the last Passover I'll eat with you until we eat together in the kingdom of God. *(He lifts the bread and prays.)* Thank you, O Lord, Maker of heaven and earth, for giving us this food. *(He tears off a piece of bread, hands it to the unnamed disciple, then hands the rest of the bread to John.)* Here, take this bread, all of you.

(John tears off a bit of bread from the loaf and passes it to Andrew, who passes it to Peter.)

Jesus: This is my body, given for you. When you eat this, remember me.

(Jesus, John, Andrew, Peter, and the unnamed disciple eat their pieces of bread.)

Jesus: *(He lifts the cup and prays.)* Thank you, O Lord, Maker of heaven and earth, for giving us this wine. This cup is my blood, which is poured out for you.

(Jesus hands the cup first to the unnamed disciple, who pantomimes drinking from it. Then Jesus takes the cup and hands it to John. Jesus converses—silently—with the unnamed disciple. John, Andrew, and Peter each pantomime drinking from the cup. Then they begin to speak and then to argue.)

John: *(to Andrew)* Andrew, what in the world was Jesus talking about? That bread is his body? That wine is his blood? I don't know about you, but that went right over my head!

Andrew: Don't worry, John. I'm sure my brother Peter understood. Let's ask him. *(He starts to turn to Peter.)*

John: That's okay. I don't need to ask Peter anything.

Andrew: Why not? You're jealous, aren't you? I can see it. You're jealous of Peter.

John: I'm *not* jealous of Peter! I just don't think he understands anymore than I do. What makes him so important?

Andrew: Hey, you heard what Jesus said about Peter when we were at Caesarea Philippi! Peter's the *rock*! He da *man*!

Peter: Andrew, Andrew, you don't have to defend me. I know who I am.

John: *(to Peter)* And you think you're "da *man*," right? You really believe that!

Peter: Listen, I think it's pretty obvious that I'm next-in-command to Jesus.

John: Next-in-command? Then how come he spends more time with me? He spends twice as much time with me as he does with you! Why? Because he's training *me* to be the leader.

Peter: Jesus doesn't *need* to spend time training me to be a leader. I already am one!

Jesus: Peter, John—all of you, listen. You know how kings and governors like to boss people around. You know how they think they're better than everyone else. Well that's not the way it is in my kingdom. And that's not the way it should be with you, my followers. If you're a leader, don't act like you're better than everyone else. In fact, the one who is the leader must serve everyone else. That's what I have done in my life. I have served others. And that is what I will do in my death. I will serve others. That's what this is all about *(motions to the bread and cup)*.

Questions

• Why did Peter think he was so special?

• How are Jesus's followers to act?

• How did Jesus serve others? What was the lesson for his disciples?

• What are some ways the disciples could serve each other and other people?

• Have you ever been a leader? How does it feel to be one? Whether you are a leader or not, what are some ways that you can lead, the Jesus way?

• In the Passover meal, after Jesus thanked God for the bread, he gave it to his disciples, saying, "This is my body given for you. When you eat this, remember me." What did this mean? What did the cup of wine represent? *(The children may have many questions about the Last Supper and the Lord's Supper as they have seen it practiced. Use this question to prompt and answer their questions in a manner appropriate to their age.)*

Activities

1. Washing feet. Tell the children that another way Jesus showed that he loved others and came to serve others was to wash his disciples' feet (John 13:1-20). Discuss why Jesus did this, and what it might have meant. *For the leader:* Read *Confession of Faith in a Mennonite Perspective* (Herald Press: 1995, pages 53-54) for further insight. You may invite the children to wash one another's feet. Or, if they are too shy to do that, have a leader wash their feet. **Debrief:** How did it feel to wash? To be washed? Why did Jesus do this to show what service was all about?

2. Give a "helping hand." Ahead of time, make hand cutouts with punched hole and yarn loop hanger. Invite the children to write on the hands ways that they can help others. What are some ways you can show your love to others and serve them, like Jesus did? **Option:** *Use a longer piece of yarn and have the children put the hands around their necks like a necklace, but with the hand cutout hanging down the back. Invite the children to go around and carefully write ways they appreciate each other, on the blank side of the hand. Encourage the children to write only good things. Make sure that every child has something written on their hand cutout.*

3. Play "Skin the Snake." This is a game where everyone is equally important and needed as part of the team. Stand players in several lines of at least 5 players each. At the leader's signal, each player bends forward and puts their right hand back through their legs, and grabs the hand in front of them with their left hand. The person at the back of the line lies down carefully, while the player just in front walks backwards, straddling the person who is lying down. Each person then tries to lie down in the same way, without letting go of hands. The object of the game is to lie down and then stand up again without breaking the chain. If the chain is broken, the team must begin again. When everyone is lying down, the last person to lie down gets back up and walks forward, reversing the procedure. The first team to completely "skin the snake," without breaking hands, wins.

21 Jesus Dies on the Cross

Luke 23:23-43; Mark 15:40-41

Characters Mary, mother of James; Salome; Mary Magdalene; voice of Jesus

Props • Large cross • Microphone

Introduction After the Passover meal together, Jesus and his disciples went to the Garden of Gethsemane, where Jesus spent a long time praying. While he was praying, a crowd armed with swords and clubs, sent by the teachers, priests, and Pharisees, came to arrest him. They took Jesus to a special room, where they asked him questions and beat him. Finally, they took him to the Roman governor, Pontius Pilate, and convinced the governor to sentence Jesus to death by crucifixion.

The Romans used crucifixion to execute criminals. It was a horrible way to die. The soldiers nailed the person's hands and feet to a cross, stuck the cross in the ground, and waited for the person to die. That is what they did to Jesus, even though he never did anything wrong.

In this skit, three of Jesus's followers have come to the cross where Jesus is dying. They are Mary, the mother of James and Joses; a close friend of Jesus named Mary Magdalene; and Salome, the mother of Jesus's disciples, James and John . . .

(The large cross is at the back of the stage. If there is a cross on the front wall of your church sanctuary, use the sanctuary for this skit. The environment of the sanctuary is appropriate. Mary, Salome, and Mary Magdalene enter stage left and look up at the cross. All three react with shock and grief.)

Mary: *(Covers her face to cry.)* No! My God, my God, what have they done to him! I can't look at this.

Salome: *(putting her arm around Mary)* You don't have to, Mary. No one should have to see something like this. You don't have to stay.

Mary: No, I can't leave. I can't leave him. He was like a son to me!

Salome: I can't leave him, either. He never left us.

Mary: But how could they do this to him? He was a good man. He was a righteous man. He never did anything wrong—never!

Magdalene: *(angrily)* They knew that! Those teachers and priests and Pharisees, they knew Jesus never did anything wrong! That's what made them so mad. They hated him for telling the truth . . . about them. I am so angry, I'd like to . . .

Salome: *(interrupting her)* Shhh, Mary! The soldiers can hear you! Do you want them to arrest you, too?

Magdalene: I don't care if they do arrest me! Look at what they've done to him. They've beaten him, mocked him, and *crucified* him! How could they do this? If I could get my hands on . . .

Mary: Mary! He can hear you, too *(pointing to cross)*. He's still alive. I don't know if he can see us, but I know he can hear us.

Magdalene: *(Looks up at Jesus and speaks in a calmer voice.)* Do you think he's listening? Do you think he's listening to us?

Salome: Mary, Jesus always listened to us. He listened to every word we said. And more than that, he listened to our souls. He knew what we were thinking, what we were feeling.

Magdalene: *(starting to cry)* Do you think he knows what we're feeling now?

Mary: I'm sure he does. I *know* he does. I wonder what *he's* feeling now.

Salome: Shhh! He's starting to say something. Listen!

Jesus: Father, forgive them. Forgive them, for they do not know what they are doing.

(Salome, Mary, and Mary Magdalene stare at each other.)

Questions

• Jesus was a good man; he never did anything wrong. Why did some people want him to die?

• How would you have felt if you were one of the women there?

• I wonder what questions you have about this story. *(It may be appropriate to read the text in the Bible if there are questions.)*

• While he was dying on the cross, Jesus said, "Father, forgive them, for they do not know what they are doing." Who was Jesus talking about? Why would he want to forgive them?

• It's hard to forgive people who do bad things to us. Think of a time when someone did something really bad to you. Did you forgive that person or persons? Why or why not?

• Jesus died on the cross. It was a sad time for Jesus's family and disciples. How would you have felt? But the story didn't end when Jesus was placed in the tomb. God's love for Jesus was stronger than death, and we know that Jesus was raised from the dead. God gave us another miracle to show that love is stronger. How can you celebrate Jesus's life and ministry? *(Be sure to include this information, especially if there are unchurched children in the group.)*

Activities

1. Play "What would you do? What *should* you do?" Jesus loved and forgave even those who hurt him. That is hard for us to do. Read a situation (examples below), then discuss in groups what you would do in that situation. Then stop and discuss what you *should* do, based on Jesus's example.

• Situation #1: A bully knocks you down on the playground. What would you do? What *should* you do?

• Situation #2: Your best friend is sitting with someone else at lunch, and won't talk to you anymore. What would you do? What *should* you do?

• Situation #3: You're invited to a friend's birthday party. But you remember that your friend didn't give you a present for your birthday. What would you do? What *should* you do?

2. Create a cross with nails. Place the two 2½-inch (7.25 cm.) nails next to each other, facing opposite directions. Wrap wire a couple or times around the nails, about 1/3 of the way from the top. Place two 2-inch (5 cm.) nails next to each other, facing in opposite directions. Lay them across the first set of nails and wrap the wire around the nails to form a cross. Bring the wire up and around to the head of the nail at the top of the cross. Wrap the wire around the head and then form a loop with the wire. Cut off excess wire.

3. Make "Resurrection Buns." Ahead of time, thaw frozen bread dough. Have children pull the dough into 2-inch (5 cm.) pieces and place a large marshmallow in the center of each one. Cover with dough and let rise to desired size. Bake at the temperature recommended on the bread dough package. The marshmallow will hold its shape and then melt as the bun is baked, leaving it empty (and sweet) inside. When the children bite into the cooled buns, they will be surprised to find them empty—just as the tomb was empty on Easter morning. *Option: Roll dough pieces in cinnamon and sugar before baking.*

22 Jesus Is Raised from the Dead

Mark 16:1-8; Matthew 28:8

Characters Salome; Mary, the mother of James; Mary Magdalene; Salome; Angel

Props • Bag containing spices and oil • Chair

• White robe for the angel

Introduction Jesus hung on the cross for about six hours until he died. After he died, Joseph of Arimathea took Jesus's body, wrapped it in cloth, and buried it in a tomb. The tomb wasn't dug in the ground. It was cut out of a big rock, and a huge stone was rolled in front of it. The women who were at the cross saw the tomb where Jesus was buried.

All this happened on Friday. The next day was Saturday, the Sabbath day. No one went anywhere. However, early the next day, just after sunrise on Sunday morning, Mary, Salome, and Mary Magdalene went to the tomb to put oil and spices on Jesus's dead body. Our skit begins as the three women are walking toward the tomb . . .

(Mary the mother of James, and Mary Magdalene enter stage left and walk very slowly to the right. The entrance to the "tomb" is about two-thirds of the way across the stage. The angel is seated on the chair stage right, facing stage left.)

Salome: Mary, did you bring all the spices and oil we will need to anoint Jesus's body?

Mary: Yes, I have them right here. *(Mary touches the bag. Then she stops, covers her face, and begins to weep.)* I don't know if I can do this!

Salome: If you don't want to touch his body, that's okay. I can do that part. I understand if you don't want to touch a dead body.

Mary: It's not that, Salome. I just can't bear to see him dead. I loved Jesus so much. Everyone who really knew him loved him. How could anyone hate him enough to kill him?

Salome: I don't know. I still don't understand. But I *do* know that Jesus was expecting it. My sons, James and John, told me he spoke about his death again on the night of the Passover. He said he was going to die so our sins could be forgiven. I've been thinking a lot about that. Maybe his death had a purpose.

Mary: That may be true. We all heard what Jesus said while he was dying: "Father, forgive them, for they do not know what they are doing."

Magdalene: But still, he's dead. He's dead! I'm not sure I can go on living if he's dead.

Salome: We *have* to go on living, Mary. We have to. It's going to be hard. It's going to be hard every day.

Mary: And we have something hard facing us right now. How are we going to roll the stone away from the tomb so we can go in and anoint Jesus's body? You saw that stone— it's enormous!

Magdalene: I don't know. I don't know anything anymore. *(Begins to weep.)*

Salome: *(looking up in amazement.)* Look! Look at the stone! Someone already rolled it away!

Mary: Oh, Salome, I'm afraid. Who could have done that? Maybe someone has stolen Jesus's body! Maybe they're still in there!

(Salome and Mary turn and start to run away.)

Magdalene: Salome, Mary! Don't leave! Don't leave me here alone. We have to go in. If someone has taken Jesus's body, we have to find out.

(Salome and Mary stop and turn around.)

Salome: You're right. I don't want to go in, but you're right.

Mary: *(praying)* Lord, protect us and save us from anyone who would harm us.

(Magdalene, Mary, and Salome stoop to enter the "tomb" and proceed cautiously and hesitantly. Suddenly they notice the angel and step back, surprised and afraid.)

Angel: "Do not be afraid, for I know that you are looking for Jesus, who was crucified. He is not here; he has risen from the dead, just as he said. Come and see the place where he lay. Then go quickly and tell his disciples: 'He has risen from the dead and is going ahead of you into Galilee. There you will see him.' " (NIV)

(Magdalene, Mary, and Salome rush from the tomb and stop momentarily, outside the entrance.)

Salome: Who was that? Where *is* Jesus? What should we do?

Magdalene: We should go and tell Peter and the other disciples! Let's go! Hurry!

(Magdalene, Salome, and Mary exit stage quickly. Then the person who did the introduction tells more of the Easter story.)

It says in the Bible that as the women were running to tell the disciples, Jesus met them. Jesus told them what the angel had already said, "Do not be afraid. Go and tell

my brothers to go to Galilee; there they will see me" (Matthew 28:10 NIV). Jesus really was alive. He had risen from the dead.

Questions

- What do you think the women expected to find at Jesus's tomb?

- What would you do or say if you were surprised by an angel?

- Would you have believed the angel who said that Jesus was alive? What would you have done next?

- This story has a lot of feelings—sadness, surprise, joy. How do we express our feelings when we celebrate that Jesus is alive?

- We are sad when people we know and love die. We know that they won't come back to us. How can we remember and celebrate their lives?

- Share with the kids what being a follower of Jesus means to you. Talk with them (especially the older kids) what it would mean for them to become followers of Jesus.

Activities

1. **Go on an Easter egg hunt (for meaning).** Give each child a large plastic egg. Invite them to go outside and find something that symbolizes the true Easter message. When they come back, put their names on their eggs, and hide all the eggs around the room. The children may each find one egg (not their own). When everyone has an egg, sit in a circle and open them, one at a time. Have the person who gathered the contents share why they chose to put the item in the egg.

2. **Go Easter caroling.** This is a great time to sing favorite Easter songs, or learn a few new ones.

3. **Dye Easter eggs.** Discuss the history and/or meaning of Easter eggs. (Check books about holiday customs and web sites about Easter traditions.) Eggs symbolize life. Because Jesus gives those who believe in him eternal life, we often use eggs as Easter symbols. Dye eggs together and mark Christian symbols on the eggs, representing the life that Jesus gives to us.

23 Peter and John Heal a Crippled Man

Acts 3:1—4:1

Characters Peter, John, crippled man, temple guard

Props • Spear or sword for temple guard

Introduction After Jesus rose from the dead, he appeared to his disciples several times over a period of six weeks. Then he went to heaven to be with God. But Jesus didn't leave the disciples alone. He sent them God's Spirit, the Holy Spirit, to be with them. In this skit, two of Jesus's disciples, Peter and John, are going to the temple in Jerusalem to pray. Let's see what happens to them . . .

(Crippled man is sitting on the floor, stage right, with his hand out in a begging position. Peter and John enter stage left, walking slowly toward stage right.)

Peter: It's hard to believe it's been a month already since Jesus went into heaven . . . almost three months since he died and rose again.

John: And what an amazing three months! Just think of all the changes! Thousands of people have believed in Jesus; thousands have been baptized.

Peter: But you know, John, the most amazing change is the change in us. Remember how afraid we were after they arrested Jesus? We ran away and went into hiding. But since God gave us the Holy Spirit, we aren't afraid to tell people about Jesus. And remember how you and I always used to fight? That's changed, too.

John: *(joking)* No, it hasn't!

Peter: *(not understanding the joke)* Well . . . well . . . yes, it has . . . I think!

John: I'm just teasing, Peter. Of course, you're exactly right. We don't fight like we used to. We have a lot more peace, and a lot more courage. I know I do. The Holy Spirit has made some amazing changes in our lives.

Peter: Still, I have this feeling that something more has to happen. We still aren't doing everything Jesus used to do. Yeah, we're preaching and teaching. But we're not healing people like he used to.

John: Yeah, and remember how the religious leaders always gave Jesus trouble? That really hasn't happened to us. Things are . . . I don't know . . . too smooth and easy.

Peter: Maybe *that* will change. Well, here we are at the temple gate. We'll make it in time for prayer . . . if we can get past all these beggars. There are always a ton of beggars at this gate.

Cripple: In the name of God, have mercy on me! Please, just a few coins for a poor cripple . . .

(Peter and John stop and look at each other. Then both turn and stare straight at the crippled man.)

Peter: Look at us!

Cripple: *(Holds out his hand to Peter and John.)* Yes, just a few coins for a cripple.

Peter: To tell you the truth, I don't have any money at all. But what I *do* have, I'll give you. In the name of Jesus Christ, stand up and walk! *(He reaches down, grabs the cripple by the hand, and lifts him up.)*

Cripple: *(Looks down at his legs in amazement. Still looking at his legs, he takes a few tentative steps. Then he begins to run back and forth, jumping up and down.)* I can walk! I can walk! You healed me! Thank you, thank you! Praise God! I can walk! *(To Peter and John)* You two! I don't know who you are and I don't know where you're going. But wherever it is, I want to go with you!

John: We were going into the temple to pray. But maybe we need to speak to the people instead. *(Motions to the audience.)* A lot of people have seen this miracle. They need to know who really healed you.

Peter: *(speaking to the audience)* People of Israel, why are you staring at us? We aren't the ones who healed this man. This man was healed by Jesus. Yes, you remember Jesus . . . because you were the ones who wanted him be crucified. You got your wish; he was crucified. But here is something you *didn't* want or expect: God raised him from the dead. We saw Jesus alive after God raised him. And it is by this Jesus, and by faith in him, that this crippled man was completely healed.

Now, I realize you didn't understand what you were doing by arresting Jesus. When Jesus died, God did not abandon him, but raised him from the dead. God will forgive you if you turn your life around. God will refresh you with new life!

Temple guard: *(Enters stage left.)* Hey, what do you think you're doing? You can't be preaching here in the temple about that Jesus character! You're under arrest! *(He leads Peter, John, and the former crippled man out stage right.)*

Note: *This story is continued in the next skit.*

Questions • How had Peter and John changed since they received God's Spirit?

• Peter told the beggar, "Silver and gold I do not have, but what I have I give you." What did Peter give the beggar?

• Peter gave Jesus the credit for healing the crippled person. He said it took faith to be healed. What does faith in Jesus have to do with healing?

• While Peter was speaking to the people in the temple, the temple guard arrested him and John. Why do you think they were arrested?

• Peter and John didn't have any money to give the crippled beggar. Most kids don't have a lot of money, but they do have some. Should you give your money to people who need help (like the crippled beggar)? If so, how should you give it? What else can you give to people in need?

• When people feel sorry for their actions and repent, it means they turn their lives around and follow Jesus. God is loving and forgiving. Can you think of someone whose life was turned around when they were forgiven?

Activities

1. **Invite someone who has experienced a miraculous or life-changing event** to share about that experience. Ask them to talk about how they felt the power of God in that situation. What was it like to tell others about it?

2. **Toss coins into a "beggar's" tin cup.** See how far away the children can stand and still get the coin in the cup.

3. **Play "Walking and Leaping and Praising God!"** This game is a variation of leapfrog. You may choose to have teams or do the game together as a group. The first player must walk 3 steps, leap, and then take 1 big skip, waving hands in the air and shouting, "Praise God!" Then he or she must squat down. The next player walks 3 steps, leaps over the first person, skips, and then squats down. Continue until the group reaches the ending line. *Option: Time the game and see how fast the group can go.*

4. **Make a "beggar's bank."** Invite the church treasurer to tell how the offering money is spent. How does sharing our few coins provide miracles for others? Make "beggar's banks" for spare coins, using recycled plastic containers. Decorate with stickers or markers.

24 Peter and John Are Arrested for Preaching About Jesus

Acts 4:1-22

Characters Peter, John, Annas, Caiphas, healed cripple

Props
- Table
- Chairs for Annas and Caiphas

Introduction Peter and John were going to the temple to pray when a crippled beggar asked them for money. They didn't have any money, but instead, they healed the man. Then Peter preached to the people in the temple about Jesus Christ, and the temple guard arrested him and John. In this skit, Peter and John are brought before Annas and Caiphas, two of the priests in charge of the temple.

(Annas and Caiphas are seated at the table center stage, facing stage left. Entering from stage left, the temple guard escorts in Peter, John, and the former cripple.)

Annas: So, which one of you used to be crippled?

Cripple: *(excitedly)* I'm the one! These two men healed me in the name of Jesus Christ!

Caiphas: Quiet! We don't want to hear about Jesus Christ! *(He speaks to Peter and John.)* Now, just who gave you the power and permission to do this?

Peter: Your honor, if we are on trial today for being kind to a poor cripple, then let me be perfectly honest: It was Jesus Christ who gave us "power and permission." Yes, Jesus Christ, whom you crucified, is the one who healed this man.

Annas: We said we don't want to hear any more about this Jesus!

Peter: You asked me who gave us power to heal, and I told you. Jesus is the only one whom God has given power to heal and save. If *you* want to be saved, *you* must believe in Jesus.

Caiaphas: I'm not interested in your "salvation," and I'm not interested in your Jesus. I am interested in order, respect for the temple, and respect for our laws. We'll deal with you in a minute.

(Annas and Caiphas get up from their chairs and go behind the table, stage right, to talk privately.)

Annas: I recognize these guys! These are two of those men from Galilee who followed Jesus. But they were just country hicks! How did they get to be such good speakers, such *powerful* speakers?

Caiphas: I don't know. The more important question is: What are we going to do with them? News of this healing is already all over Jerusalem. There's no denying that the man has been healed.

Annas: I say we nip this in the bud. I say we threaten them and tell them not to speak about Jesus anymore. Maybe this whole "Jesus thing" will just die out.

(Annas and Caiphas take their seats at the table.)

Caiphas: *(in a threatening tone)* Now listen here, you two. We're going to let you go . . . for now. But if we catch you speaking about this Jesus anytime or anywhere, then you just might end up like him—dead.

John: Should we obey you, or obey God? We'll let you think about that one. But for us it's clear. We *have* to speak about what we have seen and heard.

Questions

• Why did Annas and Caiphas have Peter and John arrested? Why didn't they want Peter and John to tell people about Jesus?

• How were Peter and John's lives changed by God's Spirit?

• Peter and John decided they had to obey God rather than the people in authority. Was that the right thing to do? Why or why not?

• Peter said that Jesus had the power to heal and save people. What power does Jesus have today?

• What are examples of the power of God that we see in our world today?

• How can the power of God work in you? *(Use responses to form a prayer.)*

Activities

1. Play "Four Corners." Peter and John kept getting in trouble with the authorities. Help Peter and John run away from them. Number the four corners of a room. Choose one child to be "It." "It" must face a wall, with eyes closed, and slowly count backwards from 20. The rest of the players quietly walk to any corner by the time "It" counts to zero. "It" then calls out a corner ("Corner number 3!"). All the players in corner 3 are out. Continue play until there is only one player left. That person becomes the new "It."

2. Create a megaphone from construction paper or posterboard (roll into a cone shape and tape or staple). Decorate the megaphone with the verse, Acts 4:20. Learn the verse. Have the children pretend they are cheerleaders and shout the verse through the megaphone. Break into smaller groups and create a cheer or rap that encompasses the verse and theme.

3. Discuss what it means to share Jesus with others. What ways are helpful and loving? What ways would not be appropriate?

4. Create a story. Divide children into groups and have them create a story about getting in trouble for doing something God wanted them to do. Then invite the groups to act out their story for everyone. (Example: You saw a new student eating lunch alone. You thought God would want you to be kind to this new person, and sit with them, but your other friends thought you were stupid for doing that. Now they are mad at you!)

 Debrief: Discuss the situations presented, and compare them to the story of Peter and John. Did everyone always like Peter and John? Would they rather have people like them, or have God be pleased with them? Do you think it's true that people who follow God will always have people opposing them? Do you know of anyone who has suffered for their belief?

A Surprise in the Stable

Christmas Play

Characters

Group One	Group Two
Innkeeper	Shepherd #1
Innkeeper's wife	Shepherd #2
Anna	Shepherd #3
Beth	Shepherd #4
Carmela	Shepherd #5
Deborah	Angel
Mary	Heavenly Host
Joseph	Bethlehem Citizen #1
Narrator	Bethlehem Citizen #2
	Bethlehem Citizen #3

Props
- Appropriate costumes for all characters except Narrator
- Manger filled with hay
- Baby doll
- Seats for Mary and Joseph
- Rakes and brooms for Innkeeper's children

Instructions for the director

This Christmas play may be adapted to fit the needs and number of children in your program. Parts for the Innkeeper's four children (Anna, Beth, Carmela, Deborah) may be combined into fewer parts or split into more parts. The gender of characters may be changed. The same is true for the parts of Shepherds and Bethlehem citizens.

The play has a number of features to facilitate rehearsal and performance:

The cast is divided into two smaller groups that can rehearse separately. Scene One is performed by Group One. Scene Two is performed by Group Two, although the

Narrator, Mary, Joseph, and the four Innkeeper's children (all from Group One) each have one line in Scene Two.

The Innkeeper's children and the Shepherds generally speak in the same order, so the children can better remember when it is their turn to speak. The Innkeeper's children's names are in alphabetical order.

The Heavenly Host can be played by a group of small children.

SCENE ONE

Narrator: *(Enters stage left or right and reads Luke 2:4-7.)* The Bible doesn't tell us anything about the keeper of the inn that had no room for Mary and Joseph. We don't know if he was nice or mean. We don't know if he was married or unmarried. We don't know if he had children. But for our play we are going to imagine that he was married and did have children—four daughters. And their names were Anna, Beth, Carmela, and Deborah.

(Narrator exits. Anna, Beth, Carmela, and Deborah enter stage left and lie down on the stage, asleep. Mary and Joseph take their places stage right. Innkeeper enters from stage left.)

Innkeeper: *(to children)* Rise and shine! Rise and shine! What are you doing in bed at this hour? Get up and feed the animals! It's 5:00 and the cows are hungry! *(Exits stage left.)*

Anna: It's 5:00 and the children are sleeping.

Beth: Were sleeping.

Innkeeper: *(from offstage)* And clean the stable while you're at it! *(Throws rakes and brooms onstage.)*

Carmela: I hate cleaning the stable!

Deborah: I hate feeding the animals!

Anna: How come the dumb old animals get to eat before we do?

Beth: Yeah, I'm starved! I can't work on an empty stomach.

Carmela: Well, we can't eat breakfast until we do our chores.

Deborah: Yeah, we'd better get to work.

(Children go across stage to the "stable" and are startled to find Mary and Joseph there.)

Children: Aaahhhhh! *(Scream and run back across the stage.)*

(Innkeeper and wife enter stage left.)

Innkeeper's wife: What's going on?

Anna: There's a man and a woman and a baby out in the stable!

Innkeeper: Oh yeah, I forgot to tell you about them.

Wife: They showed up last night, wanting a room. Of course we're all booked up, but your father was kind enough to let them sleep in the stable. The woman looked very pregnant.

Innkeeper: Wait a minute. Did you say a man, a woman, and a baby?

Wife: That poor woman must have had her baby last night! What an awful place to give birth! Let's go and see how she's doing.

(All cross the stage to the "stable.")

Joseph: *(to Innkeeper)* I'm sorry we startled your children. Is it still okay for us to be here?

Innkeeper: Of course it's okay. It looks like you had your baby.

Mary: He was born about midnight. We borrowed your manger, here, for a crib. We couldn't find anywhere else to lay him.

Wife: *(to Mary)* I'm so sorry you had to give birth in this stable. But he's a beautiful child. What's his name?

Mary: His name is Jesus. An angel appeared to me and told me to give him that name.

Joseph: An angel appeared to me in a dream, too. He told me we were to name the baby "Jesus," because it means "God saves." He will save his people from their sin.

Innkeeper: *(skeptical)* This baby will save his people? An angel told you? Whatever . . . *(to children)* Okay, you kids. Baby or no baby, it's time to get back to work!

(Innkeeper and Innkeeper's wife turn and begin walking to stage left.)

Wife: *(to Innkeeper)* I feel so sorry for that poor woman, having her baby in a stable.

Innkeeper: I feel sorry for that poor baby! His parents sound a little crazy, if you ask me.

(Innkeeper and Innkeeper's wife exit stage left and return to seats.)

Beth: *(to the other children)* Do you really believe angels appeared to those people?

Carmela: *I* don't. I'm with Dad—I think they're a little crazy.

Deborah: Well, *I* believe them! There's something special about that baby. I can just feel it.

(Children exit stage left.)

SCENE TWO

(Shepherds enter stage left and lie down center stage asleep, except for Shepherd 1. Shepherd 1 stands stage left, facing the audience.)

Narrator: *(Enters and reads Luke 2:8-9, then exits)*

(Angel and Heavenly Host enter stage right behind Shepherds and face audience. Shepherds 2, 3, 4, 5 wake up and stare in amazement when Angel begins to speak.)

Angel: "Do not be afraid. I bring you good news of great joy that will be for all the people. Today in the town of David a Savior has been born to you. He is Christ, the Lord. This will be a sign to you: You will find a baby wrapped in cloths and lying in a manger." (NIV)

Heavenly Host: Glory to God in the highest, and peace on earth!

(Angel and Heavenly Host exit stage right and return to seats.)

Shepherd 1: *(bewildered)* What happened? Who *were* they? What was that all about?

Shepherd 2: Those were angels! They said the Savior has been born in Bethlehem! But what kind of savior? Who is he?

Shepherd 3: I don't know . . . but I want to find out! Let's go to Bethlehem and investigate!

Shepherd 4: But . . . but . . . wait a minute! What about the sheep? We can't just go off and leave the sheep!

Shepherd 5: Sure we can. If those angels want us to go see this baby, then they'll take care of the sheep!

(Shepherds act out going to Bethlehem by walking in a circle, stage left. Then they face stage right. Bethlehem Citizens enter stage right. The encounter between the Shepherds and the Citizens occurs center stage.)

Shepherd 4: *(to other Shepherds)* The only way we're going to find this baby is to start asking people. Here comes someone. Let's ask her.

(Bethlehem Citizen #1 enters from stage right)

Shepherd 4: Excuse me, we're looking for a baby that's just been born here in Bethlehem. We were told he's lying in a manger.

Citizen 1: What kind of baby? A baby sheep? A baby goat?

Shepherd 4: A baby *person*.

Citizen 1: A baby person . . . in a manger. Yeah, right. Crazy shepherds! *(Exits stage left, shaking head.)*

Shepherd 5: *(to Shepherd 4)* No, no! You're going about it all wrong! Here, let me ask the next person.

(Bethlehem Citizens 2 & 3 enter stage right.)

Shepherd 5: Excuse me, I know this sounds a little unusual, but we heard a fascinating rumor about a baby born in Bethlehem last night. And after he was born, he was laid in a manger. Have you, by chance, heard about this baby?

Citizen 2: A baby, lying in a manger? Who in the world told you that?

Shepherd 5: An angel.

Citizen 2: An *angel* told you about a baby lying in a manger? Yeah, right. Crazy shepherds!

Citizen 3: Wait a minute! I was passing by here a few minutes ago and thought I heard a baby's cries from that stable over there. *(Points toward manger.)* I thought it was just my imagination, but maybe it wasn't. Why don't you guys go check?

Shepherd 4: Thank you very much! *(To other Shepherds)* Let's go see!

(Bethlehem Citizens 2 & 3 exit stage left. Shepherds face the manger and Mary and Joseph, stage right.)

Shepherd 5: *(amazed)* There he is! There's the baby, lying in a manger! There's the Christ child!

Mary: How did you know about our baby?

Joseph: And how did you know that he was the Christ?

Shepherd 4: This night, while we were watching our sheep, an angel appeared to us and said, "I bring you good news of great joy. Today in Bethlehem a Savior has been born to you. He is Christ, the Lord."

Shepherd 5: The angel said, "You will find the baby lying in a manger." And then a whole bunch of angels appeared, praising God. And here he is, just like they said. He must be the Savior!

(All the shepherds look into the manger.)

Shepherd 4: If he's the Savior, then other folks should know about this. Let's go tell the people of the town!

(The shepherds turn to exit stage left as the Innkeeper's children re-enter stage left.)

Shepherd 5: *(to children)* Hey, kids! Go see that baby there, in the stable. He's special. He's the Savior! An angel told us!

(Shepherds rush to exit stage left. Children stand center stage and stare at each other for a moment.)

Anna: Dad didn't believe them. Mom probably didn't believe them. I wasn't sure whether to believe them or not.

Beth: Yeah, all that talk about angels and Saviors sounded pretty crazy to me.

Carmela: It's hard to believe the Savior of the world would be born in a dirty old stable. (Well, it's not *that* dirty; we just finished cleaning it.)

Deborah: *(turning to look at baby)* But it must be true! It has to be true! You heard those guys. An angel told them the same thing. This baby *is* going to be the Savior—someone who will save us, someone who will forgive us, someone who will bring us peace. This little baby is the Prince of Peace.

(Deborah kneels in front of the manger.)

THE END

Notes

Notes

Acknowledgments

This book grew out of an after-school children's outreach ministry initiated by the Warden Mennonite Church in a low-income, predominantly Hispanic community. To maintain the attention of kids with limited English skills, unchurched backgrounds, and little Bible knowledge, we began to use Bible skits. We wrote and acted the skits ourselves. The kids paid attention and remembered the stories. They asked questions about faith and life. Most importantly, the skits communicated the good news of God's love.

I thank my wife, Irene, for her work with our club program and for her encouragement of this writing project. Thanks to Warden Mennonite Church for its support and guidance. Through the years, at least half of the adult members of the congregation have been involved in some capacity with our program, called Venture Club. I am grateful to Mary Burkholder, who had the original vision for this ministry, and to Glenn Burkholder and Marlene Unruh, who have been leaders through most of its history. Wanda Dorsing wrote the original version of skit # 7. Skip Gray's retreat cabin was a serene spot for writing and editing.

Finally, I thank the kids who have attended Venture Club for challenging my faith, my imagination, and my patience. The goal of our club program is simple: Let the children know that God loves them; Jesus loves them, and so do "those old folks in the church."

—**David M. Morrow**, author, is pastor of Warden Mennonite Church in Washington State.

Rachel S. Gerber contributed the suggestions for response activities for each Bible skit. Rachel earned a BA in Elementary Education from Goshen College. She has taught fifth grade and served as minister of youth and young adults at College Mennonite Church, Goshen, Indiana. In 2005, she received a MDiv from Eastern Mennonite Seminary and is currently associate pastor of faith formation at First Mennonite Church, Denver, Colorado. Rachel and her husband, Shawn, live in Denver.